advance praise for

Barn Quilts and the American Quilt Trail Movement

"Finally, ten years after the birth of the Quilt Barn Trail in Adams County, Ohio, a book documenting its very beginnings. Parron did an excellent job of preserving the chain of events that touched off this national phenomenon. Since that first quilt square was painted in 2001, new and different quilt patterns continue to pop up like spring daisies on old barns all across our rolling landscape, adding a touch of color to the countryside of rural Adams County. This book and those barns are a constant reminder of the lasting endurance of Donna Sue's vision that still takes root today."
—Tom Cross, Executive Director, **Adams County, Ohio, Travel & Visitors Bureau**

"The quilt barn trail is the embodiment of what persistence and abiding love can achieve. Donna Sue's original vision of combining a traditional art form and a traditional structure continues to resonate with the history of our rural and agrarian culture. Documenting this unique achievement in this book is a wonderful gift from Donna Sue and Suzi to all who seek a full understanding of our American heritage."
—Julie S. Henahan, Executive Director, **Ohio Arts Council**

"Bravo to Suzi Parron and Donna Sue Groves for bringing to light the colorful and rich history of the barn quilt movement. It's a tale of heart, hope, and deep, rural roots—roots that started in Adams County, Ohio, but spread quickly across the land. Parron's deep research and Donna Sue's deep love of the subject provide a unique chapter in America's art history."—Doug Weaver, publisher, **Kansas City Star Books**

"In an age of 'viral' marketing, Donna Sue Groves's grassroots effort spread like wildfire! When something defines you, there's passion. Her passion for Ohio, the arts, and the tradition of quilting were used to honor her mother's pastime with a simple yet beautiful tribute on their family barn. This changed the landscape across Adams County, then Ohio, then the Midwest and beyond. A unique clothesline of quilts emerged from rural America. Communities everywhere have barn quilt tours, capitalizing on Donna Sue Groves's innovation. And Donna Sue Groves receives nothing for this phenomenon she started other than acknowledgment as its creator. That defines this legend. She gives her soul and expects nothing in return."
—Frank R. Satullo, owner of **OhioTraveler.com**

"After ten years of international travel encompassing twenty trips, we have finally found a replacement activity—Barn Quilt Trail photography! Iowa born and raised, we have never met a barn we did not like and now a quilt block has been included. Our photography has taken us to Iowa, Minnesota, Illinois, Ohio, Georgia, Colorado, and Nebraska. We have experienced: back roads, friendly people, no semis at 80 mph, lots of free kittens and puppies, and just the peace and quiet of the beautiful American countryside. Please come join us!" —Dave and Ruthann Kern, **Illinois**

"The Barn Quilts of Neversink Project has encouraged visitors to explore our rural countryside and property owners to repair and upgrade their barns, and has helped to create a new identity for our township."

—David Moore, Barn Quilts of Neversink, **New York**

"The Barn Quilt Trails project has taken public art into all arenas of our community. The Barn Quilts are a perfect blending of the heritage art form of quilting, the importance of agriculture in our county, and the significance of the architectural elements of barns and farm outbuildings. Barn Quilts bring it all together in a delightful, colorful way!"

—Jane Lonon, Executive Director, Ashe County Arts Council, West Jefferson, **North Carolina**

"The Quilt Trails project has brought our community together in a way I never dreamed possible, helping to build bridges, mend fences, and tell the many rich stories of our community. Each block serves as a history repository, and the published stories about each reveal hidden secrets and wonders of our community. Further, students have started exploring their county and learning about the back roads and stories of their neighbors. Teachers have started using the project to teach history, math, and civics, having the students design a quilt block to tell their family story.

"Because I'm a quilter I have seen the power of a quilt to bring comfort and delight and to trigger deep emotions and feelings. So it is especially satisfying to me as the Director of this project to see the power of the quilt magnified so enormously and to see it still work its magic. Our communities are richer and kinder because of this project, our self-esteem is a bit higher. . . . My personal thanks to Suzi Parron for helping to bring this wonderful project to the attention of the nation. We can all be richer for her efforts."

—Barbara Webster, Executive Director, Quilt Trails of Western **North Carolina**

"The Upstate Heritage Quilt Trail in **South Carolina** has generated a surprising amount of enthusiasm among quilters, non-quilters, history buffs, and folks with fond memories about quilts from their past. Even more surprising is the response from people of all ages and their willingness to join in on the design and painting of quilts for the buildings and homes in our area. Honoring quilters past and present has been a real joy and brought a sense of community ownership and pride to our Trail. We feel we're creating a whole new generation of quilt lovers as well as encouraging people to explore our communities and experience the beauty this area has to offer."

—Martha File, Chairperson, Upstate Heritage Quilt Trail

"The quilt trail inspires people! To paint, to photograph, to travel, to celebrate, to get off the beaten path and discover the treasures of Appalachia. The beautiful blocks are a source of community pride and attract hundreds of visitors every year who come to experience all that the trail has to offer . . . from antiques to lavender farms, the

Appalachian Quilt Trail has something for everyone. It is one of the most affordable and effective marketing tools in rural **Tennessee** today."
—Lindy Turner, Executive Director, Clinch-Powell RC&D Council

"The Miami County Barn Quilt Tour has far exceeded our expectations, bringing many more people from all across the country to visit Miami County than we could ever have imagined. While here, taking the roads less traveled, they are not only appreciating the beauty of the Barn Quilts themselves, the historic barns, and our lovely rural countryside, but they also visit our historic small town shops, restaurants, hotels, and various attractions, thus creating sustainable tourism."—Diana Thompson, Executive Director, Miami County Visitors & Convention Bureau (**Ohio**)

"Alcona County's residents have worked together to create our own unique quilt trail that truly represents our heritage, our people, and our natural and commercial resources. We welcome visitors as they enjoy touring our beautiful Michigan countryside while learning about our way of life, shopping at our locally owned businesses, and dining at our family-owned restaurants. The Alcona County Quilt Trail has a very positive impact on our economy, while also fueling community pride within all areas of our county. It's a wonderful project to be a part of."
—Cindi Van Hurk, the Alcona County Quilt Trail Project (**Michigan**)

"The Osceola Quilt Trail has generated a lot of positive comments from both tourists and locals about how much they enjoy seeing this public art form as they drive around the countryside." —Elsie Vredenburg, Osceola County, **Michigan**

"The Barn Quilts of Kankakee County are a wonderful attraction for our area, drawing interest from visitors from as far away as Michigan, Indiana, Washington, and California. Displayed on historic barns and corncribs throughout Kankakee County, each Barn Quilt shares a unique story of growth, celebration, toil, and tradition. These colorful patterns and well-preserved homesteads invite visitors to venture off the beaten path."
—Nancy L. Fregeau, Kankakee County Convention & Visitors Bureau (**Illinois**)

"Barn quilts are a perfect fit with our area; they are an excellent companion to the other ag-tourism opportunities in Green County. This has been a great project because it ties the entire county together with an artistic rural theme, promotes county-wide pride, and gets our visitors to all the communities for a true adventure in exploring the roads less traveled along the way."
—Noreen Rueckert, Green County, **Wisconsin**, Tourism

"I grew up in a community where once a month, women gather together for 'Love Day'—turning scraps of fabric into quilts that are sent all over the world. I have great respect for traditional quilting, but a quilter I am not. However, the communal joy these women have found in working with other women to create quilts inspired me to express my imagination, my heritage, my vision in a barn quilt. And, in doing so, I was able to offer something of myself through community service to the bluff country region." —Karen Bingham, Spring Grove, **Minnesota**

"The barn quilts have brought people together, new partnerships and networks have formed, and Sac County citizens have great pride in our barn quilts. . . . The barn quilt project is one of the most successful and satisfying projects we've ever been involved with, and we're excited that this book documents the spread of this creative idea across our nation and beyond." —Harold and Sue Peyton, Sac County, **Iowa**

"Through what started as an effort to promote tourism and preserve the cultural heritage of a farming community, a little paint and wood has not only put a little color back into 'Colorful Colorado' but has brought together a community and has put Morgan County, Colorado, on the map of the nation's growing barn quilt trail."
 —Nancy Lauck, Project Coordinator, Morgan County Barn Quilts in **Colorado**

"In January of 2009, a local group from several city and county organizations began meeting with the intent of building a Quilt Trail. The goal was to create a tie between our rich local history and the wonderful talents of local quilters. Three years later, with 81 quilt blocks installed on historical barns (Barn Trail Loop) and buildings (Walk Our Blocks), we have the added benefit of encouraging tourists to spend a little more time in our community. The Tillamook Area Chamber of Commerce reports that the Quilt Trail is tied with the Three Arch Capes Loop as the two most asked about attractions on the Central Oregon Coast."
 —Tillamook County Quilt Trail Coalition, Tillamook, **Oregon**

"Lake County celebrates art in rural places. The first quilt trail in **California** consists of quilt blocks decorating the sides of pioneer barns, pear packing sheds, winery tasting rooms, and other historic structures. Each quilt has a story that connects to the history of the building, honors farming, or celebrates family. The Lake County Quilt Trail is an agricultural and tourism project designed to promote and celebrate our community pride." —The Lake County Quilt Trail Project Team
 (Vicky Parish Smith and Marilyn Holdenried, Lake County, California)

"For me the clothesline of quilts has brought many new friends—more than I would have ever hoped for. Discovering a new quilt barn, hearing the story of the quilt square, the history of the barn, and the reason they choose the pattern is delightful. I am proud of the legacy Donna Sue leaves behind, especially when I learned of the Groves family farm connection in West Virginia. Most of all I celebrate the enjoyment that the project has brought to me and so many others."—Nina Maxine Groves

BARN QUILTS AND
THE AMERICAN QUILT
TRAIL MOVEMENT

BARN QUILTS AND THE AMERICAN QUILT TRAIL MOVEMENT

Suzi Parron

with
Donna Sue Groves

OHIO UNIVERSITY PRESS

SWALLOW PRESS

Athens

Swallow Press / Ohio University Press, Athens, Ohio 45701
www.ohioswallow.com

© 2012 by Ohio University Press

To obtain permission to quote, reprint, or otherwise reproduce or distribute material from
Swallow Press / Ohio University Press publications, please contact our rights and permissions
department at (740) 593-1154 or (740) 593-4536 (fax).

Printed in the United States of America
Swallow Press / Ohio University Press books are printed on acid-free paper ∞ ™

20 19 18 17 16 15 14 13 12 5 4 3 2

Library of Congress Cataloging-in-Publication Data

Parron, Suzi.
 Barn quilts and the American Quilt Trail movement / Suzi Parron with Donna Sue
Groves.
 p. cm.
 Includes index.
 ISBN 978-0-8040-1138-9 (pbk.)
 1. Barns—United States—Pictorial works. 2. Barns—Canada—Pictorial works.
3. Outdoor art—United States—Themes, motives. 4. Outdoor art—Canada—
Themes, motives. 5. Culture and tourism—United States—Pictorial works. 6.
Culture and tourism—Canada—Pictorial works. I. Groves, Donna Sue. II. Title.
 NA8230.P36 2012
 725'.3720973—dc23
 2011036642

contents

preface

These past couple of years, I have often been asked, "What is your book going to be about?" At first I would reply, "Oh, it's something you wouldn't be interested in." Rather an odd characterization, since taking on a topic unlikely to engage readers is hardly a writer's purpose. All right, I decided, I'll just answer, "It's about barn quilts." That didn't work out too well, as the questions that ensued led to protracted explanations, much longer than the inquirer anticipated or desired. Finally, I developed a stock answer, which by now I deliver by rote: "You know that quilts are made up of squares? Well, a barn quilt is a replica of one of those squares, painted on plywood, usually eight-by-eight feet, and hung on a building for passersby to see. Most of them are mounted on barns, so they are called barn quilts. There are thousands of them all over the country—currently in thirty states—and in Canada."

That usually does the trick.

When I set out on this journey, that answer was my guidepost. My plan was to document where and how the quilt trail had begun, how it grew, and just where the various sections are located. I would spend six months investigating the barn quilt phenomenon and then about that long setting it all down. It took only about a month to abandon my plan. Each time I looked for one trail, I found two—or three. Often they appeared when I wasn't looking at all. That's the problem with documentation; one never knows what will be uncovered. My journalistic instincts led me to embark on a treasure hunt of sorts, with a continually changing map as my guide.

Sometimes there is more to the story of a barn quilt than just the pattern name, who painted it, and when. More often, a cast of characters, sometimes going back generations, has to be introduced to complete the tale. Often, when I collected one story, I was led to another. The tales spun away from the quilts themselves into the communities, the histories, and the ways of life that are as varied as the quilt patterns. Six months' research turned into a year. As word spread that this project was under way, I received invitations from quilt trail organizers across the country and spent far more time traveling than I had imagined—a bit more than two years in all. It was the adventure of a lifetime, and if it weren't for deadlines, I'd still be hard at work.

I am so grateful to all who were part of this project. Dozens of individuals organized community meetings, escorted me on tours of their quilt trails, and kept me well fed along the way. More than three hundred people set aside time to speak with me, and quite a few welcomed me into their homes when I turned up unannounced. Not all of those generous folks made their way into these pages, but each contributed to this work and to the journey that has enriched my life beyond measure.

I would like to thank Donna Sue Groves, who trusted me with her story, and her mother, Maxine, without whom there would be no story to tell. Many thanks to Gillian Berchowitz of Ohio University Press for her support and to her colleagues, Nancy Basmajian and Beth Pratt, for their patience in answering my many questions. I am so grateful for the skill and care with which Jeff Cox prepared dozens of images. This book would not have happened if not for my dear friend Charlie Haddad, who told me years ago that I should write and kept after me until I promised to do so. And finally, I am indebted to Belenda Holland, whose kindness to a trespassing stranger started me on this journey.

BARN QUILTS AND
THE AMERICAN QUILT
TRAIL MOVEMENT

the trail begins

As I ROUNDED a bend on a Kentucky two-lane, a flash of bright color startled my road-weary eyes: a large yellow sign, with two painted rows of pink, red, blue, and purple triangles, affixed to the side of a small dark-planked barn. I slowed for a moment. The intricate geometrical design and the placement of colors and shapes looked exactly like a Flying Geese quilt square! As I crept along, a glance back revealed that the opposite side of the barn was similarly decorated, but with a Pine Tree pattern. I pulled onto the grassy shoulder and stepped out of the car for a better look. Those were definitely quilts. Standing alone in a strange place, four hundred miles from home, I felt that I belonged and was welcomed. The familiar images called up memories of family and childhood, of things long in the past yet a vital part of my identity. With thirty miles to drive and a tent to pitch before nightfall, I hurried on, but the desire to know more had begun to pull at me already.

Throughout the night, through the next day's hiking and kayaking, my mind kept returning to those quilts. I just couldn't leave the area without knowing their story. With my late afternoon's leisure put aside and my black Labrador mix, Gracie, in the backseat eager for adventure, I retraced the dusty gravel that led to the highway. I stopped at a BP gas station and inquired, hoping to solve the mystery without having to retrace my trip all the way to Cadiz. A leisurely discussion of the lottery results was paused just long enough to permit consideration of my question. No one knew why those signs were there, but my informants acknowledged that they sure were pretty. The owner of the thrift store didn't live in that direction. Every couple of miles, it was the same story—"I don't know anything about 'em,

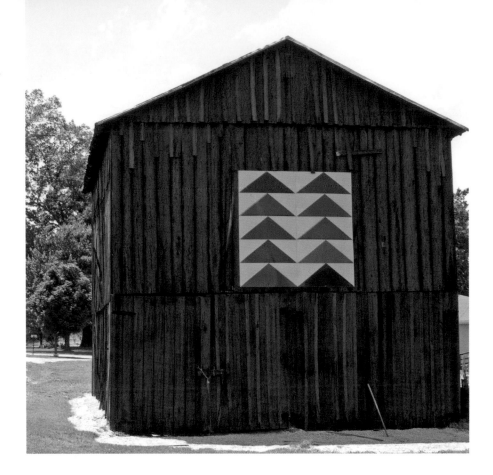

but I like 'em." There seemed to be no option but to drive back to the first barn. "This had better be good," I thought. "Sixty miles round-trip to ask somebody about a barn."

Being an intrepid soul, I pulled onto the gravel driveway of the farm and took a few photos of the barn right away. Someone was barely visible behind the house, seemingly oblivious to my arrival. "Hello," I called, "I apologize for trespassing, but I wonder if you could tell me about your barn." I hovered near the car, in case the owner came out with a shotgun or let loose a dog, but no quick getaway was necessary. Belenda Holland appeared, apologizing for having to stop to empty her hands of laundry. The khaki Bermuda shorts and Teva sandals looked more California than Kentucky, but the accent was pure country. Her tanned face crinkled when I told her how far I had driven to have my question answered. "Well," she said, "someone had the idea of putting quilt squares on barns to celebrate the art of rural America. Everyone thinks of agriculture and the men hard at work; we wanted to recognize the women's role and remind folks that we have always produced art as well."

Belenda didn't need to remind me of the significance of quilting. I grew up in Florida, where kerosene stoves were the only source of heat, so quilts were often part of my winter bedding. Dozens of quilts, most decades old and worn to a

comfortable softness, filled a hall closet outside the bedroom where I slept at my grandmother's. The first night was the best: carefully unfolding a half dozen or so, placing them one by one on the bed with each one squared with the one beneath so that they would remain just so, and wriggling underneath. The warmth created by my great-grandmother's hands insulated me from both the winter chill and the uncertain world.

As the years passed, those quilts, faded and torn, mended by many hands, became the last connection to my great-grandmother and her folkways, to my cultural heritage. Many a friend has scoffed at my insistence that my quilts must be made by hand, but quilting is not simply a means of producing a bed covering. The craft is at once a creative outlet and a reminder of who I am—a child of the rural South.

That small Kentucky farm seemed my own personal heaven: the art of my great-grandmother on public display, preserved for all time. Belenda directed me toward Highway 91, where about ten more quilt squares were hung on barns. This detour would take me another twenty-plus miles out of the way and leave me to return to camp after dark. None of that mattered. It was as if I had family scattered throughout the countryside, waiting for me to come by, to see how they lived and to share our stories. To stop and visit each seemed the natural thing to do. I set off toward Hopkinsville and the beginning of what would become my first quilt trail.

Route 91 yielded another quilt barn almost immediately, this one a massive gray building with a peaked roof and a bold red and blue star on the front. Some of the barns were set far back from the road, and many of the quilt squares were hung on barn sides, so eight miles' worth of barns had to be carefully scrutinized. Once my attention was drawn to the structures themselves, I was struck by the amazing variety of barns that I encountered. Some were long abandoned and fallen to one side, barely held together by masses of ivy. Others were a well-preserved testament to the hard work of the current owners. Most of the barns were separated from the houses by fields, but on a few farms the two were side by side. In contrast to the horizontal boards on the houses, those on the barns hung vertically. Why place the boards on one building one way and those on another the opposite? With the question filed away, the hunt for barn quilts continued.

The variety of quilt patterns was as great as the variety of barns. Most were simple geometric designs painted in bright contrasting colors, often red and blue, which made them easily visible, even if the barn was far from the road. Although cloth quilts often include shades that are more muted, bright yellows and greens and even the purple and pink of the barn in Cadiz most readily created the desired effect. Some designs, though reminiscent of my beloved scrap quilts, were more difficult to make out, as they were more detailed and painted in pastels. Of course, to an already captivated mind, each discovery was a sweet surprise.

One in particular stood out; with over sixty pieces, it would have been challenging to stitch, much less to paint.

Near the main road, the quilt squares appeared less often, and my attention returned to the barns. The vertical alignment of those planks fascinated me. My fixation might have been pushed aside if not for the connection with the quilts. I pulled in next to a roadside shed where a farmer worked on a tractor that appeared to be older than I but which his confident manner indicated would be running momentarily. He stopped and wiped the sweat from his eyes, applying another streak of grease to an already grimy face. "This may seem like a strange question," I said, "but why are the boards on those barns vertical?"

He took a couple of gulps from a gallon jug of water and replied, "They're tobacco barns. Gotta be hollow ta hang tobacco. We build 'em on a frame—ain't no need to waste time with a buncha studs since there won't be no walls inside, but that means ya can't nail the boards side to side like on a house." Seeing that I didn't quite grasp the concept, he went on, "It's kind of like a big H, that's all." Now I understood. "Thanks a . . ." He had already picked up a wrench and gone back to work.

Understanding how the barns were built inspired yet another detour, down side roads that were often unpaved, sometimes barely driveways. Vertical boards allowed for many variations in form. Most of the barns were rectangular, but some were octagonal, some almost round. Many seemed to have been shaped to adapt to the surrounding terrain, precisely planned and executed. It seemed that the women of the region were not the only artists. The men who created those barns were equally skilled at their craft. I wondered whether those men and women had thought at all about the legacy that they had built, piece by piece, board by board.

I soon discovered that dozens of quilt trails spread throughout Kentucky and are not confined to the state or even to the South. Those quilt blocks that seemed such a personal tie to my roots were symbolic to folks in Ohio, Iowa, and New York as well. It hardly seemed possible. As for the travelers who drove the quilt trails, did they feel the same sense of belonging when in front of one of those painted squares that I did? Did they stop—just for a moment—and recall the pride of place that existed before the city or suburbia became home? I wanted to know their stories, to discover how quilts transcend culture and region and represent a larger connection.

My questions led to Donna Sue Groves in Adams County, Ohio, and the story of the American Quilt Trail began to unfold.

◼

The road to Donna Sue began with a call to Judy Sizemore of the Kentucky Arts Council. A brief chat yielded a bit more of the story and piqued my curiosity. I had to know more. Judy went on to explain that Donna Sue Groves had created the

first quilt barn and that the story was hers to tell. She passed along Donna Sue's phone number and wished me luck.

What Donna Sue refers to as her West Virginia twang was to my ears a close cousin to my mother's Southern drawl. That voice and the warmth behind it made me feel at ease almost immediately. Our first conversation lasted over an hour—a subtle dance of my wanting to know the answers to a host of questions and her needing to know who was asking. Over the next couple of weeks, Donna Sue and I spoke about a dozen times. It's hard to say just when our ease of communication developed—how long it took until our conversations fell into a sort of rhythm as she began to anticipate my questions and I learned to be silent and allow her to fill in the spaces. I never asked the nagging question, though—the one that had instigated that first phone call. One evening as we were saying our goodbyes, Donna Sue paused and said with measured emphasis, "Suzi, I'm going to trust you with my story." And so it began.

The word *Appalachia* often carries a negative connotation, even among those whose roots are in the region. But Donna Sue describes her heritage as a gift: "I am part of those early settlers that moved into the hills and river valleys of Appalachia looking for a new life, a new beginning, and a safe haven to create a home." Her childhood home in Crede, West Virginia, on the banks of the Elk River was such a haven. Fronted by railroad tracks and a state road, with a mountainside directly opposite, it was Donna Sue's cocoon. She says, "I had it all as a child—the magic of the ever-changing river and the enchantment of the woods." But it was when visiting family away from her much-beloved home that Donna Sue became connected to both barns and quilts.

"Chew Mail Pouch—twenty points!" "Bank barn—ten!" Donna Sue and her brother, Michael, sat in the back of the car scouring the landscape on the way to visit their grandparents. While children in other parts of the country might be occupied with spotting license plates, cars that drove the back roads of West Virginia seldom afforded that opportunity. Maxine Groves created a unique game of counting barns to keep her children busy. Some barns were two points; others, red barns for instance, were worth more. If the barn had outdoor advertising on it, such as "See Rock City" or "RC Cola," whoever spotted it got a bonus of ten points if able to read the slogan. The game led to discussions and questions about the barns: Were they English, Welsh, German? The various construction methods and uses of barns led to history lessons that were both educational and engaging. About the time Donna Sue entered her teens, the family began to travel to New England for vacations, and along the Pennsylvania Turnpike, the beautiful Pennsylvania Dutch barns with their hex signs appeared. Donna Sue recalls, "They had the most colorful, wonderful, geometric designs on them, and they were worth fifty points in our car game; that was pretty exciting. I looked forward to seeing those barns." In this fashion, barns, particularly decorated barns, were imprinted on Donna Sue's mind.

The quilts of Donna Sue's childhood were much more personal, as they were direct ties to her family heritage. Here, the two of us connected, as the treasure that is a homemade quilt was sacred to us both. Quilting had been a tradition in Donna Sue's family for several generations. The "pieced" quilts made by her maternal grandmother fascinated Donna: "I remember the cloth that Grandmother Green used to make her quilts. The scraps of material were so tiny, and when she finished, I could not understand how she created something so big and beautiful. The fabric scraps were leftovers from her dresses; when I touched the quilt squares it was like touching Grandmother." When Maxine Groves took up the craft some years later, she used her mother's piecing method to create traditional patterns, which evolved into the masterpieces that brought her admiration from her daughter and recognition from so many others.

Donna Sue's voice filled with wonder when she told a story of her Grandmother Groves. During one fall visit, Donna Sue was told to select her three favorite maple leaves from the yard. Donna Sue carefully made her selection but was curious. When asked what she would do with the leaves, Donna Sue's grandmother replied, "You'll see." The question was posed on the next visit: "What are you going to do with my leaves?" Her grandmother replied, "You'll just have to wait and see." Each visit, the same question was asked, the same answer given. Several months later, her grandmother pulled out a quilt with appliquéd maple leaves in oranges and browns made just for Donna Sue. To Donna Sue, "It was magic. In it were the very outlines of the leaves that I picked up off the ground that she had used as templates." The magic of her family quilts and the fascination with barns stayed with Donna Sue throughout her life.

The Groves family moved from West Virginia to Xenia, Ohio, to seek better economic opportunity. But for Donna Sue, West Virginia was always home. After her father passed away and her mother retired, she was ready to return to West Virginia, but her mother suggested a compromise. In 1989, Donna Sue and Maxine Groves bought a thirty-acre farm in Adams County, Ohio, in the foothills of what Donna Sue calls "my beloved Appalachian Mountains." The property included a small barn, which had not been used in some time. Donna Sue was thrilled to finally have a barn of her own, but this particular barn looked nothing like those that had captured her childhood interest. The tobacco barn was much simpler and plainer than those in West Virginia or those that she remembered from her trips to New England. In fact, Donna Sue declared it "the ugliest barn I have ever seen in my life." As they stood looking at the barn, the idea clicked. Donna Sue said, "Mom, it needs some color; this needs some brightening up. I'm gonna paint you a quilt square on it sometime."

Donna Sue's focus turned to other projects, and that "sometime" would not come for several years. Beginning with the Ohio Appalachian Arts Initiative and continuing as Southern Field Representative for the Ohio Arts Council, Donna

Sue worked with nonprofits and artists to nurture community development through the arts. She describes her interaction with local artists as "a lot of handholding, cheerleading, listening, networking, offering of tools and resources, empowering them until they were able to move forward. I felt like they were little boats on the river; once they got their little boat all built and got it off the shore and into the water and floated on down the river, if I had done a real good job they didn't even remember that I'd been around."

But during all of the years spent encouraging others, Donna Sue never forgot about her promise to her mother.

"I told her I was gonna paint her a quilt square, and I told everybody else that I was gonna paint a quilt square." Finally, in January 2001, two of Donna Sue's friends encouraged her to complete the project. After a community meeting, Pete Whan with the Nature Conservancy Edge of Appalachia and Elaine Collins, the Adams County Economic Development Director, approached Donna Sue. Pete said, "Donna, your idea of painting the quilt square for your mother is such a great idea. She's getting older and you really ought to do it; Elaine and I would like to help you." Donna Sue was excited about the idea, but the impulse to help local artists also leapt to mind: "If we're going to paint one, let's paint multiple ones and create a driving tour for folks to come into the county—for them to drive this trail—in hopes that we can capture their tourism dollars." A committee was formed, funding to begin the project was received, and a trail of twenty "quilt barns," including the one for Maxine Groves that sparked her daughter's idea, was begun.

The two concepts—Donna Sue's desire to honor her mother and her enthusiasm for local arts initiatives—had emerged as one project. But creating quilt squares on the sides of barns also resonated with Donna Sue's deep love for Appalachia and the rich heritage of the region. Donna Sue explains,

> I hoped that we would be able to preserve those stories, about those that built the barns and the family farm stories and the quilts. Of equal importance are the quilts in those families and the stories that go along with them. Preserving those stories will help us to know where we came from and who we came from. We can reflect on the strength—the energy and focus and dedication and hardship—all of those things that our foremothers and forefathers did so we could be where we are today. We need to remember those stories. That's our DNA; maybe our larger community DNA connects us all together just like a quilt.

Feeling like one of the "little boats" to which Donna Sue had referred, I set out to discover just what that quilt was made up of.

the trail begins

the adams county
quilt sampler

DONNA SUE HAD kept meticulous records of the quilt trails' progress—not only in Adams County but also in the many states in which barn quilts had become part of the landscape. Dozens of e-mails, a detailed timeline of events, news articles, minutes of meetings—a flood of documents flowed from Ohio to Georgia. I knew that the quilt trail extended far beyond my early discoveries in Kentucky and the original trail in Ohio, but the sheer volume of information was staggering. "For the past several years, I put in many hours each week working on this project in addition to my full-time job with the arts council," Donna Sue explained. "It was nothing for me to respond to a dozen requests for information in one day."

Her comments resonated with the life that I had recently adopted. After all, I had to continue teaching high school while dedicating a great deal of time to barn quilts. The timeline that Donna Sue had given me included eleven states—a lot of ground to cover in just a bit over a year. Soon it became clear that twelve states were home to barn quilts, thirteen, fourteen. The two of us worked furiously to keep up with new developments while simultaneously reconstructing the past.

When the news came that budget cuts for the Ohio Arts Council had resulted in the elimination of Donna Sue's position, I was shocked by the decision and by

what seemed a serious injustice, but soon convinced myself that it might turn out to be only a temporary setback. This, after all, was the woman who had launched the largest grassroots arts movement in our country. The excitement of discovery—we were up to sixteen states—and the growing sense of just how incredible the quilt trail story would turn out to be pushed the concern aside as the two of us continued to work.

The realization of how quickly the quilt trail was spreading was a bit overwhelming. Donna Sue was always delighted to hear of new discoveries but seldom seemed surprised. "It's big," she would say, "bigger than we know." All of those years of working with artists and communities had created in her an intuitive sense of how readily barn quilts would resonate in rural communities across the country. With a new sense of urgency, we set about the task of recording the quilt trails' beginnings.

Quilt barns had synthesized Donna Sue's love for barns and quilts and her ongoing efforts with the arts council: "I was always trying to figure out a way to help local artists. Our artists were struggling in their studios creating wonderful things, and I thought if there was some way to bring tourists here that it would be an opportunity for sales. When Pete and Elaine asked, 'How would we do that?' I said, 'I don't know, but let's form a committee and sit down and plan how we could devise a trail based on using quilt squares.' They talked to some people, I talked to some people, and about twelve or fourteen of us sat down at the first meeting." Donna Sue recalled that the choice of twenty as the number of quilt blocks was no accident: "At that first meeting, somebody asked how many we were going to paint. I asked Mom, 'How many quilt squares does it take to make an average bed-sized quilt?' She said twenty, so I thought, OK—we will do twenty."

Pete Whan, who had enthusiastically embraced Donna Sue's idea, was cofounder of Planning Adams County's Tomorrow (PACT). The planned project fit perfectly with PACT's mission of bringing economic development and tourism to the county through its natural and historic resources, and Brenda Emery, PACT director, volunteered to act as coordinator for the new undertaking. In February 2001, the first committee meeting was held, with representatives from the Nature Conservancy, the Adams County Economic Development Office, the Adams County Travel and Visitors Bureau, visual artists, quilters, and interested community members, and the project was officially named the Adams County Quilt Sampler. Elaine Collins wrote a grant that secured funding from the Ohio Arts Council for the first four quilt squares, and the work commenced.

Donna Sue had begun with the desire to add a painted quilt square to the barn on the farm where she lives with her mother, but once she made a gift of the concept to the Adams County community, it seemed more appropriate for the first square to be in a more public location. Committee member Judy Lewis owned Lewis Mountain Herbs and Everlastings, a business on Highway 247 just a few

miles north of the Groves farm; an annual festival at Lewis's site drew nearly 20,000 visitors to the area. The committee readily agreed that the combination of the highly visible location and the well-attended event seemed just the right starting point for the trail.

Donna Sue recalled one of the earliest meetings: "I knew that Mother wanted the Ohio Star for our barn, and that's what I had always had in mind. We were seated around the table, and someone suggested that the Ohio Star should be the initial quilt for the trail. I didn't say anything—I just looked over at Mother, who nodded ever so slightly." Donna Sue had given the project to the community, and Maxine Groves had done likewise.

With the fall colors of the Adams County hillsides as a backdrop, the Ohio Star painted by local artists Mark Lewis and Bill Brown was unveiled on October 13, 2001, and the Adams County Quilt Barn Sampler was officially dedicated to honor Maxine Groves and her Appalachian heritage. Nichola Moretti, a member of the Ohio Bicentennial Commission, described the emotional impact of the event: "I remember people lining up for pictures like enthusiastic kids lining up for school photos. It spoke to us. Standing on that mountaintop with all of those people— there was not a dry eye. I knew I was looking at a legacy."

Maxine Groves was the inspiration behind the project, but as a skilled quilter and quilt historian, she was quickly put to work selecting the other patterns that would be included in the sampler. She commented, "It was an exciting time for me because it gave me a reason to look at the older traditional patterns. I wanted the oldest ones that I could find. Quilting tradition is important to me, so I looked them all up to see when they came out in print. The Ohio Star is as old as any, but it was called the Variable Star. Friendship Star was also called Simplex Star. The same pattern will have a lot of different names, and that kind of thing interests me."

After selecting the patterns, Donna Sue asked her mom to create a sampler quilt of the twenty blocks that were to make up the trail. She said, "It was another tool for me to be able to sell the concept and a way for people to look at the quilt square on paper but also see it on fabric. Maxine sewed a sampler quilt to better show how each finished block would look. She then drew each of the squares on graph paper, colored them in with colored pencil and titled them—Shoo Fly, Bowtie, Windmill, and so on. Maxine added, "I remember the people who came to the house to look at the paper squares—they were so enthusiastic and looking forward to getting theirs done!"

Once barn owners chose their patterns, a problem arose. Donna Sue remembered, "They would want so much to take that pattern home with them because it was going to be their baby. Mother would give them the page, and then we would have one missing, so she would have to draw another one. Then the artist would need a copy. To make a color copy eight years ago cost about three dollars, so Mother just kept drawing them!"

the adams county quilt sampler

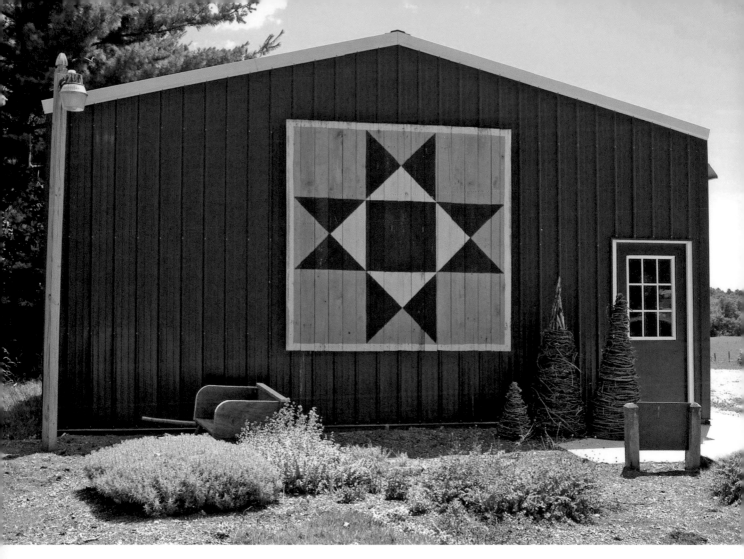

Ohio Star, Lewis Mountain Herbs and Everlastings. *Photo by Tom Cross*

Those hand-drawn copies led to a humorous incident at Moyer Winery and Restaurant. Donna Sue said, "The artist who was supposed to paint the quilt square on their barn lost the template, so he just went to the library and got a book and looked up LeMoyne Star. The next Saturday morning a bunch of quilters came to see it, and those women said, 'No, that is not a LeMoyne Star!' and they knew— the points weren't directed the right way! The restaurant called me, and I called Mother and we assessed the situation. Mother called it 'a variation of the LeMoyne Star, which shall forever be known as the Lemon Star!'" A year later, Donna Sue discovered that the templates could easily be created electronically, using Electric Quilt's BlockBase software, which saved Maxine Groves a lot of time and has since become a staple of barn quilt committees across the country.

The project moved forward with funding from the Ohio Arts Council, the chamber of commerce, and donations from businesses and individuals. Committee member Pat Ellis, director of the Adams County Travel and Visitors Bureau, became the liaison between the committee, the barn owners, and the artists, keep-

12

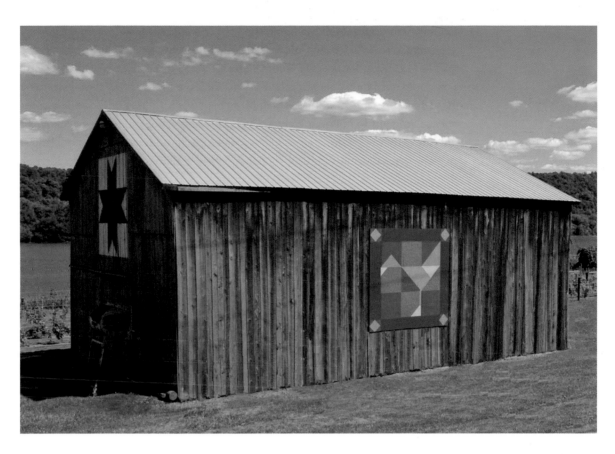

ing track of upcoming locations, pattern choices, and the progress of each painting. Careful attention was also given to noting each of the lessons learned along the way. Even simple decisions, such as following Maxine Groves's suggestion that each quilt block should be painted in high-contrast colors and be offset by a border, were recorded, in anticipation that additional quilt sampler projects would benefit.

Pete Whan of the Nature Conservancy suggested that the Quilt Sampler might partner with the Conservancy's new birding trail in the area, since the two had overlapping goals. Pete calls the Conservancy's work "a three-legged stool: ecology, economy, and community." The agency had worked with community and had been involved in ecology for years, but getting the economy involved was the last piece. Pete said, "The quilt squares seemed to have economic potential, but also a really strong element of community and culture, which resonated with our mission." Two of the quilt squares are included on the Appalachian Discovery Birding and Heritage Trail, whose brochure features a quilted bird, later reproduced as a quilt square.

I was eager to visit Adams County, to meet Donna Sue and Maxine and to document that first trail. With great excitement, Donna Sue and I made plans— we would have dinner at Moyers and take a drive along the river, travel the quilt trail,

Lemon Star/Birding and Heritage Quilt, Moyer Winery and Restaurant. *Photo by Tom Cross*

13

the adams county quilt sampler

and meet all of those who had been involved. Our conversations were infused with almost giddy anticipation: I was not simply going to begin my exploration; I was going to meet the woman who in just a few months had become a dear friend.

We had just begun selecting dates and firming up plans for my trip when Donna Sue received the crushing news—she had been diagnosed with breast cancer. My immediate reaction was that recording the history of the quilt trail was no longer of any importance. Months of unemployment had already begun to erode Donna Sue's optimism about the future. With Donna Sue facing a mastectomy followed by months of chemotherapy and radiation and the misery that would accompany treatment, darting around the country collecting barn quilt stories seemed to me a foolish enterprise. But for Donna Sue, my journey became even more critical. "You've got to do this, Suzi. The story needs to be told." And even in the face of the torturous months that lay ahead, Donna Sue was concerned that she might some-how disappoint me: "I'm just sorry that I won't be of much help to you."

I headed to Ohio in the fall of 2008. I arrived at the farm tired from hours of nighttime driving, but when I pulled onto the property, I had to stop and train my headlights on the barn—just for a minute. There it was—Maxine Groves's Snail's Trail quilt square. I was really there. It was a homecoming, of sorts, to a place where I had never been. As much as each of us had shared over the past couple of months, it was an awkward meeting, but soon the two of us were busily going over the list of barn owners whom I would meet the next day. The exhaustion with which she would struggle for months to come had begun to set in, and Donna Sue said that she had warned her mother that I might need a tour guide through the county. She followed me in her car up the gravel road and then to the cabin on the other side of the woods.

Maxine Groves smiles with her eyes. Tired though she was at the late hour, before the door was open wide enough for me to enter, she was clearly pleased that I had come. I looked past her and marveled at the sight—magnificent bed-sized quilts draped from the loft railings, smaller quilts hanging along the walls. I loved the place instantly and still feel that same sense of awe each time I pass through that doorway.

The only minor drawback to my cozy bed in her woodland home was Maxine's "alarm clock"—the garage door beneath the bedroom in the loft, which opened with a monstrous rumble when she determined that it was time for me to "rise and shine." I hoped my disappointment wasn't obvious that morning when Maxine told me that it would be she, and not Donna Sue, who would accompany me that day. It turned out to be a bit of luck, as I began to find out what Maxine Groves was all about.

barn quilts and the american quilt trail movement

The route that would take us to several of the barn quilts took most of a day to travel. Along the way, Maxine spoke about how she had come to live in Adams County. She had visited the area on several nature trips and had become fascinated with the terrain: "I love geology; that's one of the reasons I'm in Adams County. The Teays River system came up through here and curved into Indiana, which brought up southern species—we have things that are natural to here. We are on the eastern edge of the prairie, and we get prairie flowers, and the glaciers brought down the northern plants, so it's very versatile. And of course it's close to the mountains," she smiled.

The conversation was rich with information as we wound our way through the wooded countryside. I learned that the farming in the area took place mainly on ridges and that tobacco had been the main crop. Maxine pointed out a roadside tree laden with walnuts and explained that the nuts had once been taken to Manchester to be sold and hulled. Around each curve, the observations and bits of history continued—an abandoned homestead and a restored one-room school, which might have been peripheral blurs to me, held clues to the area's past. The conversation turned to barn quilts only as we approached one of the farms we were to visit.

The enormous painting on the surface of the barn nearest the Laffertys' home caught my eye before I noticed the quilt square that faced the road. Elaine Lafferty's grandfather had graduated from Ohio State University in 1905 before settling the Adams County farm in 1921, and the large buckeye logo evinced the family's loyalty to the school. Elaine recalled selecting the pattern for her quilt square: "When I went to Maxine's cabin, I knew I wanted red and white, and Shoo Fly was the one that she had printed in those colors, so that's the one I chose." Maxine laughed. "Those are the colors that the computer picked—I could have done any pattern in red and white, but this one does look good!"

The quilt square is very much a part of the barn, as the Laffertys discovered recently. The quilt was to be removed so that the barn could be sided. Elaine re-called, "The man told us, 'It is screwed in, nailed in, bolted in—we can't get it off of there!'" The crew had to put the metal siding around it and leave it where it was. Elaine had wanted the square taken down so that she could touch up the white paint, so the fellow who added the metal took on that chore as well.

Elaine is proud of the efforts to preserve the barn: "The barn is eighty-five years old and it's really warping—it's old! Old wood barns are hard to keep up, but I just can't let this one go," she said, shaking her head. "I look at it and say, 'Grandpa, I am trying to keep it together!'"

As we pulled into Mary Hughes's driveway, I almost didn't see the barn, as the robin's-egg blue and white Sawtooth Star is situated across a field near the rear of the property. Mary recounted how much she had enjoyed having artist Charlie Reed come to her farm to paint her quilt, as he spent a few days there painting the square directly onto the barn surface and visiting with her. I had heard Charlie

spoken of fondly more than once and regretted the fact that I was unable to speak to him about his involvement with the project, as he had moved from the area.

As I photographed her barn, Mary pointed out a barely noticeable flaw—a red splotch on one corner. When it came time to have her barn repainted, she had warned the crew, "It needs painting, but you see that on the barn—you can't get any paint on that! The wind was blowing and they fastened a covering so that they wouldn't get any paint on the quilt, but they got one little tiny dribble on one corner! Still, I like the way mine looks, and from the highway it's just beautiful."

Maxine and I stopped to see about half of the original twenty quilts on the trail; as she pointed out, because Adams County is so large, a tourist would need two days to see them all. One of the quilts Donna Sue had spoken of often was the Pollards', which was added to the sampler on September 11, 2002, the anniversary of the nation's tragedy. Retired fire chief Keith Pollard and his wife, Cindy, selected their simple yellow and white Windmill quilt square from a family pattern. Next to the barn doors, at eye level, a painted map of Adams County includes markings of the locations of the first few quilts on the trail, and to its side, a hand-lettered sign bears the dedication, "To Souls Lost 9-11-01." The community dedication included a Marine Corps color guard, patriotic music, and a candle ceremony, as old memories were honored and new memories were made.

The trip to Peebles to visit Steve Boehme afforded a chance to hear more from Maxine. She spoke of the Amish who lived on Wheat Ridge and their efforts to preserve their ways in the face of the twenty-first century. A discussion of economic development and the lack of industry in the area was interrupted by a sighting of a "giraffe house," whose irregularly shaped flat stones created a pattern similar to the animal's coat. Maxine spoke of her love of bird-watching and penchant for the works of eastern Kentucky and southern Ohio nature writers. Over lunch, we talked about everything from folk art to the difference in flavor between organic and soil-grown tomatoes, which led to the discovery that we both hold Barbara Kingsolver among our favorite authors. And Maxine added another bit of explanation as to why she had chosen her retirement home: "I have lived by the river and lived in the open field. That's why I chose the woods; I wanted to get to know the creatures there." I had wanted to get to know Maxine Groves, and by the time we reached Steve Boehme's Goodseed Farm I was in awe of my companion.

Steve Boehme was an eager participant in the Adams County quilt trail: "Donna Sue had this project and as soon as I heard about it, I said, 'Yeah—that's a great one; let's get involved somehow.'" His highly visible location and plans for a new sod barn at his nursery helped convince the committee that Goodseed Farm should be part of the trail. The two adjacent stars with rainbow colors emanating from each center make up one of the largest and best-known quilt barn murals. Steve explained how the pattern and colors were chosen: "We used the LeMoyne pattern because it was what you would call a sixteen-patch quilt. If you

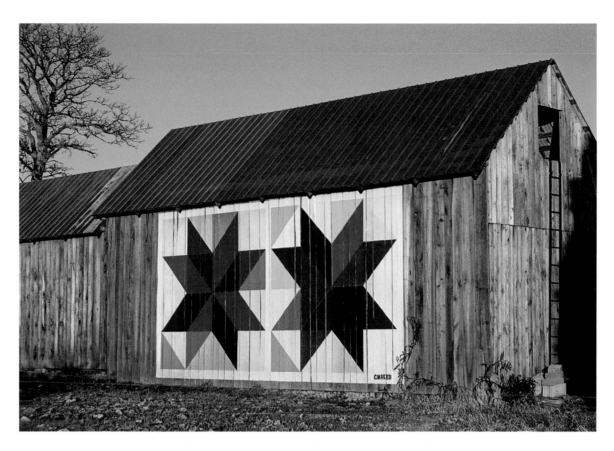

Double LeMoyne
Star, Goodseed Farm.
*Photo by Jerry Lindsey,
Athens Photographic
Project*

divide each segment diagonally, you could have 32 segments. Because of the shape of the barn, a square wouldn't look right so we said, 'Let's have two,' and we would have one with the male colors of the spectrum—blue and green—and the other with the pinks, reds, and yellows. Then you would have all the colors of the rainbow."

Once the pattern had been chosen, the real work began. Woodworker Diana Harvey sold wooden puzzles with eighteen pieces in a small frame. Steve thought, "That is cool; I've got to think my way through how we're gonna make this quilt," so he had her make a special wooden puzzle. Steve and his son, Stephen, got a bunch of Ball jars—glass jelly jars—which they numbered from one to sixty-four, then made the quilt map and numbered that from one to sixty-four. They then numbered each of the tiles on the back and proceeded to mix paint until they had sixty-four jars' worth of colors. Each of the tiles was painted one color, and Steve made the pattern out of the triangles of wood, laying them out like a rainbow and remixing colors until the proper combination of pastel and vivid shades was achieved.

Charlie Reed did the actual brushwork, and when he saw the puzzle, he understood the concept. Steve said, "We were really under the gun by that time because there was a big publicity event planned to roll out the Heritage and Birding Trail,

17

and we had a bunch of dignitaries invited. It was getting closer and closer to that day and we just had to make it happen. The weekend we were gonna paint, it rained. So we're under the tarp, it's dripping wet and we're walking around in the mud and we've got the sixty-four jars of paint." Son Stephen worked as Charlie's assistant; he would stir up one of the pots of paint and hand it to Charlie with a clean brush and take the dirty brush and pot, keeping the rotation going. Steve added, "It was a marathon because it happened in the wet, and I was happy that we had oil-based paint. We would have been sunk; even with the tarp and rigging this thing up for working in the rain, there was still a lot of water and a lot of moisture, and it would have been a total mess."

Despite the difficulties, everything came together on time and as planned in May 2003. Shirley White, wife of Ohio State Senate president Doug White, did the last segment as part of the ceremony. The crowd included representatives from Ohio State Tourism, the Adams County Chamber of Commerce, the local tourism and visitors bureau, and the governor's office. Of course, Maxine and Donna Sue were among the proud spectators. "That was a shining moment," Steve said.

Documenting the Adams County Quilt Sampler had been a priority for Donna Sue early on, and she invited the artists of the Athens Photographic Project to spend three days at the Groves farm to travel throughout Adams County taking photographs of the inaugural quilt trail.

Elise Sanford, founder of the project, explained that the Athens Photographic Project is a way of teaching people who are severely mentally ill how to express themselves with cameras: "My son has schizophrenia; I had had a lot of experience with him and with trying to make up for the gaps in the mental health system. I was also trained as a photographer, and I was fascinated for years with how people who are mentally ill see the world. It turns out they see the world very well and understand it very well. I knew how to teach meaning to the students."

Donna Sue had been a very early backer of the photographic project through the Ohio Arts Council, and she understood how art was being used to help people identify and express themselves. Elise explained, "People who have been hospitalized and medicated heavily don't know who they are anymore, so they start talking about their lives through imagery."

Elise was thrilled to have an actual commission—to be asked by Donna Sue to take on the task. She brought eleven students, all of whom were dealing with mental illness in one form or another but had their illnesses under control. The students were asked to take one documentary photo of each barn and then to experiment. Elise said, "It was such an enlarging experience for my students. Each time we got to a barn, it was like an anthill—half a dozen spread out all over. They just took picture after picture—it was like I had died and gone to heaven!"

One of the most rewarding outcomes of the Athens Photographic Project's Adams County commission was a series of public showings of the artists'

Opposite:
Snail's Trail, Groves barn. *Photo by Effie Mullins, Athens Photographic Project*

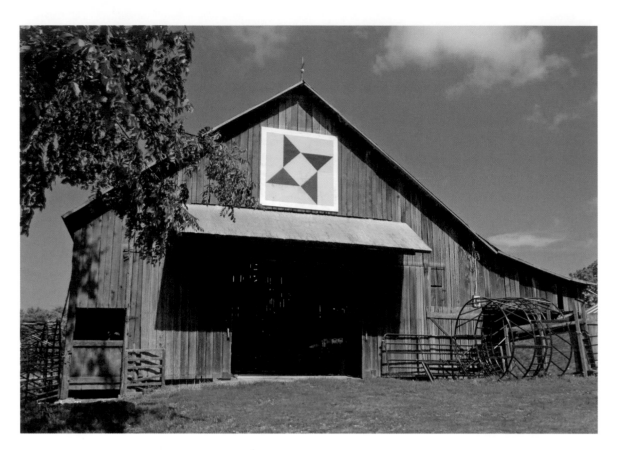

Friendship Star,
Phipps barn. *Photo by
Tom Cross*

photographs. For the artists to see their work matted and hanging, treated with
respect, was both rewarding and overwhelming. "People came in and interacted
with their art; they had done something many people can't do," Elise said. "This
reassured them that they were competent people—what it did for their self-
confidence and self-esteem was amazing!"

She concluded, "It was very important for us to know Donna Sue and for her
to know us. They were living a normal life instead of a life with stigma—they were
living a life as photographers."

Donna Sue calls the experience "a time that I will treasure forever. Breaking
bread together, seeing them grow and watching them go out into the area with-
out any stigma—it all touched me deeply." Some of her most prized among the
images taken by the group are those of the Snail's Trail pattern on the Groves
barn, which artist Geoff Schenkel of Marietta, Ohio, had recently painted. Maxine's
quilt square was not the first completed, and Donna Sue had hired an artist rather
than painting the square herself so that the quilt block would mirror the skill of
Maxine's quilting. But the promise to her mother had been fulfilled.

At the time of the Athens Photographic Project visit, fourteen of the twenty
squares had been painted and installed. Carol Phipps had mulled over the idea of

20

participating in the project and realized that the time had come. Her enthusiastic recounting of her barn quilting experience made it seem as if it had taken place just a few weeks earlier. Carol had talked to Maxine about painting a quilt square, and when she ran into Maxine several months later, Carol found that only six patterns remained. Carol, her neighbor Dortha, another friend, and Carol's mother each claimed a square, leaving only two. Carol chose the Friendship Star because it seemed to suit the location: "This is the friendliest road. Everyone on this ridge— we are all friends. If a cow gets out, someone will come to help!" The Old Maid's Puzzle, which dates to the nineteenth century, was chosen for her mother's barn because she preferred an older pattern.

Carol painted both her and her mother's quilt blocks in her garage. The red and blue of the Friendship Star are surrounded by a yellow border, and the colors are reversed in the Old Maid's Puzzle, with the pattern in blue and yellow and a red border. Having admired the barn quilt on the way to the Phipps home, I was surprised to hear that Carol had created it without the aid of painters' tape to keep the lines straight. "I drew it out," she explained, "but then I painted freehand. I kept thinking, 'How am I going to paint it and get all of those points?' When you are quilting and the pieces don't come together exactly, they say, 'She lost her points.' I made sure I didn't lose my points!"

What Carol remembers most about the process was the hanging of the two blocks. With her husband, Corbett, on a ladder on top of a wagon and boys in the barn pulling the ropes looped around the heavy plywood square, Carol stood below, excited but barely able to watch. Once the square was secured, the group headed to Carol's mother's home. Carol recalled, "They had to build scaffolding, and I remember standing there holding it—it was November, and gosh, that metal was so cold!"

The effort was worth it, and Carol is proud that her barn is part of the Adams County quilt trail: "People say, 'Oh, you poor Appalachians. You're not this and you're not that.' They have no idea how well educated many of us are and how beautiful a place this is. We moved to our family farm, where my mother lives, when I was about thirteen, and I have been part of Adams County ever since."

"It was the beginning," she said, "and there are a lot of barns now. But this is one of the original twenty—that is what I tell everyone."

In a 2002 interview, with only three quilt squares completed, Donna Sue had said that she hoped other counties in the region would be inspired to create quilt squares. "Just think," she said, "we could have an interconnecting clothesline of quilts throughout Appalachian Ohio." Just a year later, the clothesline pulled up stakes and began to expand.

21

new pegs along
the line

W HEN DONNA SUE'S Appalachian clothesline of quilts crossed the
Ohio River, it stretched almost three hundred miles, to northeast-
ern Tennessee.

Candace Barbee of the Clinch-Powell Resource Conservation and Develop-
ment Council in Tennessee saw an article about the barn quilts during a visit to
her native Scioto County, Ohio, and thought that they might fit the council's goals.

Of course, my immediate reaction was to wonder what an RC&D council
might be. Council director Lindy Turner would later explain, "We are a nonprofit
organization whose mission is to build strong communities, to care for people and
to protect natural resources. Everything we do focuses on the environment but
concerns the people as well. They don't have to be in conflict—people and envi-
ronmental quality."

The Clinch-Powell RC&D Council had received funding to create murals on
barns in rural Tennessee and started by having children paint them with the help
of professional muralists. Two murals were completed, each covering an entire
barn. The projects were a huge success but quite expensive, and with scaffolding
required, the possibility of injury was a concern. I was reminded of Donna Sue's
explanation as to why quilt blocks were mostly painted on boards and then mounted
—the less time spent above the ground, the better for all concerned.

The group had just begun looking for a new public art project when Candace shared a picture of a quilt barn and the story about Donna Sue. Lindy is a quilter and quilt collector, and Candace is an artist, so barn quilts appealed to them both and seemed to fit the council's goals.

Donna Sue recalls Candace's "infectious enthusiasm" for the project when she made a visit to Adams County to find out more about how the quilt trail had been launched and the ideas that Donna Sue had already gleaned from her experience. The plan was to begin a trail in Tennessee and eventually connect between Tennessee and Ohio. When Candace returned to Tennessee, the first step was to establish a site where painting could take place so that lots of groups could be involved.

Soon, everyone from school groups and church groups to artists and Ameri-Corps workers—even the RC&D staff—were painting quilt blocks. Lindy and Candace worked to get people in each county involved, with the idea that each would have a loop and they would all join together. Candace was surprised at the reception that the project received: "We thought this would mostly appeal to women because it is a quilt, but the fact that it is big and on plywood and you use hoists and lifts—the men like it, too. We had men calling saying, 'I want one of those things on my barn!'"

Just a few weeks after Candace's visit to Adams County, Carol Stivers of neighboring Brown County, Ohio, paid Donna Sue a visit. She had been to Moyer's Restaurant and had seen the quilt pattern that is painted on the end of their barn. After talking with Donna Sue, Carol got on the phone right away to Joy Hanselman, owner of Schoolhouse Quilts, who spread the exciting news with the quilters she knew.

The ladies chose patterns such as Ohio Star that had some historical meaning, as well as other traditional patterns that they thought would be exciting to work with. The quilters not only helped select patterns but also made a beautiful quilt with all of the patterns; it was raffled off as a fundraiser for the project.

Artist JoAnn May knew Donna Sue, and when she saw a photo of her and Maxine, JoAnn wanted to get involved. Sonja Cropper of the Brown County Tourism Board put JoAnn in touch with the quilters, who had already held a few meetings and were looking for an artist. The women chose twenty-eight patterns and began with plans to put one in each township.

JoAnn May accompanied Carol Stivers to consult with barn owners who expressed an interest. Once they chose the pattern, JoAnn would ask what color they absolutely did not like so that she could make sure that color wouldn't be part of their quilt. "I would go back to the studio and put colors next to each other that I knew would push and pull and place them in a way that would create the illusion of depth. That's where my part came in as an artist," JoAnn explained.

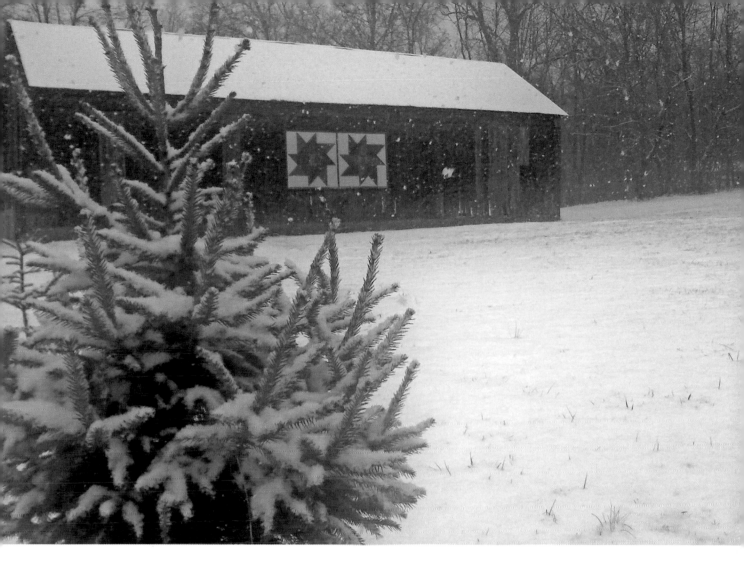

For JoAnn, the project combined professional as well as personal satisfaction. She said, "I have always admired and loved quilts and thought they were undervalued as art. Some of the same symmetrical qualities that I had once explored in graphic design were presented in these quilts. It was very exciting to apply my knowledge as an artist to this larger format.

"When I am out driving in the country and come across one, I say, 'Oh my gosh—I did that!' I am enjoying being delighted by my own work!"

Sonja Cropper and I toured the southern half of the county; because Brown County is so large, some of the barns are quite a distance north. Bikers—both the pedaled and the powered—often stop to see a pair of quilt blocks called Double Star and Double Star, on Route 52 right along the Ohio River. Skip and Denise Bollinger moved to the property just a couple of years before the barn quilt project began; the prominent location and their hundred-foot-long tobacco barn have made their property a key location. Because the barn is so long, a single square

Double Star with Double Star, Bollinger barn. *Photo by Denise Bollinger*

25

new pegs along the line

would hardly do, so JoAnn May created two stars side by side, each shaded for a three-dimensional effect, one with green layered onto red, and one the opposite.

As Denise walked around the barn, she talked about plans to restore the tobacco barn so that it can accommodate the community farmers' market, in addition to the plans to turn the house into a bed and breakfast. Meanwhile, an unusual idea is in the works for the property along the water near the mouth of the river. Conventional cabins might flood, so Denise and Skip intend to build tree cabins in the sycamores along the water's edge. "Just think," Denise said, "how beautiful it would be at night to look across the river at the Kentucky Hills." I left thinking that if their idea comes to fruition, I might have to find out firsthand.

JoAnn May's artistry is quite evident in the variation on the Martha Washington Star that she created for Pat and Lanny Ogden. Pat and Lanny wanted to honor their two grandsons—one who had been in the navy and one serving in Iraq. Lanny told me, "Tyler was on the SS *Roosevelt,* and he is back here working now. Trent is with the National Guard in Iraq. Every day you watch TV and just hope you don't hear his name."

When Carol and JoAnn interviewed Pat, she asked, "I know you're not supposed to, but is there any way you can cut up the American flag and make it into a quilt?" JoAnn and the quilters created a unique pattern by beginning with the Martha Washington Star and adding an American flag, in honor of Tyler and Trent. Pat said, "It just tickled those boys to death!"

Pat teared up for just a moment as she reached for a photo of the two handsome young men side by side in uniform. "They are so precious to me. We stay in touch with Tyler by e-mail, and when we send him packages, we always send the papers from Brown County. He is over there with others from Brown County, so those papers are passed around. I'll bet they even read the yard sale ads!"

Brown County was the first to extend the Ohio quilt trail and also began the tradition of including a quilt square painting as part of Make a Difference Day Ohio. Sonja Cropper explained that on one Saturday each October, groups of volunteers across the state get together to complete a service project for their communities, and most try to include kids in some way. The Brown County project for 2004 was a quilt block, and the LeMoyne Star that hangs on the county fairgrounds was the result of the day's work. Quilt trail committees across the state have since built on this tradition of using the statewide event as an opportunity to draw new volunteers into their project.

Monroe County, Ohio, was the first to come up with a unique name for their quilt trail—the Patchwork Jewels of Monroe. Just the name attracted my attention—the desired effect, I suppose. Stephanie Rouse, then tourism director for Monroe County, heard about the quilt trail in Adams County, and when she met Donna

Sue at a community meeting in 2004, she immediately asked to meet over lunch. Within a few months, a committee that included members of the Monroe County Arts Council and owners of local quilt shops had formed to collaborate on the project.

Arts council president Susan Pollock became the other driving force in Monroe. "We had ideas about exactly what we wanted," Susan recalled. "We wanted the quilts, but it was important to preserve the look of the barns—people like the old look." Adams and other Ohio counties had begun painting quilt squares on boards and then hanging them on the barns, but the Monroe committee believed that the patterns would be more striking painted directly on the barn surface. Once the committee had determined a route of twenty suitable barns whose owners agreed to host a quilt square, the search for a suitable artist began.

Scott Hagan hadn't planned to become a barn artist; he began by painting on a small scale and kept enlarging the size. How large a painting, he wondered, could he lay out freehand and still have it turn out well? To find out, he needed larger surfaces on which to paint. The biggest thing he could find was his dad's barn, where he started with the Ohio State logo and the Brutus mascot.

Without Scott's knowledge, his grandfather took a picture of the painted barn and showed it to the local newspaper, which ran a story on it. Nichola Moretti, a member of the Ohio Bicentennial Commission, was in the area that week, and upon seeing the story, she was taken with Scott's work. Two weeks after Scott Hagan painted his father's barn, plans were under way for him to paint the Ohio Bicentennial logo on a barn in each of the state's eighty-eight counties. By 2002, the renowned logo appeared on barns spread across the state, and most are still beautifully displayed.

Harley Warrick, well-known painter of the Mail Pouch Tobacco barns, lived nearby and was an inspiration to the young artist. Warrick had retired just before Scott began his career; though he did not get a chance to work with Warrick, Scott said, "I visited him several times over two years; he liked to talk politics and made it a comical subject. He was at work on his little mailboxes and birdhouses, and he shared some helpful advice."

Scott's success as a barn artist led to his commission to complete the twenty-barn sampler in Monroe County. As in Adams County, the number of squares was chosen to reflect the number of blocks that would generally be used for a full-sized bed quilt. In Monroe County, the blocks were chosen differently, to reflect the various aspects of the county. I was eager to see them; a couple of the early barn paintings in Adams County were painted on the barn surface, but a trail made up exclusively of such quilt blocks was something else entirely.

One of the most visible barn quilts is the multicolored Bowtie pattern at the Wells Farm, which I was later told represents the area's garment industry. The Carpenter's Wheel was a bit more obvious—a reminder of the skilled artisans on

new pegs along the line

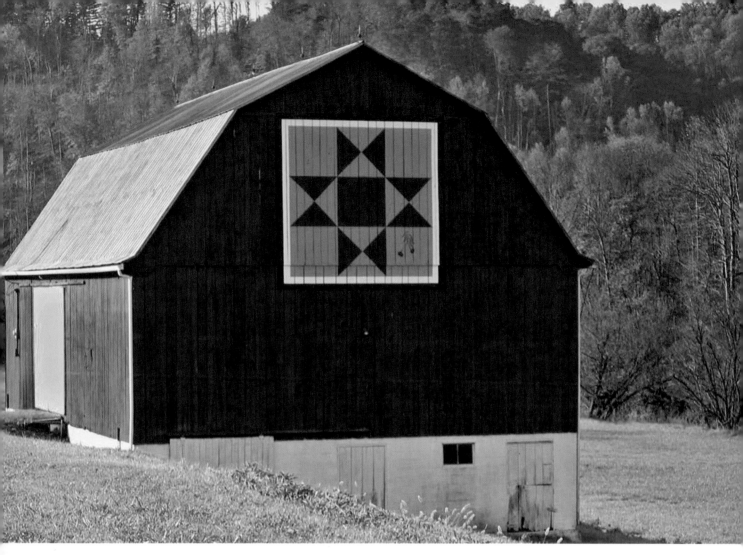

Ohio Star, Cox barn.
Photo by Stephanie Rouse

whom every community depends. I supposed that Grandmother's Fan was a nod to the women of the families, but the Crazy Patch had me a bit puzzled. Susan Pollock explained that it stands for the patchwork of unique people throughout the county—never mind the "crazy" part.

When I visited Monroe County, I had already seen a few bank barns and been well schooled as to their fitness for Ohio farmland. The Cox barn with its Ohio Star block is a perfect example of this well-known method of construction in the hilly terrain. The presence of a bank of earth provides an opportunity to build a sturdy barn, with the door and entrance level with the top of the bank. On the opposite side of the barn, stalls for livestock are built with doors that open to the outside so that animals can be housed separately from the main barn. The stalls are usually open on the top so that feed and hay can be distributed from the upper level. The barn's structure adds to the interest for those who stop for a roadside view.

28

The appeal of barn quilts is largely the impulse to work in cooperation with the surrounding community, but early on, a handful of women painted quilt squares for their barns, despite the fact that no one nearby showed an interest. Donna Sue calls them "the lone quilters" and believes that their determination to display their creativity demonstrates the ways in which barn quilts can be personal statements as well as public displays.

For many years, Judy Zaspel was the "barn quilt lady" in Wisconsin. Judy grew up in St. Paul but had always wanted to live on a farm. She got her wish when her husband retired in 2003, and they moved to a dairy farm in northwestern Wisconsin. On seeing the property, Judy's first thought was that the big red barn was so charming that she would love to do something with it.

In 2004, Judy found the Adams County quilt trail website and e-mailed Donna Sue: "Our barn needs painting and has a large flat area facing the road. I am planning on adding a lovely quilt block to the face of the barn, thanks to the inspiration from the website." With a bit of guidance from Donna Sue, Judy painted two blocks of her own—Judy's Star, an adaptation of the Ohio Star, and Honeybee, chosen because Judy wanted the challenge of working with a curved pattern. As Judy puts it, "I am so quilt nuts anyway—I love anything about quilting. And my husband is a carpenter, so he was ready to hang them for me. It seemed a natural."

Judy's farm is a bit hard to find, but Judy tells people, "If you see the barn with the quilts on it—that's our place." Judy keeps hoping that her beautiful quilt squares will inspire others nearby to paint their own, but in the meantime, she is proud to have been the pioneer in her state.

"My barn quilt is solely for Donna Sue," Gaytha Quinlin declared. "I was diagnosed with breast cancer four years ago. After the surgery, my son and his wife said they were having our first grandchild, so I started looking toward the future. I just wanted to move forward, and then I happened to read a magazine article about Donna Sue and said to myself, 'I don't know anything about this, but I want to.'"

Gaytha was surprised to learn that no one had created barn quilts in Virginia, and it seemed the perfect thing to celebrate new beginnings. She recalled, "I contacted Donna Sue, and once I talked to her one time, I loved her. I told her, 'I want to do this for you, and I am doing it for me, too!'"

Gaytha was still recovering from breast cancer surgery when she fell and broke her leg; despite the fact that she was using a walker, she and her husband, John, used the instructions Donna Sue had provided to create an eight-foot version of Gaytha's favorite pattern—the Star Cross.

"Just by picking up a magazine, this came about," Gaytha smiled. "It was meant to be. Barn quilts aside, I got to be friends with Donna. I feel so close to her just

29

new pegs along the line

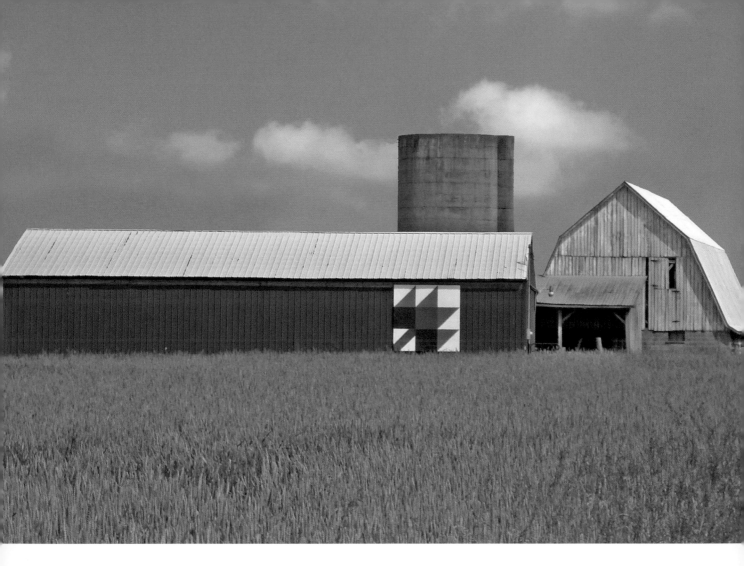

Maple Leaf, Yauger
Farm. *Photo by Mollie
Yauger*

from talking to her. That article brought us together, but it's more than that. I brought part of Donna Sue to Virginia."

Mollie Yauger was always looking for an excursion for her Mason County, West Virginia, quilting guild. A 2003 article about Donna Sue and the Adams County quilt trail just a few hours away caught her eye. Donna Sue was delighted that a group of quilters would come and look at the Adams County barns. She met them with excitement and took them to meet Maxine as well.

Being a farmwife and having a barn on a well-traveled highway, Mollie just had to have a quilt block on one of the family's recently purchased farms, Maple Glen. Her husband encouraged her to go ahead and paint it, so in the spring of 2004, Mollie started working on the Maple Leaf block, to go with the name of the farm. The block was mounted on the barn on the first of July.

30

barn quilts and the american quilt trail movement

Mollie's barn quilt project was for her enjoyment, but before long, the fall-colors leaf began to draw attention. Mollie was quite pleased: "We own a business just south of my quilt barn, and customers would ask, 'What's that on the barn down the road?' 'What does it mean?'" Most had not seen a quilt barn block, so it created a lot of interest. Mollie began to think that Mason County should have its own quilt trail, and her conviction led to the county's adoption of the project a few years later. Until 2008, though, Mollie remained a "lone quilter" in West Virginia and one of the earliest pioneers of the quilt trail beyond Adams County.

new pegs along the line

barbara webster day

Aᴅ ᴛᴀʟᴋɪɴɢ ᴡɪᴛʜ Donna Sue and visiting fifty or so barns in Ohio, I was beginning to understand how the quilt trail idea had caught on, but recording further history would have to wait. I felt the need to experience firsthand the excitement of building a quilt trail. Burnsville, North Carolina, was set to celebrate the installation of the one hundredth quilt square in the western part of the state. Trail organizer Barbara Webster seemed eager to play tour guide after the event, so I headed northeast into the hills of the Blue Ridge Mountains.

As I drove along two-lane Highway 19 nearing my destination, a flash of gold and blue on a faded red barn was already behind me by the time I saw it. The hanging event was set to commence in half an hour, and I wasn't quite sure how much farther I had to go, so I hurried on, trying to recall the spot so that I could return to document my first North Carolina quilt barn.

Guests were beginning to arrive at Allen and Bevo Peterson's farm, whose barn looked as if it had been built for the occasion—perfectly situated on a manicured lawn among a clump of trees, where a few scattered early fall leaves created the perfect setting. Just as a bucket truck began to back noisily onto the property, someone identified a petite white-haired woman as Barbara Webster. Barbara shook my hand on the run, simultaneously directing the truck into place and waving me into the barn: "Go check out the quadrants!"

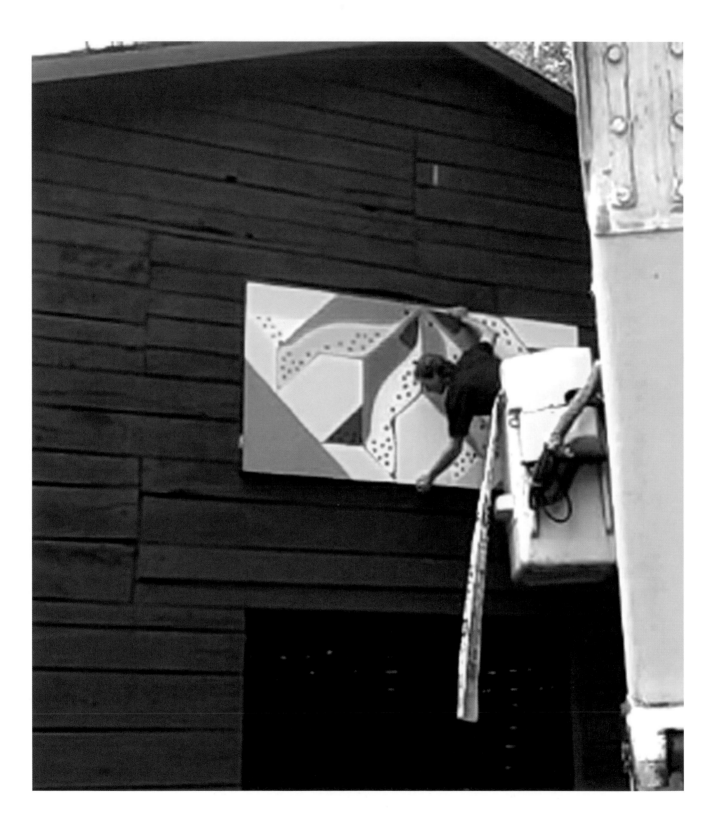

Quadrants? Here was something new. Though they were a bit hard to see in the dark interior of the barn, I made out four pieces of framed, painted plywood leaning against the wall. The pattern and colors were difficult to discern, but I was more interested in the squares themselves. "Why are there four?" I wanted to ask, but shouts from outside indicated that the action was under way, so my question had to wait.

The crowd, numbering about fifty, converged around Barbara Webster, who blushingly listened as one of the county commissioners read a proclamation declaring October 11, 2008, Barbara Webster Day in Yancey County. Barbara stopped just long enough to receive a plaque and bouquet of yellow daisies before scurrying back to the barn to supervise the installation.

Jeff Phillips climbed onto the bucket truck and leaned down to lift the first section of the quilt block and brace it against his chest. The bucket jerked upward. Laughs burst forth as an onlooker called out, "Don't forget to write!" Leaning precariously toward the barn, Jeff hefted the square into place with visible effort; I immediately understood that the weight of the full block had required that it be divided into pieces for mounting. The neon-colored painting with eight fish arranged in a circle did not look like the barn quilts of Ohio or any cloth quilts that I had seen before, but as the last piece was slid into place, it appeared stunning against the red barn surface. Barbara Webster would later explain that the block is in fact a traditional pattern, with spots added on the backs of the fish so that they more closely resemble Allen Peterson's favorite catch—the speckled trout.

A lot of attention focused on Barbara, but she took the opportunity to recognize many of the volunteers who had been instrumental in the project's early success. Sincere accolades and brightly hand-painted gifts such as quilt-patterned hammers and birdhouses were bestowed upon more than thirty volunteers. Barbara presented the most special gift to Deborah Palmer, the "paint captain" for the Mitchell/Yancey program, who jokingly delivered a salute and a grin as she accepted a handmade quilt stitched by Barbara's expert hands. The onlookers gathered for a slice of a sheet cake with "100 BLOCKS" written in icing; they applauded the success of what had become one of the nation's largest quilt trails in only two years.

Barbara turned for one last look at the day's accomplishment as she headed toward her car. "By the way," she said with a smile, "we've got the best quilt story of all. But that will have to wait until later; I promised you the tour." Indeed, there was no time for storytelling as Barbara wheeled toward town and began to talk excitedly about the trail that wound through the streets of Burnsville. Here was another unexpected development—a barnless quilt trail! Barbara stopped in front of a nondescript brick factory building and explained the significance of the odd gray and red pattern hanging near the entrance. Burnsville Hosiery Company, the town's oldest manufacturer, had never had a sign. It seemed to Barbara that a building that had played such an important role in the community should have some sort

35

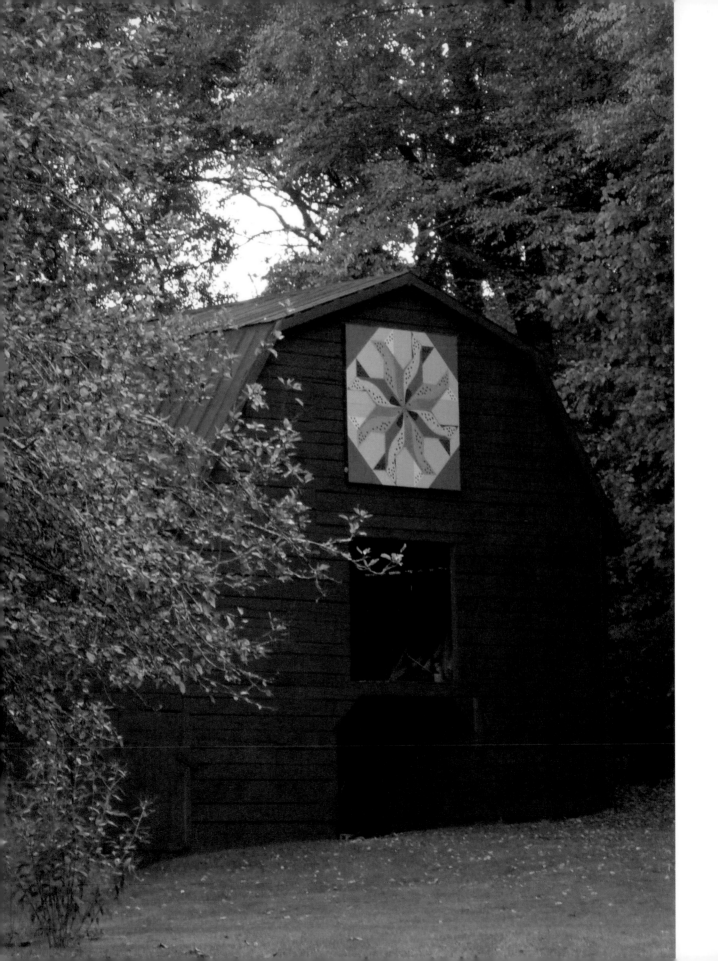

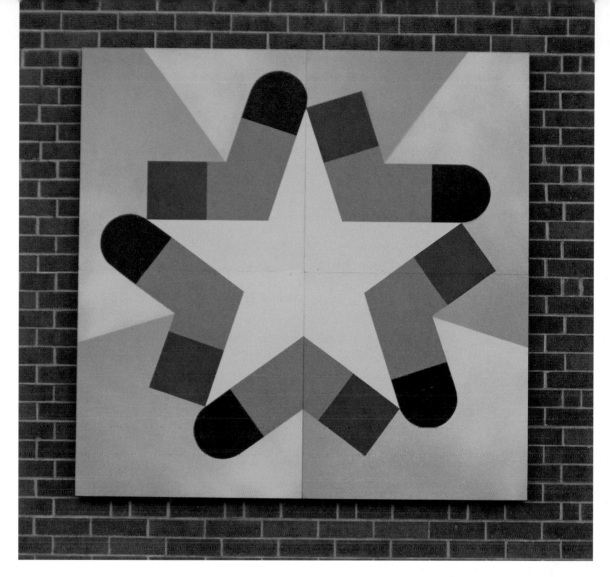

of marker, and of course, that meant a quilt block. No blocks existed that related to socks, so Barbara turned to her husband, Martin, a graphic designer, for help, emphasizing that the design should be a quilt—a geometric design that could be cut out of cloth and sewn together. Martin put together five socks to create a design that he named Twinkletoes.

Because Burnsville is the center of activity for the area, Barbara set to work decorating the entire town with quilt squares. She explained, "We wanted all of them to be stars, to show the rising self-esteem of the community. And we wanted each one to connect to the business where it is hung." On a whirlwind tour of Burnsville's downtown, I came to believe that quilt blocks appeared on every corner—there were too many to take in all at once. Some are traditional designs that fit the location, and others were specially created. The School Girl's Puzzle hangs between the white columns of Terrell House, now a bed and breakfast inn but once a dormitory for a school nearby. The Yancey County Courthouse

Twinkletoes, Burnsville Hosiery Company

Opposite:
Fish Block, Peterson barn

37

barbara webster day

overlooking the square exhibits a Courthouse Steps quilt, while the county library displays the Rose block to honor Rose LeFevre, one of the library's founders.

Throughout Burnsville, quilt blocks are found in the most unlikely locations. No one would expect to find a quilt block named for William Shakespeare, but a block named Bard of Avon had already been created—perfect for the Parkway Playhouse. Just around the corner, the Burnsville Gym has on its side a swirling Sneakers block—designed by Barbara Webster herself. Even the local Subway restaurant franchise has its own block—Railroad Crossing—as a reminder of the train depot that once stood nearby.

About a mile from town, we passed a sign indicating the entrance to Heritage High School and soon stopped in front of a plain steel warehouse on the campus. "This is it," Barbara said. "This is where it all happens!" The interior of the hollow building was half occupied by a partially built house frame, and the front section was a barn quilt workshop. Dozens of painted quilt blocks sat stacked against a wall, framed and set for hanging. Blocks in progress lay on sawhorses, the designs drawn and ready to be painted, with colors that would be chosen from among the rows of Mason jars that lined the metal shelving along one wall.

The boards had been assembled and primed by students in teacher Mike Orr's carpentry classes as part of the industrial arts curriculum. Adult volunteers used computer-generated images to draft the designs onto the prepared four-by-four-foot squares so that they would create a complete pattern when assembled. Blue painter's tape crisscrossed each of the squares, as each color of paint was applied and left to dry, and a color image of the desired finished product hung next to each quilt in progress to guide the artists in their work. The entire process had been carefully planned and executed; small wonder that the group was able to produce fifty of the painted quilts per year.

Pulling away from the school, Barbara pointed out a quilt block on the building itself—Pillars of Habitat, designed by Mike Orr. "Pillars" is the program through which his students build houses, which are sold as a benefit for the local Habitat for Humanity chapter. Mike's block consists of four houses with golden pillars, symbolic of the support needed to keep a house—or a project—on solid ground.

The Toe River Arts Council launched the barn quilt program in October 2006 with a grant to pay for eight quilt blocks. Council director Denise Cook approached the Mountain Piece Makers quilting group, and as Denise would later relate, "Barbara Webster was ignited by it!" A notice in the newspaper asked interested barn owners to apply for a block, but no one came forward. Finally, in January 2007, a couple of residents were persuaded to allow quilt blocks to be mounted on their barns in very visible sites along Highway 19—Old Maid's Ramble on the Buckner barn at Price's Creek on the west edge of Burnsville and Grandmother's Quilt on the Presnell barn in the east. The North Carolina Star in town at the arts council building helped create interest as well. "Still," Barbara recalled, "we had to

talk people into it. After they understood that we were going to share their family stories through the quilts, the trail really took off."

One of those family connections was soon revealed as we arrived in front of the barn that I had passed a few hours earlier. The design seemed to be a simple star on a dark background, but a close inspection revealed crisscrossed blue and red lines throughout what had appeared to be a solid green. The quilt square had been specially designed for the McIntosh family barn. The block, which was painted by students in art classes at the high school, incorporates a star pattern on a background of plaid using colors that are in the family tartan.

The McIntosh barn was the last I would see before heading away from Burnsville, and on half a dozen return trips, it was always the first to appear as I approached the western edge of town. Several months elapsed before the entire story of quilt trails of western North Carolina came together, and on each trip the sight of that barn let me know that it was time for another discovery.

39

barbara webster day

buffalo gals

I HAD BEEN INTRIGUED since the first time I heard about the Buffalo Gals Quilt Trail. Who were these "Gals," I wondered—a bunch of horsewomen who wrangled barn quilts? They claimed to have a trail of about 150 quilts—the most I had heard of—and I was eager to document the lot. A call to University of Kentucky Cooperative extension agent Connie Minch, the contact person for the legendary group, led to an appointment with a couple of the "Gals." I eagerly headed to Georgetown, Kentucky, my mind filled with visions both of the horse country I had never seen and of the extraordinary women I was about to meet.

The "Gals" turned out to be Bradford and Carole Landry—a silver-haired couple who filled the tiny room at the extension office with scrapbooks, folders, and homemade posters showcasing the trail that they had helped to create. Almost immediately, Carole began spreading photos on the table, and the feeling was more family reunion than interview. "Oh, yes—this one. She was so tickled with it!" A few photos later, she paused. "Remember how delightful these kids were? Look— here we are with all of them." I didn't count, but the array of photos spread before me was certainly impressive. But the Landrys never mentioned tourism and had no glossy brochure filled with information. I had set out to document the history of the quilt trail and was hoping for facts, dates, some concrete research.

The Buffalo Gals are a homemakers' group, part of the local extension service and an organization that I would hear more about as I traveled throughout

Kentucky. The ladies decided to take up quilting and organized a class so that they could learn the basics, but once each member completed a small sampler, the interest stopped. As Carole explained, "We're just not patient people." Leo Kettenring, the husband of one of the Buffalo Gals members, had read an article about painting barn quilts in nearby Carter County, and after a reconnaissance trip to the area, the Buffalo Gals set to work on a project they thought would be more to their liking.

Carole told most of the story, while Bradford nodded his assent and added occasional details. Bradford had been the draftsman for what became truly a grass-roots effort. Group members took the squares home to paint—in front rooms, on kitchen tables, in garages, and basements. The quilt blocks took up a lot of space in the group's homes and lives. In about eighteen months, the handful of self-proclaimed "elderly people" had painted and hung more than 150 quilt squares, with about 70 of them the standard eight-foot size. Extension agent Connie Minch shook her head in amazement. "Four or five individuals brought about this phenomenal project of beautifying Scott County with these barn quilts."

Connie added another bit of information that created quite a picture. Early on, a seemingly insurmountable obstacle had presented itself. The group had finished their first paintings, but no bucket trucks were available for hanging the squares. With funds provided by the town and the farm bureau, the group was able to purchase scaffolding, and the problem was solved. Remarkably, Bradford Landry, who admitted to being seventy-plus, hung almost every square. "He is the sky man, and I stay on the ground," said Carole, with a sparkling smile that reflected fond memories. "People stopped by to look; I don't know if they thought we were trying to climb to heaven or what!"

Carole continued, "We really enjoyed the project, and we tell our grandchildren, 'This is all we are leaving you!' Hopefully, we have gotten them interested in doing community projects and art projects, and it'll come to fruition later. You never know."

I was eager to set off into the Kentucky countryside but first had to ask about the meaning of the name "Buffalo Gals." Stamping Ground, Kentucky, a town of about seven hundred where the group is centered, got its name from the legendary stamping down of the vegetation so that the buffalo could feed along their way. The origin of the memorable name was a bit disappointing, but at least it made sense to me now.

Leaving the Landrys with map and lists in hand, I drove the few miles to Stamping Ground, where Buffalo Gal Betty Kettenring was set to escort me to see some of the barn quilts. The first stop, Betty said, would be at her farm, not too far from the tiny downtown. There she hosts what is known as the "quilt barn gallery," with five quilt squares on her barn. This first batch of barn quilts allowed the homemakers to practice creating the intricate patterns and to experiment with

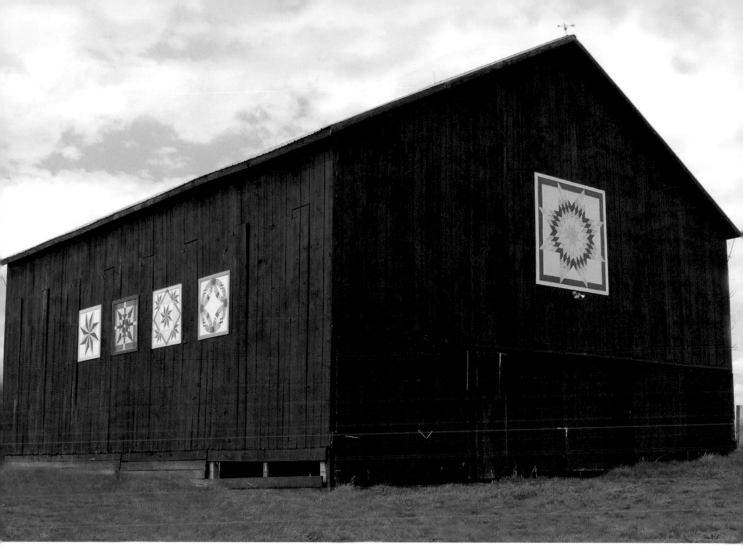

colors. Immediately, I loved this barn—it was the first time I had seen multiple quilt blocks hanging together and was also my first black barn. Soon I was on tiptoes atop a grain wagon trying to squeeze all five into a photo, then lying on the ground, determined to find just the right angle to capture the scene before me.

The large yellow and green Radiant Star hangs on the front of the barn facing the road, and four smaller quilts are mounted along the side. Betty explained that two of the four quilts were painted in honor of her parents—Stars over Tennessee honors Betty's father, Gayle Calvert, and a LeMoyne Star is in Georgia Calvert's favorite blue. The lavender Double Wedding Ring is in memory of Leo's mother, Alma, who had been married fifty years, as Betty and Leo have now been. Southern Lights, a tribute to George Kettenring, completes the set, which served as a model for prospective barn quilt owners and is still a popular stop along the Buffalo Gals' Quilt Trail.

Betty took me on a tour of about twenty barn quilts in the Stamping Ground area and then left me with my map and a list of barn owners who were expecting

Kettenring Quilt Gallery

43

buffalo gals

my visit. As I headed out of town toward the Mason farm, the terrain changed from nondescript farmland to almost impossibly green expanses of rolling hills. Crisscrossing white fences, horses leisurely grazing—this was the Kentucky of my imagination. I discovered one barn quilt after another and hoped that my frequent stops wouldn't make me terribly late. First a Schoolhouse pattern appeared along a rocky roadside, then a lavender and purple Skyrocket high on a hill, where a smile and a wave captured the attention of the farmer, who stopped his mowing as I drove up the steep gravelly lane toward the barn. Unable to speak over the noise, he nodded and opened the gate so that I could drive up for a closer look. The bright colors surrounded by the black barn were set off almost like a painting hung in a gallery frame.

I passed an orange and blue barn quilt high above the road and turned in to Bob Mason's driveway, in sensory overload and more than impressed with what the homemakers had achieved. Bob told me that he became interested in the project when his niece, who attended Georgetown Middle School, participated in a science enrichment activity, mapping the GPS coordinates of the barn quilts so that more-user-friendly maps might be created. Integrating lessons in art and history with the latest in technology kept the students interested as they learned more about the culture of the surrounding area. Once he learned of the barn quilts, Bob immediately wanted one.

Bob knew that his grandmother had made a quilt that went to the Chicago World's Fair, so he was eager to have that quilt on his barn. The embroidered pattern couldn't be reproduced on a painted quilt, though; instead, another of his grandmother's quilts—the Double Wrench—was chosen. Bob is immensely pleased whenever someone stops by to see his quilt square and is always ready to escort visitors through the pasture for a closer look at the replica of his grandmother's handicraft.

I spent a full day zigzagging across Scott County, sometimes choosing the most likely route on the map, sometimes chasing down a favorite quilt pattern that I wanted to see. The list included my personal favorite, Grandmother's Flower Garden. Other than a resourceful nature, the only inheritance I received from my maternal grandmother was her bag of fabric scraps—some from her own clothing, some swatches she must have bought at a yard sale. One of the first quilts that I made was a Grandmother's Flower Garden, pieced from those scraps. Along the quilt trail, I developed a strong affection for barn quilts of the same pattern.

I found my destination easily enough. Lying on my belly in a deep green field to photograph the barn at just the right angle, I was roused by a shout from behind me: "What are you doing in my alfalfa? I thought you were a groundhog!" I had to wonder whether groundhogs routinely drive Hondas but was somehow pleased to have gained a bit of farming knowledge. Being able to recognize alfalfa had to be worth something.

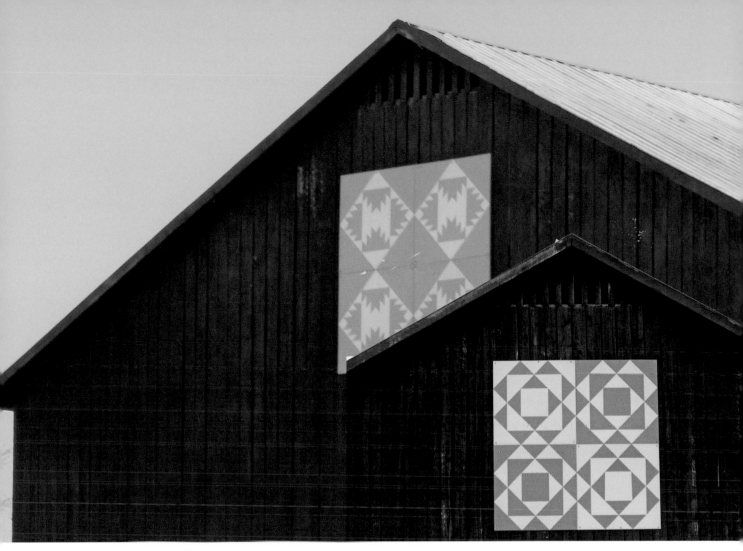

Some of the barn quilts were designated as Civil War patterns; I had never encountered one of those—either in cloth or in wooden form—so the Barbara Fritchie Star and Union Soldiers were important detours. A friendly horse posed in the clover in front of a Storm at Sea pattern, painted in multiple shades of blue to include the wavelike textures of the fabrics in the original quilts. As dusk approached, there were close to a hundred barns remaining on my list, but I had one final appointment.

Dale Glass had been watching for my arrival, and he was at my car door before I could open it. Together we walked up the steep grassy slope toward the barn. He waited until we were settled in front of the barn and in a somewhat reverent gesture, removed his cap before beginning to talk about his quilt squares. On the far end of the barn was a yellow and white Bear Claw block that replicates a baby quilt made by Dale's grandmother Jessie Glass for his father, William, in 1906. The soft blue Gentleman's Pleasure block in front of us was the pattern that his mother, Hazel Glass, created for her home when she married in 1935.

Bear Claw and Gentleman's Pleasure, Glass barn

45

buffalo gals

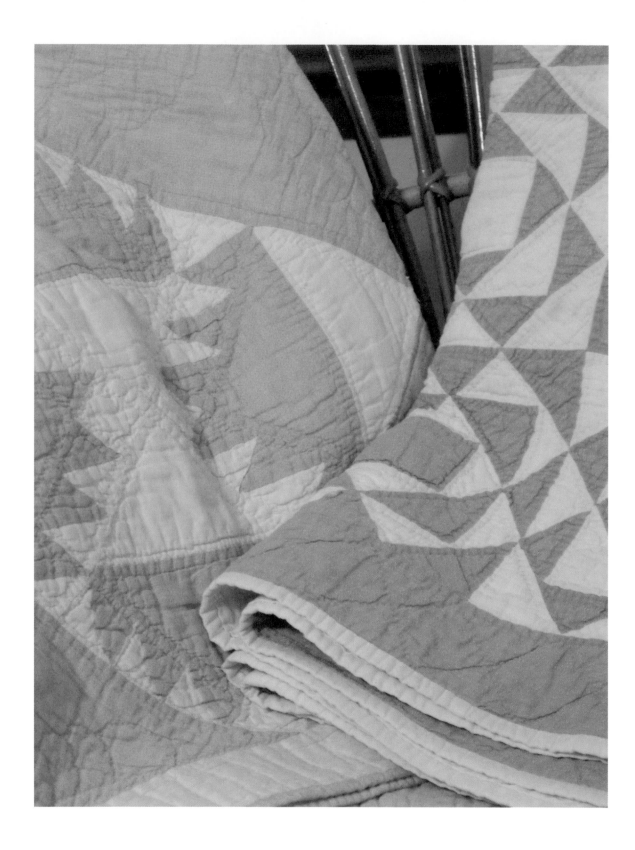

"She lives right here," Dale told me, indicating a home just a few yards from his own. "Don't you want to see the quilts?" Sure enough, Hazel had both quilts in her home on the farm that her husband purchased in 1952. Dale wasn't quite successful in explaining to her why I was there, but Hazel smiled as her son and I laid the quilts out, one against the other, and admired them. Hazel nodded as we spoke, and I wondered what sort of memories of her life and marriage she might have shared if she were able.

For Dale, the barn quilts are both a means of showing pride in the land where he lives and farms and a sweet reminder of his family. "That's my mom and my daddy on each end of the barn," he explained. As Donna Sue had done, Dale had placed his devotion to family on display—making the personal public. I had come to Kentucky to document the efforts of a prolific group of barn quilting gals, to verify their number of barn quilts and record the dates and names of all involved, but I left there convinced that stories such as those of Dale Glass and his family were what I really wanted to capture.

Opposite:
Mom and Dad's
Quilts

tennessee

I WAS ENERGIZED BY my visits to Burnsville and Georgetown and ready to dig into the trail's beginnings. Donna Sue had shared the story of Candace Barbee, of the Clinch-Powell RC&D Council, who brought the quilt trail to Tennessee, but I had also discovered that the Appalachian Quilt Trail, as the group was called, was expanding quickly across the state. I was ready to find out more, so I made arrangements to meet with Lindy Turner, director of the Clinch-Powell RC&D Council in Rogersville, Tennessee.

When heading east on Highway 11W a few miles east of Knoxville, I saw the landscape shift from suburban industrial complexes to become less congested— a tractor dealership here, then a couple of modest houses, then more and more stretches of farmland. I was on the lookout for the first barn on the trail. A gray barn with its multicolored quilt square welcomed me back into the realm that was starting to feel like home. Less than a mile down the road, the bright pinks of a Tennessee Tulip pattern adorned the bare boards of a tin-roofed tobacco barn.

Next on the map was listed Trip Around the World. I slowed as much as traffic allowed and glanced every few seconds at the opposite side of the divided highway until a stunning red barn leapt into view just past a stand of trees. I executed a somewhat precarious U-turn and parked in the narrow strip of pavement just a foot or so from the roadway.

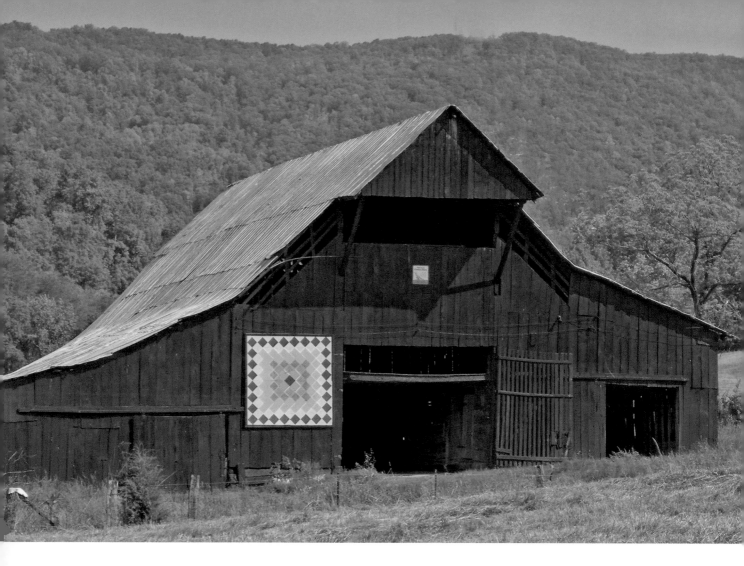

Trip Around the
World, Rutledge,
Tennessee

I cannot pinpoint why some barn quilts compel me to stop and stare; I suppose the impulse is akin to walking through a museum and being taken by a painting that others pass by. I spent about half an hour crouched in a roadside ditch brimming with wildflowers, taking photo after photo, hoping to capture the power that drew me to the site. I didn't know the story of the barn or the quilt square, but neither mattered. Ironically, when I later spoke to Lindy Turner and described the barn, she answered with a satisfied smile, "My grandmother made that quilt, and it's one that I have."

Lindy had promised to take me to a very special location whose access was restricted to an invited few, but she would reveal nothing more. As she drove, Lindy talked a bit about the mission of the Appalachian Quilt Trail. She characterized the quilt trail as "a way to string dissimilar attractions together into a major tourism attraction. Sometimes they're on barns, and sometimes they're not. Connecting cash registers is part of it, along with the culture and the heritage." A look through

the map revealed that quilt squares draw visitors to craft shops, galleries, antique stores, and even a winery.

About forty-five minutes' drive from her office, a small road sign indicated that we were entering Surgoinsville, and Lindy told me that we were going to visit the Fudge Farm. The name brought to mind a country store filled with sugary confections, but I had a feeling that it was something else entirely. Several large pastures led to a family farm that would turn out to be a repository of history unlike any other that I would encounter.

Mary Ann Fudge, a sprightly elderly woman dressed and coiffed to receive company, led us into the sun-filled parlor. As we walked by, I caught a glimpse of a large brick kitchen off to the left; it looked very different from the sunlit room ahead. I could sense that Lindy shared my eagerness to tour the house, but being Southern girls, we knew the rules. We were joined by Mary Ann's sister, Jane Fudge Cole, and spent an hour or so chatting about the family and the farm. The two women are the great-granddaughters of Josiah Fudge, who founded the farm in the early nineteenth century. I was stunned to hear that Jane had been born in 1920. She moved away to work as a teacher but returned to the farm in the 1990s to help make sure that it remained in the family. I'm not sure which was more shocking—that the woman in front of me was ninety years old or that she ran a two-hundred-acre farm.

As she leafed through family photos, Mary Ann inventoried some of the buildings that had once been part of the property and also shared a bit about how the two women had been raised. "Mother insisted that we would not have a marriage license in our hand unless we had a college diploma in the other." Along with five other siblings, Mary Ann had lived up to their mother's challenge and graduated from Middle Tennessee State University. The family was prominent in the area, but the family name led to some teasing: "We were always called 'the sweet ones,'" said Jane.

I was itching to see the rest of the house, and finally it was time for the tour. We stepped from the parlor into the high-ceilinged antebellum kitchen, with walls made of deep brown bricks that had been forged on the property and exposed beams that served as the frame. Huge fireplaces filled most of two walls, and Mary Ann revealed that they had once been large enough for the girls to play in. Taking it all in was difficult, and just as I had begun to feel transported back into another world, Jane asked, "Do you want to see the quarters?" I wondered whether I had heard her correctly.

We were led outside and down into a cellar that contained another large fireplace and a heavy wooden farmhouse table. Mary Ellen stated that slaves had once prepared meals for the family in this rustic kitchen. The women had created sort of a living museum, with massive iron pots and nineteenth-century cooking implements surrounding the hearth as if its inhabitants had just gone out to the harvest. The room was at once beautiful and disturbing, as I thought about how

51

Pinwheel, Fudge
Farm corncrib

fortunate I was to see such a piece of history firsthand and how unfortunate had been those who had once occupied the space.

I wondered with some trepidation what the adjoining areas of the cellar might reveal, but Lindy and I had come to see a quilt, so we headed back into the house. Each room was replete with exquisite details. Hand-carved banisters, intricate white moldings around the massive doors—the craftsmanship was impressive and bespoke the wealth that was part of the family legacy. Spinning wheels, glass-fronted cabinets filled with antique glassware, and even a light fixture with circa-1930 bulbs connected the current residents to their forebears. Upstairs, in what had once been the only bedroom, a dark wooden chest at the foot of the bed contained the sought-after treasure—a Pinwheel quilt, which is believed to have been made in Virginia and brought to Tennessee when the family settled the farm.

Unlike most of the traditional quilts of the era, the Pinwheel is an appliqué design in which individual colored fabric shapes are cut and sewn onto the top of the quilt. Appliqué is often used to create patterns with intricate or curved designs, which are nearly impossible to piece together as is done with geometric shapes. As Mary Ann carefully spread the delicate and worn quilt onto the spindle bed, Lindy and I looked out the window and spied the matching quilt block on the farm's

52

corncrib across the street. The sisters braved an icy wind to bring the quilt outside to pose in front of the dark gray building where the Century Farm designation hangs. Unfortunately, the obvious discomfort on the two elderly faces was too evident, so the photo remains in my collection—a reminder of a piece of our history that few are privileged to witness.

My next trip to the area took me farther into the hills to River Place on the Clinch River. Gracie Lee, my faithful mutt, had been with me on that initial visit to Kentucky when I first encountered barn quilts, so it was only fitting that she be allowed to enjoy another adventure. Gracie loves to meet new people and to chase critters—either real or imagined—across open expanses of land. And when left behind for a while, she will doze off comfortably in the backseat of the car, as long as the engine is running with the air conditioning on, a habit that has created a stir on more than one occasion. With a well-mapped route at the ready, we were off to Tennessee.

I drove north on 11W once again, this time with a couple of side trips planned. A turn off the main highway into the wooded hills led me past a tiny wooden building at Jeri Landers's Hopalong Hollow Studio, covered almost completely by an intricately detailed Confederate Rose barn quilt. The road turned into a terrific drive—winding up the mountain just a bit faster than suggested, rocking side to side up the narrow way, slowing only to negotiate the passing of an oncoming vehicle.

Near the crest of a hill, I spotted my destination. Joppa Mountain Pottery was barely visible through the trees and might have been missed if not for the Four Square quilt block nestled in the shade of the roadside greenery. Long rows of shelves holding pottery jars of all sizes lined the gravel drive, and dozens of smaller pieces were laid out on tables and shelves everywhere I looked. McDonald Crosby, whose long reddish beard made him look more like the quintessential mountain man than a potter, explained that the work is all done by hand by members of his family. Each piece was unique, and many were decorated with etched leaves and other designs.

I purchased a small jar—almost pocket sized—as a gift for Donna Sue. Some days her continued battle with chemotherapy was accompanied by an optimistic countdown of the remaining visits, but most of our conversations were still filled with despair. I recalled her comment some months back that her favorite of all of the photographs of quilt squares she had seen to date was one of Joppa Mountain, and that it always made her smile. I hoped that the token would do likewise.

I made my way back down to the highway and then began to head toward the ridge along the Clinch River, where we would spend the night. The map led down country roads to some of the more remote quilt blocks, and I wanted to see as many as I could. One thing I love about this area is that the traveler is seldom more than a few minutes from a quilt square. The excitement of discovery is greater when leaving one location immediately begins navigation to the next.

53

tennessee

Unfolding Star, Candle in the Wind Studios

Candle in the Wind Studios sounded like a place worth visiting—something about its similarity to an Elton John song, perhaps—and indeed it was. Gil and Tammra Russell's tiny white building is home to the Unfolding Star quilt block, whose intricate hand-painted calico patterns warranted a few minutes of study. Tammra thought that because the two are artists and Gil is a sign maker, they had to have "sort of a fancier quilt." With a deep laugh, Gil said, "We hate to be sort of braggardly, but we've got the best one around."

Gil Russell is not from Tennessee, but he understands the value of barn quilts: "It's kind of like a cultural event—like an old-time quilting bee. We aren't literally stitching things together, but just like the people that live in these hills used to meet and get together, that's what we do now—get together."

The two are from New England but have managed to become part of the rural Hancock County community, whose members Gil describes as "wicked cool."

River Place proved to be a beehive of excitement, with canoe rentals, a small café, and a country store all emanating from the same tiny building. Kim Belcher was the center of it all, and she whirled by, welcoming me with a promise to sit down and talk "in a minute." Instinct told me that it would be a long minute, so I took off for some exploring, finding a gem of a barn quilt in University of Tennessee orange on a cabin along the riverfront a few miles away. On my return, Kim wanted to chat but also wanted me to meet Scott Collins, purportedly an

54

barn quilts and the american quilt trail movement

expert on the Melungeons. I had noticed that the name of the trail was the Melungeon Star, so I was intrigued and ready for another lesson in history and culture. Late that afternoon, I followed Kim through thick woods to a remote cabin high on Newman's Ridge, where we climbed onto a picnic table among the trees to talk.

Kim's reaction when Candace Barbee introduced the quilt trail idea to the Clinch-Powell RC&D had been a resounding "Yeah!" As a council board member, Kim was pleased with the opportunity to bring travelers to the area, but her excitement was also tied to an ongoing project. Kim volunteered her summers to run a recreation program for the children in the community. Painting quilt squares was a perfect addition to the task of entertaining up to 150 kids per day and provided much-needed support for a program that ran on a shoestring budget.

A grant paid for materials and for artists to paint the squares, and Kim created enthusiasm by making it an honor to participate. She told the kids, "I will *let* you be part of this if you will come and paint." Art teacher Sherry Baker directed the older kids in outlining the shapes, and then, as Kim said, "The little kids would smear in the middle and the big kids would come in and fix it." In keeping with the grant, the artists were paid, but rather than the money going to individuals, the summer recreation students were paid as a group, with the proceeds going to buy art supplies for the program. I admired Kim's ingenuity and added one more item to the list of ways that quilt trails had benefited communities.

Scott Collins slid onto the table next to Kim and began his tale by stating that his dark skin and hair were characteristics of the Melungeons who had settled Newman's Ridge. Their origins are difficult to document, but local lore has it that this unusual ethnic group migrated from Portugal in the late sixteenth century trying to find a place that they could call their own. They gradually moved westward and higher into the mountains until they came to Newman's Ridge, where many remain.

Scott went on to say that the Melungeons were known for their use of local medicinal herbs such as sassafras and yellowroot but were most widely known for making moonshine. Four hundred years later, the dense hardwood forest still felt as if it might hold their secrets.

Scott talked for nearly an hour and clearly had as many stories as I had time to listen. He related one legend that was particularly amusing, about a five-hundred-pound woman named Mahalia Mullins: "The story goes that a newly elected sheriff got a warrant to arrest 'that big woman who lived up on the ridge making liquor.' When he got to the cabin, the sheriff looked at the door and realized that Mahalia was too large to fit through the space. He wrote on the warrant, 'catchable—but not fetchable,'" Scott finished, grinning at having gotten the story just right.

Because the Melungeons originally populated Hancock County, the quilt trail in the area began with Scott's Melungeon Star block. I had already admired his

55

Melungeon Star,
Scott Collins barn

1925 barn, with its chestnut timbers and foundation of layered stone, along the highway far below us. Kim added that the quilt square's glossy blue and gold are the colors of the nearby high school, blending centuries of heritage with the county's future.

Whenever I mentioned Tennessee, Donna Sue would ask, "Have you seen Roy?" I knew that she was referring to Roy Settle, director of the Appalachian Resource Conservation and Development District in the northeastern corner of the state. Jonesborough is more than a four-hour drive from my home, so I had placed it on my list of summer destinations. But as she neared the end of her treatments, Donna Sue was struggling mightily. I thought perhaps hearing about a visit to her dear friend would lift her spirits.

Roy Settle told me right away that he had never expected to be involved with quilters and quilting. However, four years after introducing barn quilts to eastern Tennessee, Roy is as well known to the quilters of the area as he is to the farmers.

Roy had been working mostly with agriculture and soil conservation when Lindy Turner told him about the quilt trail that was flourishing in her region of the state. He thought that the idea sounded interesting and that creating a few

blocks for local residents to enjoy seemed like a good idea. But the concept really began to make sense when it connected with an important mission. Roy explained, "Our council had identified the need to preserve and protect farms in this area, and as we began to work with the quilt trails, suddenly, here was a way to do that.

"A lot of the farms go back before statehood—they were Revolutionary War land grants, and it's important to protect those. We have helped capture the stories of those farms by asking the history of the barn and property and their owners as well as the history of the quilt. Recording those histories has been one of the best parts of this process."

Roy suggested that my first trip to Washington County begin with a visit to Marcella Epperson. I was to arrive in Johnson City late in the afternoon, and her farm was apparently near my motel, so I made arrangements for a quick visit. The directions led down a four-lane highway, past a drugstore, then down another road a bit beyond a medical center. I thought I was surely lost. But just as frustration began to set in, the farm appeared out of nowhere—right where it had been since 1848, before the rest of civilization built up around it.

I was all ready to talk about the barn quilt, but Marcella was having none of that. In the manner of the Southern hostess who might have been one of the first occupants of the farmhouse, she said, "I thought we'd have a snack first." Two slices of homemade quiche, a congealed salad, and an ice cream sundae later, it was time to talk quilts.

A basket in the parlor was stacked with hand-stitched heirlooms, and I was amazed to hear that some of them were over a century old. Marcella unfolded a few for me to see and laid them across the sofas and chairs. Many were pieced with pastel colors, which don't show up well at a distance, so Roy Settle had worked with Marcella to select the best among her treasures. They decided on the LeMoyne with Swallows pattern—a variation made by Marcella's grandmother—because the brilliant colors would be striking against the unusual herringbone-patterned barn.

Speaking of her experience as a judge at quilting competitions, Marcella stated with great conviction, "I do not approve of quilts being machine quilted. I could never put a first blue ribbon on a machined quilt—it's not a quilt." She is, however, quite fond of her painted quilt and often serves as hostess when a tour is scheduled.

As we walked onto the grounds, Marcella pointed out Master's Knob, a sharply pointed rise that appears on the horizon just past the barn. The farm was dubbed Knob View when it was settled and has been known as such ever since. Marcella walked me past the table in the yard where leather was once tanned and spoke about the pigs and chickens that once lived on the property. It was hard to believe that the practically suburban farm had been in operation just a few decades ago. After giving her a brief introduction to Gracie and a promise to return, I reluctantly headed off to prepare for the next day's adventures.

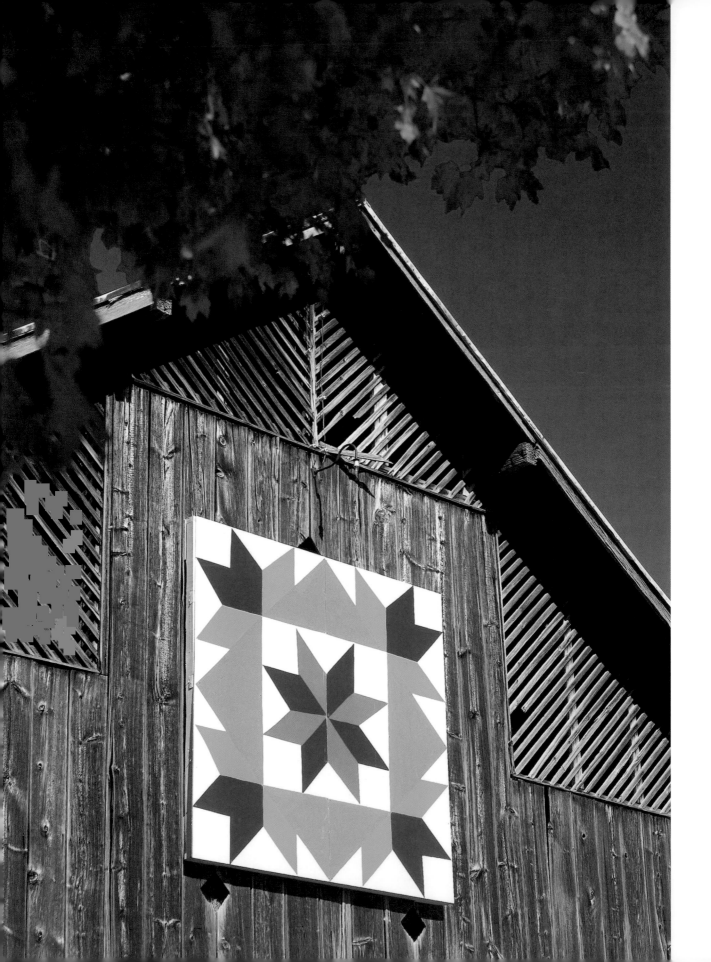

Roy Settle had listed St. John's Mill, with its Dutch Boy and Dutch Girl quilt square, as a spot not to be missed. The painting hangs on a large gray barn across the street from the mill, where I found Ron Dawson sitting at his large wooden desk behind the crowded racks of feed and fertilizer. I had barely introduced myself when Ron produced a coin and displayed his skill at making it disappear and reappear. "See," he said, with a performer's flair, "things aren't always how they seem." Ron went on to explain that the mill might seem like an ordinary feed store but was so much more—the oldest continually operating business in Tennessee. St. John's Mill was still in operation despite the nearby modern "one-stop" retailers, and had also overcome many obstacles in the past. I sat back, an eager audience, as another quilt trail history lesson ensued.

Ron told me, "This mill has been here 231 years and it has paid taxes to four different governments and hasn't budged an inch. It's been in the same bloodline for the whole time." He described the mill's founding, when about three hundred Pennsylvania Dutch families moved to the area from Colonial Virginia to start new lives. Ron described in great detail how the trees were cut so that the stumps were just low enough to allow a wagon to safely pass. He also took pride in the settlement's means of dealing with lawbreakers and spoke as if recalling firsthand: "We needed to have some kind of protection. So we set up magistrates, and if we found someone who was stealing, we would take him before a jury and hang him. The first independent government was here in the Watauga Valley."

The mill's ability to survive under the worst circumstances continued into the Civil War, when, according to Ron, forty of Washington County's forty-two mills were burned by Union troops in an effort to break supply lines. The mill's owner at the time was a minister who held services in the building. Ron proudly declared, "They wouldn't touch it because they respected a church."

The rich history of the mill inspired Roy Settle to ask Ron if he would like to have a quilt on the barn across the street. Ron didn't have to think long before making a choice. The family has more than a dozen quilts with the Little Dutch Boy and Little Dutch Girl in one form or another—the Little Dutch Angel, the girl with the sprinkler can in her hand—mostly baby quilts that go way back in the family. The farmer boys in their denim overalls and the girls in their signature bonnets on the barn are a visible tie to the generations of family members who continue to operate the mill, and to the raconteur who stands ready to entertain travelers along the quilt trail.

On the way to St. John's Mill I had whizzed past a massive red barn with a quilt block mounted under the roof's gable and made a note to retrace my steps later in the day. I had an appointment to meet with teacher Barbara Miller of Mary Hughes Middle School and knew that her time would be precious.

The Massengil Farm holds an important place in history as the oldest Century Farm in the state and now holds a very special place in the hearts of a group

Opposite: LeMoyne with Swallows, Knob View Farm. *Photo by Murraylee.com*

59

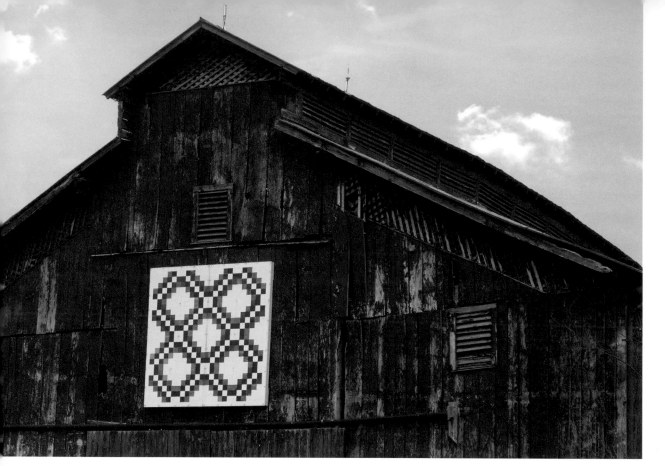

Triple Irish Chain,
Massengil barn

of young people. Barbara Miller explained that her school's special quilt square is patterned after one that was made by Sallie Massengil Bell's mother about one hundred years ago. Barbara displayed a well-worn paper draft of the Triple Irish Chain design that was chosen. The pattern became very popular with quilters and remains so because it is made up entirely of squares but allows for a lot of variation in color combinations. The simplicity of the pattern also made it the perfect block for the children's undertaking.

Barbara's art classes began the painting, and the excitement spread throughout the school as students from each grade level were invited to help. The eight-by-eight-foot block seemed impossibly large at first, but after it was divided into squares, the task became easier. With great enthusiasm, Barbara told me, "Every child who wanted to was able to paint a square. We started with the middle school and went down through each grade so that over two hundred of our students got to come in and paint. It just tickled us to death!"

I followed Barbara to see the barn, which she said was just a couple of miles from the school. Within minutes, we pulled off the roadside in front of the red barn that I had made note of on my way to our meeting. "They are all wonderful," Barbara beamed, "but this one I like best."

"The school involvement has been terrific," Roy Settle observed. "I know of two girls who were assigned a quilt square as a senior project, and one of them

used it as part of her portfolio for art school! I participate in the Johnson City Leadership Program, in which we visit schools and kids speak about clubs and organizations such as FFA that have made a difference in their lives. One group just had to share what was important to them: 'We have painted more quilt squares than any other school!' It's great to see the pride that they have; instead of art on the refrigerator for Mom and Dad to see, they have art on public display."

Many of the other quilts along the trail mark sites of historic significance. Along Tennessee's first wagon road, a barn with an impressively detailed rendition of my beloved Grandmother's Flower Garden quilt designates the turn to Yancey's Tavern, a public meeting place since 1780. Artist Anita Long and her family re-created the quilt block based on a section of a quilt that was found behind a tavern wall during its restoration. At Pioneer Homestead, furnishings, household goods, weaving, lace, and even military uniforms from centuries past are on display. A bit of coaxing might convince Margaret Holley to open the quilt cabinet, from which, with white-gloved hands, she will unfold a dozen or more nineteenth-century quilts, including her Great-Aunt Kate's Nebraska pattern, which is replicated on a barn quilt that hangs on the family farm just around the corner.

I thought I was finished with this corner of Tennessee when Donna Sue sent me a photo of a headstone with a Dutch Doll carved upon it. Of course the tale would be a sad one, but Donna Sue was touched by the fact that the project impacted someone enough to take it to her grave. She wanted to know the story of the woman who became so attached to her quilt and her quilt square that her family decided to put it on her headstone.

Roy Settle put me in touch with Janet Smith, who described the small brick church that sits on a hill near the house on the Nolichucky River where Nancy Carter was born. On the back of her marker in the Zion Church cemetery is carved a replica of a Dutch Doll, the quilt that meant so much to Nancy throughout her life—and as she neared her death.

Janet told me the story: "There are not many people who are brought into this world and leave it in the same house, but my mother, Nancy Carter, was fortunate enough to have been one of them." Nancy's affection for quilting began with her grandmother, May Johnson. May took Nancy with her to buy flour and sugar and feed, and Nancy got to pick out the sacks, which would later be used to make quilts. Nancy soon embraced her grandmother's love for quilting; Janet recalled, "Quilting was her life—she would put colors together that you wouldn't think would look good, but she had a real talent." Joining her mother on those treasure hunts is one of Janet's dearest memories—the adventure of discovery, the glint in Nancy's eye when she was thinking about how a piece of material would be part of a new project, the fun of stumbling onto new people along the way. Even when she found out that she had ovarian cancer, Nancy told Janet's daughter Jena that she wanted to make a quilt for Jena to have when she has her first child.

Nancy Carter
Dutch Doll quilt
and barn quilt.
Photo by Jena Smith

When it came time to paint a quilt square for Nancy's barn, she selected a Dutch Doll quilt made for her by her grandmother. She had a name for each Dutch Doll, and one of them was May, for her grandmother. Janet used May as the pattern for her mother's barn quilt. "Mother wanted *me* to paint it," Janet said softly, through tears. "I mixed the colors and made the quilt square on the barn match the quilt exactly—right down to the flowers and the stitching."

The quilt square went on the barn in the summer of 2006. Nancy derived a great deal of pleasure from visiting with people who would pull into the barnyard to look at the square. Janet said, "Mother just loved it; she made so many friends. She loved when people would ask to see the quilt and hear its story."

Nancy passed away in February 2008. In her final months, Nancy's hospital bed was pulled to the window so that she could see the barn. After pausing a moment, Janet went on, "She could see the Dutch Doll, and she had the Dutch Doll quilt on the bed with her. It was comforting to her; I can't express how much that quilt square meant to her."

62

I had found the story of the Dutch Doll gravestone and was grateful to Janet for sharing it with me. Donna Sue and I agreed that Nancy was someone we would like to have known.

After four years, the quilt trail that spans the six counties of the Appalachian RC&D District is home to sixty-five barn quilts, most of which are based on cloth quilts. Donna Sue explained, "There is a big difference when you go from 'What would look good?' or 'What's your favorite quilt square?' to connecting the quilt, the quilter, the barn, and the farm. Roy Settle and his program were the first to do that, and it so enriches the story for those who travel the trails."

Because Tennessee was the first state beyond Ohio to join the quilt trail, I was pleased to have completed my research there. Just a few weeks later, Donna Sue sent me a photo with a news item that she had found online. "Suzi, they painted the whole quilt. Isn't it magical?" The quilt was painted directly onto the barn and covered nearly the entire surface. I scanned the article for the location—Algood, Tennessee. I wasn't quite finished, after all.

Ruth Dyal is from Germany, but she has put down enduring roots in Tennessee. She helped found the Upper Cumberland Quilt Festival, an annual event during which family quilts are displayed in homes, churches, and other historic buildings and quilters come together to share their artistry. The Upper Cumberland Quilt Trail began as an extension of the festival, and tours are now part of the program each year.

Ruth immediately invited me to visit and said that she would ask a few other interested women to join us for lunch. The following weekend, I followed Ruth's directions to the Cracker Barrel restaurant, where a dozen women lined a long table, all eagerly waiting to meet me and to talk quilt trails. Women from nearby Fentress and Jackson Counties were brimming with excitement about the possibilities of joining the movement. When I found out that Kathy Daugherty, director of the Hull-York Lakeland Resource Conservation and Development Council, was present, I knew that this project was off to a good start, because the RC&Ds in Tennessee had been the backbone of the quilt trails' success to date.

Barbara Tolleson had worked with Ruth to begin the trail in Algood, and the three of us toured together. Barbara's brilliant gold and blue Ohio Star quilt was the one that caught Donna Sue's attention and was also the first painted. I had seen several quilt squares painted directly on barns in Ohio, but the one that covers most of the rustic gray barn at Masters Healthcare Center was pretty impressive. Barbara pointed out that each of the quilts is a replica of an actual cloth quilt. The goal was to showcase the quilting that was done and is being done in the immediate area.

The trail is very easily traveled, as the barns are close together on flat terrain. The next we would visit was Sunbonnet Sue—a familiar pattern on the quilt trail,

63

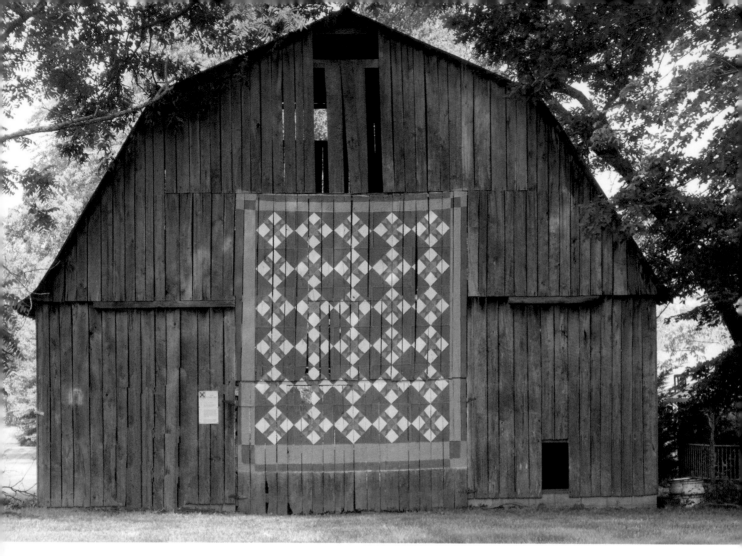

Ohio Star, Masters
Healthcare barn

but again impressive because the artist had painted a sixteen-square quilt rather than the usual single block. I had learned by now to expect the unexpected, but as I turned to walk away, the sight of a herd of Texas Longhorn cattle—complete with magnificent curved horns—in a field across the street was as startling as a UFO landing. It was another memorable moment along the quilt trail.

I loved the fact that these quilts honored some of the quilters still active in the area; that was also something new. And most of the painting had been done by local artists, as Donna Sue had initially hoped that they would be. Under the gable of the weathered red barn at Sunset Acres Farm, the Star of Bethlehem bursts with color. The painting is a replica of a quilt stitched by ninety-four-year-old Velma Thompson for one of the many dolls in the collection for which she is well known.

A bit farther along, the Stacked Bricks pattern looked like a fairly ordinary series of red, white, and blue rectangles in alternating rows, but Barbara Tolleson explained the ingenuity involved in creating the original. The quilter, Lily Mae

barn quilts and the american quilt trail movement

Hall, ripped Prince Albert Tobacco sacks apart and dyed each so that she would have the colored material to make a quilt. I had heard many times of feed sacks being used to make quilts, but tobacco sacks? That was another first.

Ruth Dyal was pleased to report that art students from the Algood School assisted in painting several of the quilts, including the most historic one on the tour, which has a bit of a legend attached to it. The only thing better than history is a good legend, so I was ready to hear the tale. White Plains Plantation was where President Andrew Jackson would stop to spend the night on the road that connected Washington and Nashville. The story goes that a quilt was on the rack and being quilted when the Jacksons came through, and Mrs. Jackson sat with the ladies and quilted a bit along with them.

The current owner of the farm, Martha Willis, still has the original Mariner's Compass quilt. This final painting on the trail is a replica of this treasure—another complete quilt, with four rows of compasses in varying reds and blues. Artist Julie Styer added an antiquing glaze to the painting so that it looks as aged as the cloth original, a method I had not before encountered. I left Ruth and Barbara behind, quite impressed with the integrity with which they approached their project.

That there would be more barn quilting news from Tennessee was inevitable; it arrived just as I returned from Algood. The publication was a library newsletter that described the "Stitch in Time" Stewart County Quilt Trail and Letitia's Quilt. Historical society president Carolyn Darke agreed to meet with me and also mentioned that nearby Houston County had a trail as well. I heard Willie Nelson singing in my head—"On the Road Again . . ." to Dover, Tennessee.

I had seen a photo of Letitia's Quilt and had studied it closely, but seeing it up close was akin to standing in front of a piece of art with which I was familiar from a book. The quilt is mounted on the side of a nondescript white building in town —chosen, I would later find, by default because it had a large enough exposed surface. I dropped to the curb and just stared. The sixteen-by-sixteen-foot painting is so full of detail that taking in all at once was impossible.

The quilt took a year to paint, not because the artists weren't dedicated to their work but because they were determined to create a unique quilt that held symbolic meaning for the area. By all accounts, they succeeded. The design incorporates twenty-four Civil War–era quilt blocks, along with a Rose of Sharon center and matching border and dozens of eight-pointed stars. I could have sat another hour, but I had an appointment at the library to meet the women responsible for this masterpiece.

Carolyn Darke recalled, "We weren't looking for a project, but one day early in 2007, Pam Ford—our librarian—said to me, 'You've got to see this.'" Carolyn had been a painter for years and had already created public art for the library and

65

a local church, so when she saw the website about barn quilts, she was especially drawn to the idea.

I laughed when Betsy Tumelson added, "I thought we *were* looking for a project." The historical society sought something unique to Stewart County, and that's when they hit upon the idea. Dover is a Civil War town, and a very significant battle was fought there at Fort Donelson. "We have such a rich heritage of family histories and some untold stories," Betsy said.

The fort was already attracting a steady stream of visitors, but it seemed to mostly appeal to the Civil War buff. As I would hear in many small towns across the country, the question was raised as to how to entice a family to extend their stay or appeal to a wider audience. Adding the female perspective with the quilts seemed a possible answer.

Carolyn Darke proved a valuable resource not only because of her artistic ability but also because of her family history. Her great-great-grandmother, Letitia Levine Smith, lived in Dover during the Civil War when the fort and town were under siege. Legend has it that when Colonel Nathan Bedford Forrest left Fort Donelson, young Letitia helped his troops escape surrender by showing him where he could ford Lick Creek near her father's property. Letitia is also legendary for her quilt making, a talent that lives on in two of her quilts, discovered when Carolyn looked through the house where Letitia spent her married life. Those two quilts were used as the starting point for the painted quilt whose full name is "With Love, From Letitia," the centerpiece for the Stewart County Civil War Quilt Trail of which I was so enamored.

Letitia's Quilt honors the woman herself, the quilters of the era, and Civil War history. The Rose of Sharon center and border are taken from the appliquéd quilt that Letitia made as she prepared for her wedding, while the four pieced stars are replicas of the other quilt that was found intact. Blocks such as the Log Cabin and Nine Patch that were staples of the time are combined with other traditional blocks to form a border around the center. Many of the quilts, as well as others along the trail, are replicas of treasured Civil War–era quilts owned by Stewart County families, with all of the colors in keeping with quilts of the period.

The remainder of the quilt's design is a history lesson in symbols: The large gold and blue star at the top represents Abraham Lincoln, while the gold and gray star honors General Robert E. Lee. Thirty-six smaller stars represent the states in the Union prior to the war: eleven large yellow and white stars represent the states that seceded; and Kentucky, Maryland, and Missouri—the Border States—are represented by gold, blue, and gray stars. Finally, the palms in the corners symbolize the constant prayers by all concerned for the safe return of loved ones. I suggested placing a plaque next to the painting so that visitors could understand all of the nuances of the design.

The three of us visited the fort, where the multicolored Jacob's Coat quilt block represents the tattered uniforms of soldiers returning from battle. Carolyn and Betsy took me to see the first barn quilt along the Civil War Quilt Trail, which honors another of the area's legendary residents. Jack Henson lived at Bubbling Springs, where he is said to have trained his slaves to become skilled carpenters, blacksmiths, and other tradesmen so that when they were freed, they would be self-sufficient. The area where the former slaves settled became known as Henson Town once Jack Henson's dream of releasing them came to fruition. The Carpenter's Wheel pattern on the Sykes barn near Henson's Bubbling Springs is representative

With Love, From Letitia, Dover, Tennessee

67

Celtic Chase, Loftin barn

of those who populated the area and passed on their trade so that the close-knit community survived into modern times.

I had one more place to visit, and there, too, was a small bit of history.

Debbie Schmidt had told me that Houston County is often known as Erin, because the county seat was settled by Irish railroad workers, who named it after their homeland. Also, some say that the green hills in the area reminded them of Ireland. When Debbie saw the quilt trail in Stewart County, she immediately wanted to bring the project to her area, and the ties to Irish heritage were the perfect opportunity to create something unusual.

The Celtic Quilt Trail is made of up designs associated with Ireland and other quilt patterns reminiscent of that culture. Celtic quilts are appliqué quilts—much more difficult to paint than the geometric designs of pieced quilts—but as a por-

trait artist, Debbie was not intimidated by the task. The committee operates on a very small budget, but Debbie said, "We bought mistinted paint, asked for donations, and got a grant to pay for brochures; it took a while, but it all came together." A variety of local artists and civic groups contributed their labors for the painting as well.

Driving around Erin, I could more easily spot the quilt blocks by eye than look for addresses in the tiny town. Evening Star popped up on the marquee post of the bank, True Lover's Knot on an appliance store, along with half a dozen other patterns that are tied to Celtic culture. The whimsical Elf and Dragonfly at the chamber of commerce seemed a bit unquiltlike, but it fit the theme. Farther into the countryside, a Double Irish Chain hangs on the barn of a Century Farm.

Dusk was nearing, and the Celtic Chase quilt looked as if it would be hard to find, but I knew I might pass this way only once, so I followed the road through darkening woods to locate the home of Robert and Elaine Loftin. The log cabin, which is said to date back to the 1780s, was a fitting backdrop to the quilt. Elaine selected the Chase—a design that was copied from an eighteenth-century Williamsburg sampler made by an eleven-year-old girl. Elaine liked the pattern because its leaping deer, birds, and singular tree fit the primitive setting in which she lives. Although the design most certainly has its origins in the British Isles, artist Debbie Schmidt took it one step further, adding the Celtic Knots in each corner to create a unique pattern—the Celtic Chase.

Of all of the places I visited, Tennessee surprised me the most. The layers upon layers of history and culture were built into each of the quilt trails in a way that still draws me back to visit for my own enjoyment—something I had never expected once this project was completed. The quilt trail that was begun in 2003 by the Clinch-Powell RC&D has become an interconnected web of over 450 stops, and the appeal of a quick trip to see more of them is never far from my mind.

69

kentucky

Donna Sue had spoken often of Berea, Kentucky, and the meetings that she had held there to introduce quilt barns to the state. Before the Adams County trail was completed, she had begun to see the project's potential and to envision an Appalachian "clothesline of quilts." Because Kentucky was between the growing trails in Ohio and Tennessee, it seemed natural for the state to be included and to be the site of the meetings. In July 2004, Donna Sue and representatives from the existing Ohio and Tennessee trails met in Berea and invited interested individuals and RC&D coordinators from Kentucky and other states to join them. The East Tennessee Foundation played an integral role in coordinating the efforts and applying for grants from organizations such as the Appalachian Regional Commission.

For three years the groups met and attempted to develop plans to work together to create something bigger—marketing the quilt trails and showcasing their ability to bring tourism to lesser-known areas. Donna Sue gave me a timeline of the meetings, minutes, notes, and e-mails documenting both the hope with which the cooperative effort began and the discord that caused it to disintegrate.

One of the sticking points came about when Iowa's barn quilt projects began. Ensuring uniformity within the group proved difficult, if not impossible, with one member so far away. The idea of a multistate effort was exciting, but the concept

of an "Appalachian clothesline" limited the states that might be included. "It was the only time in my life that I was awkward about being called 'Appalachian,'" Donna Sue recalled. "I wanted Iowa to be part of any larger effort."

Ownership of the quilt blocks was the subject of much debate, as was the proposed copyright of the designs. In the end, each participant seemed to want something a bit different. No one could quite agree on what a cooperative effort should look like: who would be included and what that would entail; how the responsibilities and expenses should be divided. And during the years that the Berea meetings were being held, new barn quilt projects continued to appear, including those in North Carolina.

The troubles that undercut what seemed like a good idea demonstrated how critical local buy-in is to the success of quilt trails. Being governed by a group that spanned several states rather than keeping control at the local level was not conducive to the type of community pride that drives the projects. But the Berea meetings did accomplish one of their original goals—bringing some of Kentucky's community organizers into the fold.

Nancy Osborne, an avid quilter, attended the meetings in Berea and came away excited at the possibility of bringing barn quilts to the city of Ashland and surrounding Boyd County, in northeastern Kentucky, so she invited Donna Sue to visit. Donna Sue would have made the trip to share the story of the quilt trail without any compensation, but she took the opportunity to strike a deal: "I'll come if you make it possible for me and Mother to see the 'practice top.'"

Donna Sue and Maxine Groves had read Linda Otto Lipsett's book about Elizabeth Roseberry Mitchell, who created a quilted graveyard that includes two brown coffins, to serve as a visual reminder of the cemetery in Monroe County, Ohio, where her two sons are buried. Donna Sue said, "I loved the book and its regional historic value; here was another way to record family history—like the family Bible in fabric and fiber." She knew that the Ashland Museum and Discovery Center owns what is referred to as Elizabeth's "practice top," as it was pieced and then laid aside when she began the final quilt, which is in the state museum in Frankfort. Donna Sue and Maxine had long wanted to see the quilt, and Nancy helped make it available to them.

Donna Sue's visit to Ashland helped spark local interest, and within a couple of months, the first quilt painting was begun. Nancy Osborne wanted to expand the quilt trail, but with few barns in the area, she looked for other surfaces on which to paint. Nancy had an idea but wasn't quite sure that it would be accepted.

Donna Sue recalled, "She mentioned the possibility of putting quilt squares on the floodwall, and I said that there are no rules—it is up to people in a local community to use their assets—to build on them and to figure out how to participate in this project. If they wanted it on a floodwall, it was no problem." Nancy was pleased that Donna Sue embraced the idea. The group had received a grant

for well-known Kentucky artist Sam McKinney to do the painting, so they simply needed permission for him to do so.

When the council met, Nancy was surprised at the resistance to the idea. One of the men wondered how quilts would be preserved on a floodwall, thinking that they would be hung in some sort of elaborate display case. Nancy explained the concept but still did not get the go-ahead, so she knew she had to come up with something intriguing. Nancy had a World War II service flag—the kind that might be put up in the window for the men and women who served—hanging in her quilting room, and she was working on a Friendship Star quilt. Nancy thought that maybe combining the two to create a salute to veterans might have universal appeal, and sure enough it did.

Nancy sent the Friendship Star to Sam McKinney, who worked from her idea to produce a pattern with two stars, side by side, surrounded by an interlocked border. At first, Sam didn't quite get the concept, but in the end, the project became meaningful to him personally, as his father had been a paratrooper during the Normandy invasion and his mom quilted "the old-fashioned way" with her guild. With Sam supervising a group of about ten volunteers, the first quilt trail mural on a floodwall was completed. Donna Sue was thrilled to learn of the artist's participation: "Because they received a grant from the Kentucky Arts Council, they had the best of the best—artist Sam McKinney. It was incredible for someone of his renown to want to create a simple quilt square!"

I didn't have a clear idea of what a floodwall, much less a painted floodwall, would look like, but after hearing so much about them, I made visiting Ashland a priority. Gracie, that faithful barn quilting pup, accompanied me as I headed to Ashland to begin a weeklong trip from northeastern Kentucky across the state. Nancy and I met in a parking lot near the river and walked to the murals. I finally understood what should have been obvious: a floodwall is a concrete wall along the river that protects the city when the waters rise. Nancy was overwhelmed with excitement as she pointed out the features of each painting—the textured blue in the Patriotic Star that takes on the appearance of fabric, the exquisite detail and the tiny grave mounds on the graveyard quilt. Upon seeing the painting of the graveyard quilt, I wished that I had accepted Nancy's offer of having the fabric original brought out of storage for me to view. The graveyard design had been meticulously reproduced by volunteers led by artist Denise Spaulding and is a fitting testament to the unusual quilt, but still, the magic of the stitches and cloth resides only in the object created by skilled hands so long ago.

With an entire state to cover in a single week, my time was limited, so I reluctantly left the floodwall to tour a few more of the quilt squares on the Ashland, Boyd County, and Catlettsburg trail, known as the ABC Quilt Alley. At Crabbe Elementary School, a sampler of four quilt blocks hangs on an exterior brick wall of the school. Sam McKinney and artist Dustin York worked with the children,

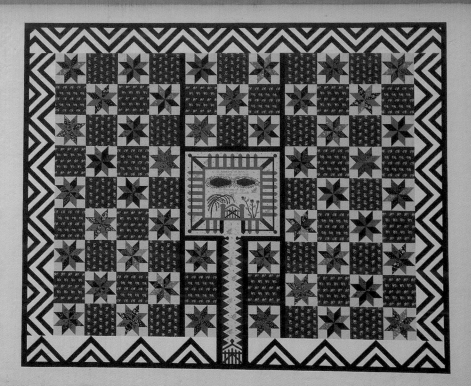

ELIZABETH ROSEBERRY MITCHELL'S
GRAVEYARD QUILT TOP

Elizabeth started this quilt top in 1836 as a memorial to her family. Two sons, John V. and Mathias (Bub) Mitchell, are named on this piece; other sons were veterans of the Civil War. A finished quilt was made from this practice pattern piece. In the 1800's era quilts like this one were made to preserve family history.

This piece at the Highlands Museum & Discovery Center and the finished quilt at the Kentucky Historical Society are historical artifacts in women's quilt history and are nationally known to be the only two existing memorial quilts of this era.

Reference: Highlands Museum and "Elizabeth Roseberry Mitchell's Graveyard Quilt", author, Linda Otto Lipsett

Make a Scene Murals, ABC Quilt Alley © 2008
Artists: Denise Spaulding, Melanie Osborne, Gary Preston and ABC Quilt Volunteers

Coordinator: Nancy K. Osborne, Quilt Historian

Sponsors: Kentucky Arts Council, City of Ashland, Highlands Museum & Discovery Center, ABC Quilt Alley, UK Boyd County Extension Service, Nancy K. Osborne, Jerry & MaryAnn York, AACVB, Ashland Plaza Hotel and SEKTDA.

Graveyard Quilt, Ashland floodwall

who chose the patterns Overall Bill and Sunbonnet Sue, a Schoolhouse, and a Mariner's Compass, each painted using the brightest of primary colors, befitting the location. Sadly, art teacher Lisa Price died in a house fire while the square was in progress, so the children dedicated the finished quilt to her memory.

Several of the quilt trail's initial goals came to life in Ashland. Donna Sue commented, "What was most exciting for me about Ashland is that they actually engaged community members under the mentorship of two established local artists to create the two floodwall squares. It also created economic opportunity for those two artists, which put the money back into the community."

For me, Ashland was the center of a controversy that I believed needed settling: Which was the first Kentucky quilt square? Nancy Osborne stated unequivocally that the Ocean Waves block painted in March 2005 in honor of Mary Slone's eightieth birthday was the first. But the following day, I heard a different story.

I headed into Carter County with my quilt trail map, eager to visit a few barns whose photos I had seen online. Within five minutes, I was certain that I had turned down the wrong road. It was difficult to tell, as quilt trail maps are seldom drawn to scale. Frustrated, I backtracked to try to get back on course. Scouring the list and map, I noticed an unfamiliar pattern with the unlikely name of Mule Train that

might just be nearby. The Sturgill barn is off the main road, but a quick detour seemed like just what I needed. I soon came upon a small barn with what looked like a painted donkey mounted on it. I judged the pattern to be cute and whimsical but certainly not a quilt pattern. I had come this far, though, so I might as well visit.

This was the first time I had made a "cold call" on a barn quilt owner since seeing that first barn quilt in Kentucky almost a year earlier. I was unsure whether I had a right to march up to someone's door and start asking questions, but once she understood why I was there, Juney Sturgill was pleased and invited me in. With a knowing smile, she said, "Seeing the painting on the barn, you would never think it could be a quilt." She reached for a worn fabric quilt of exactly the same design, situated nearby as if awaiting a visitor's query. Pulling one corner taut and proudly drawing attention to the tiny stitches, Juney told me that her mother had made the quilt for Juney's hope chest in 1957 and went on to make one just like it as baby quilts for each of her grandsons. "We never should have used that quilt because it's so pretty, but when we got married, we were so poor that we had to," Juney said with regret.

Juney's genuine affection for her quilt inspired me. Would it be wrong to ask for a photo? Feeling half ashamed and a bit pushy, I coaxed her to the yard and up the slope toward the barn, Though she hobbles slowly with the aid of a cane, Juney posed in front of the barn and the quilt square, whose geometric shapes were now easy for me to spot. I left there hoping that the painted quilt pattern will serve as a reminder of how bright the original once was and what a treasure it still is for Juney and her family.

I drove through the winding hills of Carter County waiting for another barn quilt to grab my attention. Just past a rather comical chicken quilt, a splendid field of summer goldenrod poured forth from a hill topped by a long tobacco barn. The side of the barn facing the road was decorated with a multicolored barn quilt made up of four LeMoyne Stars. The star, named after the founders of New Orleans, is one of the most often painted on barns, possibly because the large shapes are so easy to see.

Nathan Zamarron just happened to pull in and grinned with delight to discover a bramble-scratched but determined photographer in front of the family barn. Nathan said, "My pawpaw, Carl Connelly, bought this farm back in the seventies; we grew tobacco up on the farm and housed tobacco in that barn when I was growing up." Like many barns in the area, this one now stores machinery and supplies rather than crops, but it is still a source of pride for its owner. When the barn quilt committee asked for artists to paint quilt patterns, Carl Connelly painted his own. The location of the barn—just along AA Highway—makes it visible from quite a distance, and the unpaved road in front is the perfect place to pull over for viewing.

Nathan grew up in Carter County, and like many of the more recent genera-
tions, he left farm life behind. Unlike others, though, he has plans to return. Nathan
told me that he was the community arts manager for Lexarts, the local arts coun-
cil in Lexington. "I really like the look of our barn, and I think it's a great location
for an arts center," he said. Nathan is building a cabin up the hill and plans to start
an arts center there and teach some community classes. He added, "I want to
preserve the original exterior, but the inside will be outfitted to be used as a com-
pletely new space." I couldn't help wondering if that "couple of years" would
come and hoping that it would.

The day was growing late, but there was one stop I had heard so much about
that it couldn't be missed. The Garden Gate Greenhouse is the other location that
lays claim to being home to Kentucky's first quilt block—actually a pair. Barn owner

76

Grace Ramey recalled attending one of the early meetings in Carter County. When it was time to select patterns, Grace chose Grandmother's Flower Garden, her mom's favorite and a perfect complement to the greenhouse.

Each end of the barn seemed equally suited, so Grace's husband, Don, thought that they might as well have two quilt squares. Their desire to get the quilt squares hung before the end of May, when the greenhouse closed for the season, determined the timing of the installation. "You know that ours is the first in Kentucky, don't you?" Grace asked. I wasn't sure, but I did know that Donna Sue and Maxine had attended the mounting ceremony.

Donna Sue recalled, "When we got off of Route 23, the way that the road weaved looked a lot like West Virginia. We rounded that curve and I saw that quilt square on that barn, and it made my heart swell with excitement. I couldn't stop smiling. They had a stage set up and rows of people seated in folding chairs—it was really special. It was joyous." Donna Sue was also pleased that the barn quilts might generate business: "It was set up just like we had wanted—so that people would come to the spot and possibly buy flowers or things from the shop." Mindful of my budget, I resisted the urge to purchase an oilcloth purse and headed on.

I felt as if a decision should be reached about who should have bragging rights as Kentucky's first barn quilt: Mary Slone, whose quilt square was painted first, or Grace Ramey, the first to be installed? I was, after all, documenting the growth of the quilt trail, and such matters seemed important. That evening, Donna Sue took stock of the information that I had gathered, thought for a few moments, and said, "You know what, Suzi? I'm just not so sure it matters."

By the next morning, I had realized that Donna Sue was right. I continued to record facts that made a particular trail noteworthy, but what I really was after were the stories of the quilts, the farms, and the people involved. I wanted to know when and how they had become part of the quilt trail but also, more importantly, why they had chosen to do so. With that in mind, Gracie and I continued our journey through Kentucky.

I met Betty Sharp and Gladys McDaniel on a porch in Rowan County, where we talked a bit about Donna Sue. The women had heard about her illness and presented me with two soft pillows with pink-ribboned cases that they hoped she would find comforting. Such a sweet gesture.

The conversation then turned to the barn quilts of the Rowan County Foothills Trail, and we headed toward my car. "We thought about it and went through them all, and we think we've got some good ones for you," Betty said enthusiastically, hesitating before adding, "I'm not exactly a dog person." I offered to drive separately, but Gladys was eager to talk and settled the question by climbing into the backseat, next to the eighty-five-pound pooch who swatted her with a

wagging tail while attempting to climb into the front seat and Betty's lap. We toured the countryside, stopping to see a dozen or more barns, as we made our way to our first appointment.

"Be sure to talk to Marvin," Gladys urged, as we stopped in front of a large gray barn set against a backdrop of evergreen trees. Avis Kidd waved from the porch as I studied the appliquéd pansy pattern of her barn quilt. The contrast between the bright white background and the rustic wood gave the flower an almost pop art quality that was strikingly different from the others we had seen. Avis's story was sweet; she always liked pansies, so when her quilting group decided on a block for each to make, she was quite pleased when they chose her favorite flower. Each member of the guild pieced one block and was given a ticket for a drawing. Avis won all of the blocks, pieced the top together, and quilted it. A few years later when the barn quilt committee asked her, she knew the pansy was just the thing for her barn, and she asked to have it painted in purple—her granddaughter's favorite color.

Marvin Kidd's attachment to the barn stems from much earlier experience. His father bought the property in 1921, and it has been in the family ever since. "I'm seventy-seven years old," he said, "and the barn was there as far back as I can remember." Marvin also remembered a harrowing night in 1939 during which the barn may have saved his family.

"The flood was on the Fourth of July, seventy years ago. It was a flash flood, and the water was from hill to hill," Marvin told us, his arms spread wide. "When it started to come up in the floor of the house, my dad took us up inside the back of the barn. It was a two-story barn, and we had a loft with the hay. He put us up there, and he went back to the house to take care of what he could. When the water went down the next morning, Dad found the fattening hog down on the creek and three other hogs across the way. I was about eight years old, and when I went out in that water I was worried about my britches legs getting wet. I rolled those legs high as I could, and I'll never live that down. I wasn't afraid of the flood," Marvin admitted somewhat sheepishly, "I was afraid of my britches getting wet!"

I left Avis and Marvin behind with promises to come back for a visit, and doggie mayhem ensued as Gracie saw me approaching the car. I felt sorry for Betty in the chaos but was eager to see what was next on the itinerary. The ladies told me that the next quilt was a bit out of the ordinary, but other than directing my driving, they would say no more than that.

Hidden behind a stand of pink crepe myrtles, Terry Reynolds's barn is home to a quilt block whose multiple squares are divided into triangles of varying shades of magenta and pink, creating an almost three-dimensional effect. Terry stood facing the barn as if looking intently at it helped to bring back the memory. When her nephew was young, Terry's sister and her husband lived right across the street. Every Saturday evening when *Star Trek: The Next Generation* came on the television,

Pansy, Kidd barn

her nephew would trot over—pretty much from the time he could walk—and climb up in his aunt's lap to watch. "Of course, when he got bigger he wouldn't sit quite so close," Terry said with a smile. When the young man was getting ready to graduate from college, Terry wanted to make him a quilt, so she looked through quilting magazines until she found the perfect one—Dilithium Crystals.

In answer to the puzzled looks all around, Terry went on, "If you're a *Star Trek* fan, you know that dilithium crystals are what power all of the spaceships. I don't know who came up with it, but it was the perfect quilt." Even as I laughed, I pondered whether such a pattern had a place in the quilt trail. I had expected to hear more about heirloom quilts and family farms, but *Star Trek?* I suppose that if barn quilts are a reflection of our culture, TV science fiction can have its due. After all, I had heard Donna Sue say many times that "anyone who wants to can play."

The tour of Rowan County continued with a barn that was a bit more what I expected—a tobacco barn with a classic quilt block situated at the edge of farmland. Brenda Stamm was waiting for our arrival and right away reached for a handful of brown paper cutouts, which she smoothed carefully onto her sofa cushions. The pattern, cut out of a paper bag, was Brenda's great-grandmother's quilt pattern. The pieces were in remarkably good condition for their age. Brenda recalled,

79

kentucky

"When my grandmother passed away, I found this in her cedar chest; it was a pattern cut out of a paper bag that she had folded up with a pin in it. My grandmother's mother made the quilt for my grandmother when she got married." A lot of people call the pattern the Dutch Girl, but Brenda's grandmother collected dolls, and she always called it Dutch Doll. When the committee asked to put a quilt pattern on the tobacco barn, Brenda knew immediately that she wanted the one that her grandmother called Dutch Doll.

"My grandmother would have been so proud," Brenda said. "She could have sat on her front porch and actually seen that quilt. And my grandfather would be proud, too, of the way we're keeping it up, because that was his barn—that's where his cows were, where his tobacco was."

For months, I had enjoyed seeing the variety of patterns and colors and hearing the stories behind the quilt squares, but somehow I had never been present on a painting day. I backtracked on my route to make a point of arriving in Madison County on a Tuesday, for I had been promised the opportunity to apply paint to board at last.

As I pulled up to the open warehouse behind the Madison County Extension building, I wondered, "Have they saved my spot for me?" Don Hart, a barrel-chested man in a paint-smeared T-shirt, greeted me with a wide grin, motioning toward one of the partially painted boards that was laid out on sawhorses and taped to be painted. "We were about to give up on ya," he said, but there it was—a blank triangle outlined with blue painter's tape, and a small pot of yellow paint. Introductions were made all around, and the group burst into laughter as Gracie wagged among the freshly painted boards, which were just the right height for the tip of her tail to become daubed with yellow paint.

I had wanted to paint a bit of a barn quilt just as a gesture—to be able to say that I had done so. Standing there surrounded by lighthearted banter, I was momentarily overwhelmed with the significance of that yellow triangle. The simple act of dipping the brush and carefully applying paint was almost a rite of passage; I became no longer observer but participant. As I completed the job, a childlike impulse emerged, and I felt silly because I desperately wanted someone to tell me that I had done well.

The Madison County barn quilt program had begun with Don's wife, Sarah. She had joined the homemakers club and kept hearing people talking about a new quilt project. She told them, "If you are going to do quilts, I've got someone you've got to meet." Don was already creating one-foot wooden quilt squares, so he was immediately interested in the new undertaking. Don attended the committee meetings, and before long, he became "the Quilt Guy," coordinating the barn quilt program in Madison County, which has grown to over seventy blocks.

Don also serves as an ambassador for the project. He was invited by the Kentucky Arts Council to deliver a presentation on barn quilts at the Kentucky Crafted Artists' Market in 2009. Don demonstrated the process and pulled people from the audience to add a bit of paint to the block. Each of the painters was encouraged to sign the back of the block. "There are a hundred and forty-seven signatures from six different states and from one end of Kentucky to the other!" Don declared.

Don took us for a ride across the county, stopping to see some of the highlights, but he had a destination in mind. When we drove up a rutted hill, I saw the torn and sagging remains of two barns at the top and Ronnie Tussey hard at work in the farmyard. Ronnie had painted his own quilt squares—one for each of the four barns on the family farm. The Double T pattern is made up of two sets of doubled Ts, to represent the four partners (three siblings and their parents) who own the farm. The quilt square clung to one of two barns destroyed by a tornado in May 2009. The boards of the barn were held together by the quilt square, which had visible marks but other than that was still intact.

Double T at Tussey
barn after tornado

kentucky

Other, less serious, mishaps have been part of quilting Madison County, and Don Hart relished telling the tale along the way. The excitement of a "hanging day," when a crew heads out with a bucket truck to install multiple blocks, is a big event in barn quilt circles, but things don't always go as planned. Don characterized one particular day in Madison County as a hanging day gone wrong. He recalled, "The first quilt was supposed to be dedicated to a lady who used to work for the Kentucky Arts Council. It was a surprise for her, but she surprised us by not showing up. We almost lost the bucket truck in a pond at the second hanging; we had to get a winch truck to pull it out. The truck was set up to put the next quilt on the front of the barn when the owner steamed in and said she wanted it on the side. That was OK, except that we had to remove a vent door to do that.

"By now, I was sure the foreman would never hang another quilt for us. But the next block was going on *his* barn! He looked me dead in the eye as he was striding to his truck and told me, 'There won't be any messin' around with this next barn, and we will, by golly, get this quilt hung without a hitch!' It took his crew about fifteen minutes to get the boards and nails on his barn in shape to hang the quilt, but it got done!"

Most of the barn quilts in Madison County are based on the traditional patterns that are part of the area's heritage, but the Cather's Maze barn quilt is a product of Don Hart's imagination. Don had begun working with patterns and noticing geometry in his surroundings. One night he was watching a movie—*The Omen*—on television, and in one scene, the camera looks straight down at a parquet floor. The way that the shapes came together grabbed Don's imagination, so he took a quick photo of the television screen, and the next day he set to work creating a quilt pattern that replicated the arrangement of the wood. Don said, "The really neat thing is that the barn owner, Chris Cathers, is a huge fan of horror flicks; he was more than tickled when he found out where the quilt pattern originated!" Having accepted science fiction as a cultural reference for barn quilts, I didn't blink an eye at the inclusion of scary movies.

That evening, I thought back on my childlike impulses from that morning and to an early conversation with Donna Sue, when she spoke of her joy in working with artists to develop their talents. She had been referring to professional artists, but I wondered, Does painting a quilt square allow us to reach back to the time in our lives before the world convinced us that we are not worthy of being called artists? Perhaps barn quilts create an opportunity to experience once again the childlike satisfaction not in perfection but simply in the joy of the creation.

One evening some months later, I received a photograph of a barn with tobacco hanging and a pink breast cancer quilt square. My curiosity was piqued, so I tracked down Marlene Frost, the chairperson of the committee in Washington County.

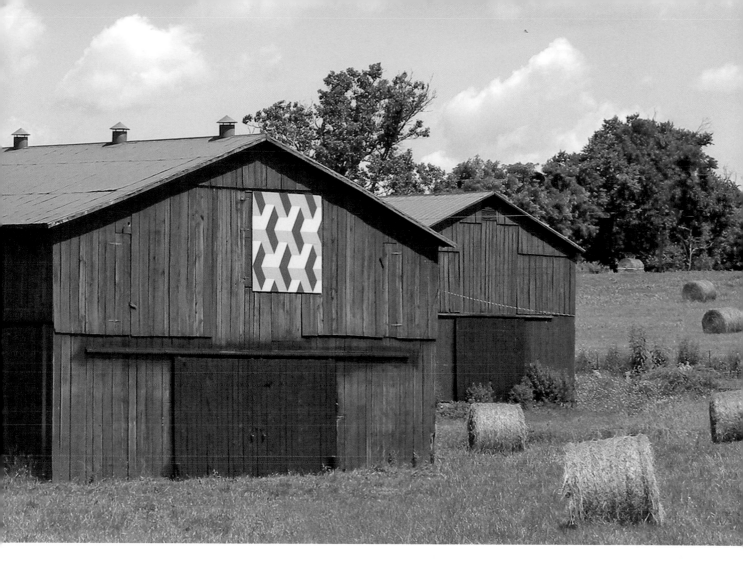

Marlene told me that when she was made head of the committee, her father was living with her, and he always loved old barns, especially the ones with signs painted on them, such as Lookout Mountain and Mail Pouch Tobacco. I was, of course, reminded of Donna Sue and her love for the same sorts of barns. Marlene said that she donated the seed money for the first barn quilt in his honor, "So that Dad has a little in each of them."

The quilt square whose photograph had caught my eye was created by the Washington County Cancer Coalition, whose mission is to educate people about breast cancer and provide the means for women without insurance to have mammograms. The group was formed in 1999, when founding member Barbara Ann Hale Wheatley was a four-year survivor of breast cancer. She was more than happy to offer her barn as the location.

Hands All Around was chosen to symbolize the spirit of community of those who have lived with breast cancer and those who have lost a loved one. The pattern

83

kentucky

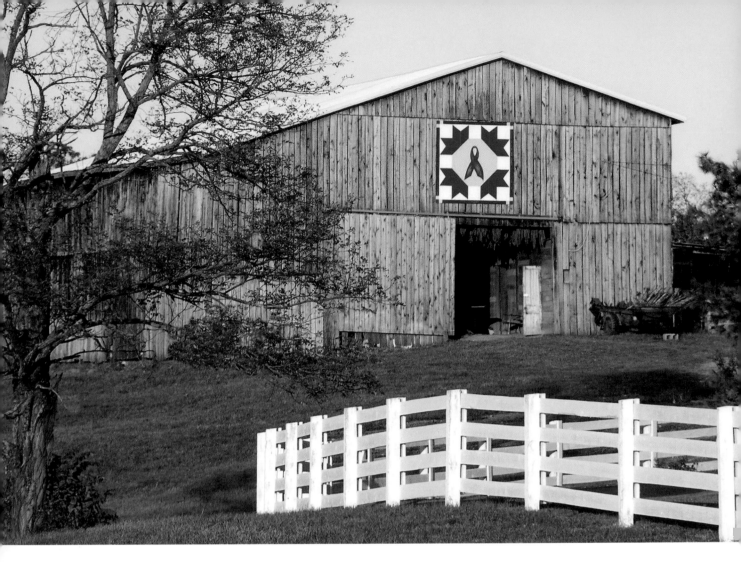

Hands All Around.
Photo by Kenny Browning

was adapted with the ribbon symbol added to the center. Coalition members helped with the painting, and before the block was hung, about seventy-five people signed their names around the outside. Many were survivors; some wrote the name of a family member.

Barbara Ann was widowed after forty-six years of marriage but recently married Benny, her childhood sweetheart, who was a widower himself. The barn quilt that sits on a hill overlooking the main road is a reminder that even after tragedy, a life filled with hope can follow.

I was led to visit Marion County by another photo—once again, Grandmother's Flower Garden. I spoke to Martha Potter, who heads the efforts in Marion. As president of the local homemakers group, Martha was excited when the local extension agent asked for help in creating a quilt trail. After completing a few squares

84

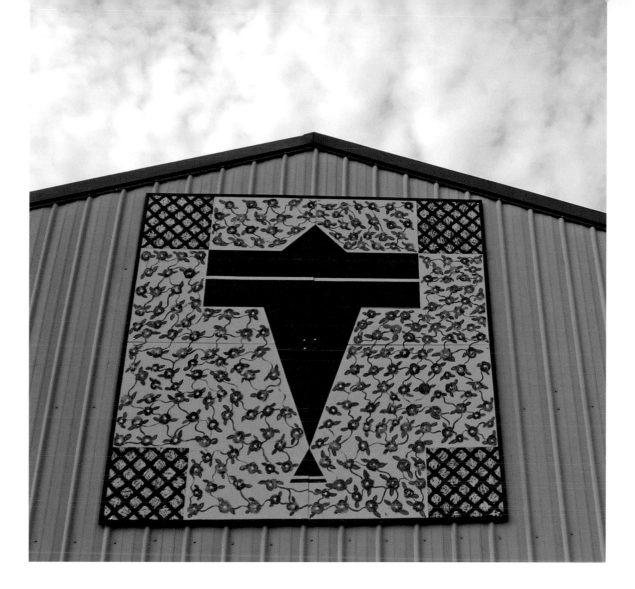

with the group, Martha found herself deriving such pleasure from her painting that she went solo and moved the operation to her home. "I have been blessed with a good husband," she said of Leonard Potter; "I couldn't do this without his help." Of course, Leonard did get one reward for his efforts. Martha told him that if she could have his barn for a quilt square, he could choose the pattern. His fondness for roosters made the choice easy, and the Potters now have a block with four roosters on their barn.

Chris Hamilton, tourism director for Lebanon, Kentucky, took me on a brief tour, which included a stop at Paul Peterson's home. The Airplane quilt block that hangs just outside the door seemed to be flying right off the building into the sky. But what grabbed my attention was the depiction of the floral fabric that surrounded the plane. I had heard many times about the patterned feed sacks that were used to make quilts, particularly during the Depression. Women would select

85

kentucky

the brand of rice, flour, or even feed for the farm based on their preference for the fabric used to make the sack. I had never seen one of the sacks, but the small buds on the quilt block gave me a better idea of what one would have looked like.

Paul traces the quilt to Dora MacFatrigge, whose aunt attended the Chicago World's Fair, saw the quilt pattern on display there, and described it to her. Dora was concerned about her son, who was in World War I, and creating quilts was a way to pass the time and ease her anxiety. "She was always waiting for the next call, hoping it wouldn't be the Red Cross," Paul told us. Dora completed the blocks, but they were laid aside until some sixty years later, when Dora's daughter, Virginia, found the blocks and asked her niece, Paul and Martha's mother, Mary Ann Peterson, to finish the quilt. Paul's sister, Martha Peterson Arterburn, added her own finishing touch to the quilt by stitching the history of the quilt inside the center block with each of the women's names who helped to create it in tiny black letters.

The story of five generations of women involved with producing a single quilt was incredible. But what I loved most about the painted quilt square was the fabric that gave a homespun appearance to what would otherwise have been simply an airplane lifting upward.

The barn quilt that had compelled me to visit Marion County was painted by Nancy Miles and hangs on her brother Danny Fenwick's barn. A family reunion was held in November 2008, and the group painted a barn quilt in honor of Nancy's mother and sister and aunt, quilters who had all passed away. Forty family members were present, including Nancy's sisters from Arkansas and Texas, and each helped paint some part of the Grandmother's Flower Garden block.

The pattern was Nancy's grandmother's and mother's favorite pattern. I was incredulous at Nancy's final remark: "Mama used to tell about Granny sewing up a quilt and then taking it back apart and doing it again—just to have something to do for entertainment." Having hand pieced dozens of those hexagons myself, I shuddered at the thought.

Nancy had always wanted to create her own fabrics, and she got the chance when the Sisters of Loretto in Nernix, Kentucky, asked to have a quilt square painted on their Motherhouse—the central building for the convent. The Sisters bicentennial was to be celebrated in 2012, and the quilt painting was an initial step in preparing for the occasion. The Log Cabin pattern was chosen to represent the structure in which they started their religious order.

Nancy researched fabrics of the nineteenth century and went to work using paint to reproduce fabric from that time. She used spools of thread, pencil erasers, and other household items to design the fabrics. One block was a kind of mauve, and Nancy couldn't figure out what she wanted to do with it, but it ended up being the most meaningful. During an ice storm, the family had no electricity for nine days, so Nancy had to paint by candlelight. It really gave her a sense of what life was like back then.

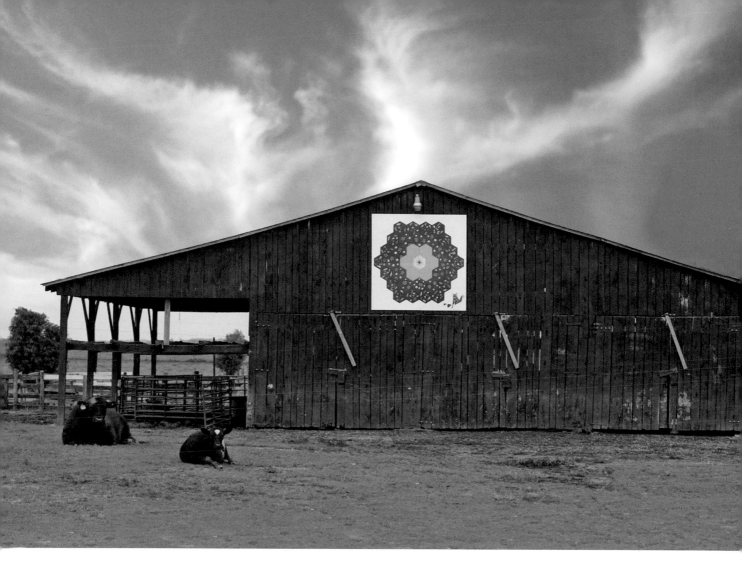

Many years ago, Nancy's sister had worked at the Motherhouse, and the nuns helped the family by sending food and clothing home for them. A family of fifteen needed all the help they could get. Nancy said, "Here it is fifty years later and I feel I am repaying them a little for the clothing they gave us, by painting the barn quilt for their barn. I do hope it gives the barn the impression of warmth that the clothes gave us many years ago. It is such an honor to have painted that block for them."

Tourism director Chris Hamilton explained that the barn quilts add a lot of enjoyment for those who visit the area: "It's like a drive-in museum. What could be better?"

The twenty-two barns of the Kentucky Quilt Line are stretched across a seven-county area in western Kentucky, but each county is small enough that a few hours' leisurely drive is enough to view all of the blocks. This was the trail I had

Grandmother's Flower Garden, Fenwick barn. *Photo by Kenny Browning*

87

kentucky

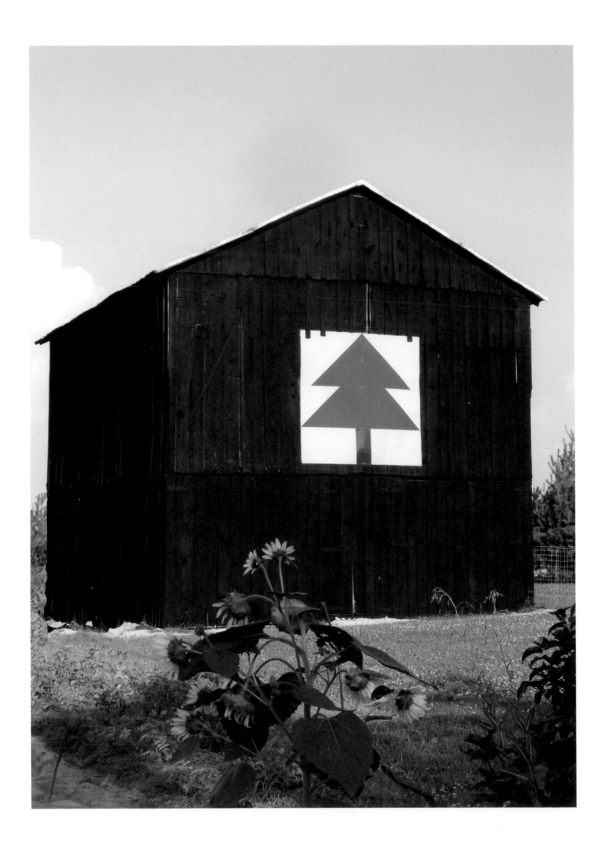

stumbled upon the previous summer that had set everything into motion. The last day of the journey had taken us through Meade, Breckinridge, and Grayson Counties, and we were about an hour away from my first barn quilt. A pilgrimage of sorts ensued, and I found Belenda Holland out back of her house, just a few yards from where we had met a year earlier. I had so much to tell her, and though I meant for the visit to be brief, it took a couple of hours for me to tell Belenda my story and to gather the details of hers.

The Kentucky barn that Belenda's grandfather once used to dry tobacco has been restored and is home to two quilt squares. "I want to preserve the farm and keep it in the family for as long as possible," said Belenda. As part of that effort, in 2003, the Hollands planted more than 29,000 hardwood trees. A few years later, a tree-patterned quilt block was hung on the side of the barn, where Belenda sees it when she pulls into the drive. "I am reminded daily," she said, "of all of the hard work we did to preserve our land and how proud I was when we finished."

Belenda's husband, Tony, was once an avid hunter and was known throughout the county as such. The Flying Geese quilt square on the reverse side of the barn might be assumed to be a trophy of sorts. What many don't realize is that Tony has progressed from goose hunter to waterfowl protector. The shallow water ponds that he has built on the property are a safe haven for flocks of geese as they migrate. Some men might want his neighbors to know about such efforts to protect wildlife, but the perennial country ham champion of Trigg County doesn't let on that he has a developed a soft spot for birds.

The farms of Kentucky continue to join the quilt trail; with over eight hundred quilt blocks on the map, almost exclusively on barns, the state has more barn quilts than any other. Often I see a news item about a new quilt block dedication in Kentucky where there is no organized trail, and I have to wonder what the actual number might be.

Opposite:
Pine Tree, Holland barn

kentucky

north carolina

M Y FIRST FORAY into the world of barn quilts had been in Burnsville, North Carolina, but the stay had been brief. I had initially visited to witness the installation of the one hundredth quilt block, but I had to make several return trips to the area to gather some of the more interesting stories of the first ninety-nine.

The brilliantly colored Starlight quilt block is tucked away above a valley east of Burnsville, but it was easy to spot against the stark grays of February. From her home overlooking the scene, Barbara McKinney shared memories of growing up on the family farm: "I remember lying on Grandmother's bed for afternoon naps, and instead of sleeping I would examine the quilt squares to pick out my favorite piece of fabric or color in each square." Barbara's great-grandfather was deeded the farm in 1899. In the 1940s and '50s, when Barbara was a child, she remembers that most of the original buildings were still in use. Barbara told me that the farm had a large smokehouse, a root cellar, a pigpen, a chicken house, a washhouse, a springhouse with running cold mountain water, a woodshed, and a barn. "I'm still amazed at the self-sufficiency of those small family farms," she said.

Most of all, Barbara remembers her grandmother's porch, only a few yards away from her parents' house. "I would lie for hours on the porch floorboards, still warm from the afternoon sun, and watch the stars twinkle. Bigger and brighter, the Evening Star would appear about dusk, and then later I could spot the Little

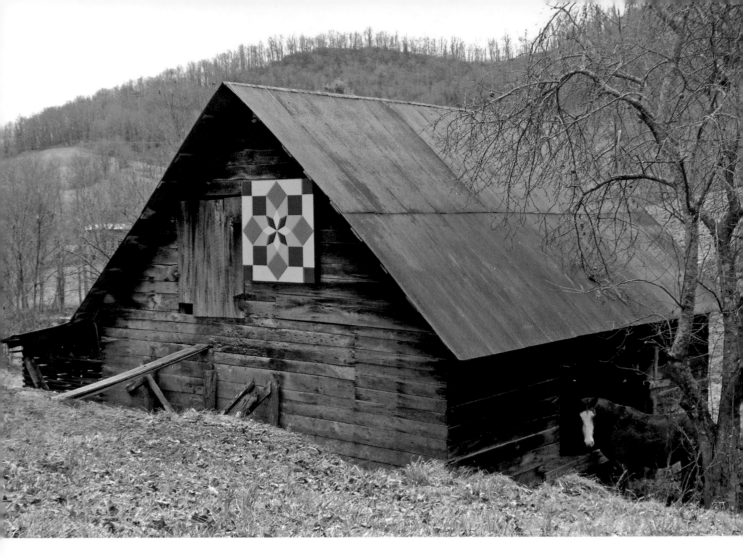

Dipper and the Big Dipper and the Milky Way, and I would try to count as many stars as possible."

In 1975, Barbara and her husband, Sam, built a home on the farm a bit farther up the mountain. "At a little higher vantage point now, I appreciate the stars even more, I believe, than I did as a child. In the evenings when we sit on the porch or when we come up the driveway on a clear night and I get out of the car and look up, the stars seem almost close enough to touch. The land carries so many memories from so many generations; the stars are testaments in a midnight sky, so Sam and I chose Starlight as our quilt square to grace our barn, the only structure remaining of the original 1800s farm."

Barbara's story resonated with some that I had heard in Ohio: quilt squares honored long-established family ties to the land and secured memories for those who would follow. Still, the connection to quilters and quilting that Donna Sue had hoped for seemed missing. Later that same day, Becky Gillespie's story—earlier touted as "the best quilt block story ever"—filled the gap.

92

barn quilts and the american quilt trail movement

In January 2001, a call came from the newspaper in Asheville, asking Becky to come in for an interview. Becky was quite taken aback when the reporter told her that Billy Graham had purchased one of her quilts and had presented it to the pope. Becky had owned a fabric shop in Burnsville for about fifteen years and worked with local quilters to create quilts to sell. Becky furnished the women with the material and then paid them for their labor. Some of the quilts were sold in the gift shop at the Presbyterian Assembly at Montreat, with the proceeds going to Presbyterian mission projects. Becky called the shop and learned that Mrs. Graham had purchased an Ohio Star quilt. Becky had sold the quilt to them about two years earlier, and she knew that Chloe Ramsey and her daughter Glenda had made it.

Becky and the two quilters made the trip to Asheville, and the next morning a color photo of Billy Graham, the pope, and the Ohio Star quilt filled the front page of the newspaper. Becky told me, "That is my claim to fame. The only thing to come between Billy Graham and the pope is that quilt. When I was in Rome and in the Vatican and saw all those amazing gifts of gold, bronze, glass, silver, and porcelain that had been presented to popes through the years—to know that Billy Graham had presented him with such an humble gift said a lot for Billy Graham and a lot for the pope, too. It heightened my respect for Billy Graham that he would choose a gift made in the area. I have always hoped that it was passed on to a homeless shelter or orphanage so that it could do somebody some good."

When the quilt trail project began, Becky made arrangements to have a replica of the Ohio Star quilt block hung on Chloe Ramsey's home in the Beelog community to commemorate the quilt Chloe had created that had come to mean so much. When asked what she thought of the pope's having a piece of her handiwork, Chloe replied, "You never know; maybe he uses it to keep his feet warm."

On each return trip to Burnsville, I discovered new painted quilt blocks and the stories behind them, but because quilt squares were continually being added to the trail, choosing which ones to visit became a daunting task. By 2009, the Mitchell/Yancey Quilt Trail had been divided into nine separate driving routes, approaching 150 squares. Sometimes just grabbing a map and heading out with no premade appointments—taking in the trail itself as well as searching out the quilt squares—seemed a more promising method of discovery.

A somewhat secluded trail leads through twists and turns and winds through country roads, past creeks and waterfalls, rustic cabins, and even an emerald mine before winding up to the Celo community along the Blue Ridge Parkway. Locating the quilt squares along this path was a bit tricky, but many of them mark a spot worth visiting for something other than the quilt square itself. Four pottery studios each have a block, and most are nature-themed to fit the environment, with names such as Butterfly Bush, Streams and Mountains, and Harvest Sun. One of the most serene spots in Celo was also one of the most difficult to locate. At

93

Mountain Farm, blueberries grow and the small herd of goats produces milk for fresh cheese and handcrafted soap. A seat on one of the hand-carved benches out front provided a soothing breath of the lavender used in making oils and artisanal spa products and afforded a close look at the small barn nearby. There, the herb's signature color and the farm's dragonfly logo form the basis of a quilt block that seemed to evoke the movement of delicate wings.

The expertise involved in painting many of the unique quilt squares of the Mitchell and Yancey County trail can be credited to Deborah Palmer. "I saw that first quilt block at Price's Creek on Highway 19," Deborah recalled. "That quilt block captured my attention and then the project captured my heart." Deborah, who served as "paint captain" for two years—coordinating times, paint, and painters—loves quilts and appreciated the chance to participate in this type of "quilting," though she doesn't sew: "The idea that I could give back in such a personally satisfying way—it doesn't get any better than that."

Deborah is proud of the contribution that the project has made to the community but also recognizes the personal benefits. She spoke of a gentleman who volunteered with the group who found out that his daughter had relapsed with cancer and had four weeks to live. He still came to paint from time to time; it was a place where he could go to deal with the pain associated with his daughter's condition. After his daughter passed away, he came to paint to calm himself. "We all have our challenges and things to deal with," Deborah said. "It's definitely a medium for that, and it's a privilege to be part of the process."

Barbara Webster agrees that quilt trails add meaning to people's lives: "Everything about quilts is metaphorical. To draw on that is meaningful to people. Whether they realize it or not, there is a depth to the project. The more blocks that go up, the bigger our quilt gets, the more we are tied together. Real quilts were made out of dresses, tea towels, shirts—history was embedded in each and every one; and that is what we are doing—making our quilt."

The quilt that covers western North Carolina extends along the roads that lead toward the mountains and the well-known ski slopes for which the area is known. The drive into Avery County beneath a thick tree canopy seemed almost ominous; had there been any turns, I would have been convinced that I had chosen incorrectly. Finally the road burst onto Highway 31 and daylight. The elevation gradually rose, but the first barn quilt—with the unlikely name of Spizorinktum —was not at the spot indicated on the map provided by the Avery County Arts Council. There were forty others to see, so one missed could certainly be shrugged off for another time. As the road curved left and topped a hill, a vivid yellow and orange square filled the horizon. Spizorinktum was misplaced on the map but could not be overlooked. The same awe that had overtaken me on seeing my first

quilt square compelled me to stop, to brave the electrified fence to study the square
from every possible angle, and to feel compelled to know its story.

The barn's owner, Carter Wiseman, recalled his grandmother saying, "Carter,
eat your greens; they're good for your spizorinktum." "I was ten years old," he
chuckled; "I didn't even know I had a spizorinktum, much less what one was."
After being scolded many times for using up his grandmother's spizorinktum,
Carter began to realize that the word meant "energy." Some fifty years later, that
energy would manifest itself in the stunning barn painting.

Carter wanted a unique pattern to highlight the barn that had been in his
family for generations, so he commissioned folk artist Heidi Fisher to design and
paint the barn quilt.

Heidi was excited about creating the mural, and because Carter had no family
pattern, she spent two weeks creating an original. She then faced working with a
larger size made up of nine sections. Heidi explained, "It was a challenge; I had to
make sure they all met—like a quilter does. I can't sew a stitch, though."

barn quilts and the american quilt trail movement

The name Spizorinktum came to Heidi after the quilt square was created. The large size and bright, bold colors seem to emanate energy, so the name fit. Heidi has gone on to create quilts for other individuals and to have her work displayed in the Avery County Arts Council's gallery. "I appreciate tradition," Heidi said, "but I'd rather try something new. I hope that someone will see one of them or purchase one of them and make it their family pattern, and this piece of folk art will be passed down from generation to generation. That would be the greatest thing."

I made my way up to Banner Elk and found the tiny stone building that houses the Avery County Arts Council. Director LouAnn Morehouse had been kind enough to open the office on a chilly Sunday, and prospective barn quilt owner Voreta Caraway had taken the opportunity to visit. Voreta wanted floral patterns to hang on each end of her barn as a surprise for her daughter, who was serving in Iraq and missed her rose gardens. I was glad to be on hand to witness the selection process. LouAnn used BlockBase computer software to display dozens of geometrically designed flowers from which to choose. One by one the blocks were rejected, until only two remained. LouAnn went on to patiently create color combinations from a seemingly endless array of shades of red and pink on the screen until Voreta deemed her selections "perfect!"

As the soon-to-be barn quilt owner left, LouAnn commented, "The quilts are just fascinating—they speak to people." As one of those people who listen, I headed out into the autumn countryside.

Among the first in Avery County to hear the call of the barn quilts were Odell and Jean Sluder. Jean had seen several quilt squares on a tour in Tennessee and knew that she wanted one, so when the couple saw the advertisement for barn owners to place quilt blocks on their property, they were the first to sign up. The barn quilt committee was still organizing, so Odell set to work himself, choosing a traditional family pattern.

Odell's grandmother, Toby Sluder, used the pattern she called Battleship in quilts for her grandchildren, and when it came time for her daughter, Comeylee, to send her son Odell off to college, she did the same. Odell still has one of his mother's quilts, which has a ship in each square with all of the flags flying toward the east. In one square, it looked as if Comeylee had made a mistake, as the wind seems to be blowing the sails in the opposite direction on one ship. Odell later saw one of his grandmother's quilts that a cousin had. She, too, had turned one of the ships backward. As Odell later discovered, it was common practice for a quilter to sign her work by including a square with a "mistake" in it, especially when creating an often-used pattern.

The Battleship square is an unusual six-by-six—a perfect fit for the space on the barn. Once he had finished, Odell had a four-by-four-foot piece of board left over, so the Carpenter's Wheel quilt block that adorns the opposite end of the barn was created to honor his father, the carpenter with whom Odell had built the

97

barn in 1950. A photo in the Avery County Quilt Trail brochure of Odell and Jean smiling in front of their barn while holding the cloth quilt made the farm worth a visit, and the moment was rewarding even on a gloomy day.

As I left the Sluder farm, the quilt trail map once again led into an area that didn't resemble farmland, but just when I became convinced that the steep hills and switchback curves simply couldn't be home to a barn, an eight-foot painted blue flower rose to eye level and proved me wrong. A couple of snapping barnyard dogs let me know that I was not welcome at the vacant property, but I spoke to Judy Hunter a few days later.

Although not a quilter, Judy had always loved quilts, so she eagerly became an early participant in Avery County's project. Picking out the pattern was difficult, though. The horses that occupy the farm didn't lead to much of anything, and trees—chosen because Judy's husband, Tony, has a tree service—just didn't have the "Wow" that the plain gray barn needed. Finally, Judy thought about flowers, to reflect her love of gardening.

Judy had been a biology teacher and had spent time out west at the LBJ ranch one May. She recalled, "I had never seen wildflowers like that in my life! A sea of bluebonnets, a blanket of flowers as far as the eye could see." The week Judy was looking at barn quilt patterns, Lady Bird Johnson died, and there was a picture of her in the paper with a hat on sitting in a field of those flowers. Judy immediately said, "This is it!"

"The quilt also incorporates the Blue Ridge Mountains," she explained. "It reminds me of that receding blue that gave them their name—where they reach the sky and reflect that blue. The pattern represents three things—the local area, what I love to do, and wonderful memories of Lady Bird, who did so much for conservation."

The sky had become cloudless and turned the almost impossibly brilliant shade admired by Judy Hunter and known by natives of the area as "Carolina Blue." On a return stop at the Wiseman farm to view Spizorinktum once more against the rich background, the quilt square appeared almost three-dimensional, providing an unforgettable ending for the day's journey.

On later trips to visit the quilt trails higher in the Blue Ridge, the sight of that singular quilt square was much anticipated and always compelled me to stop. A few minutes in front of that barn—whether at the edge of the fence or in the middle of the pasture among the cows—always provided the energy needed as I faced the long drive along miles of twisting mountain roads that lay ahead.

Opposite:
Texas Bluebonnet,
Hunter barn. *Photo by*
Judy Robinson Hunter

I had visited Mitchell, Yancey, and Avery Counties, where most of the North Carolina barn quilts are located, several times. Because the Mitchell/Yancey project has been so successful, many folks believe that it was the first in the state, but

organizer Barbara Webster had made it clear that the trail had migrated to her area by way of Madison County—just to the west. I certainly had to make just one more trip.

I had made some appointments using the map provided by the Madison Arts Council and set out to discover new territory. Ponder Cove was easy to locate not too far off the main highway. I knew that I was going to like the place before I arrived; after all, what could be better than a dog-friendly bed and breakfast? Gracie wasn't along on this trip, but as I drove up the curve through the wooded property, I envisioned her romping along, happily treeing wayward squirrels.

Martha Abraham isn't a native to the area, but a lot of transplants have moved to the foothills of the Blue Ridge, so I wasn't all that surprised. Martha had worked in the fashion business in New York and California. She was ready for a change of pace and had definite ideas in mind—a place where city people who needed a respite could come and have their blood pressure go down immediately, with plenty of land and trees and a sense of calm about it. As soon as she drove down Ponder Creek Road and saw the property—ninety-two acres and the house tucked away in the hollow—she said, "This is it!"

Ponder Cove Bed and Breakfast had to be the type of getaway that Martha herself would want to visit. She had two dogs that she took everywhere and had been known to sneak them into places. She said, "It would be hypocritical for me not to let people bring their dogs!" Her statement, and the fact that a painting by one of my favorite folk artists hung just inside the doorway, let me know that we were kindred spirits. She had done what I would love to do—gotten away from it all, on her own terms.

Martha's roots are in the Ozark Mountains, but she feels very much at home in the foothills of the Blue Ridge: "Mountain folk are mountain folk and mountain craft is mountain craft. I look out at that barn quilt and am reminded of my grandmother, who quilted until she was almost eighty." Martha collects quilts, so when the opportunity came to add another to the collection, she agreed without hesitation. The artfully crafted square—whose unique pattern has no name—greets guests as they pull into the driveway eager to draw that first refreshing breath.

Ponder Cove is in a well-traveled corner of Madison County, but the vast majority of the county is very rural, easily navigable by long-term residents but a bit unsettling for the rest of us. I drove through the town of Mars Hill and the campus of the college with the same name and found myself on true country mountain roads, with few street signs. My GPS became confused, so I was forced to employ good old map navigation—unlike my forays along the well-marked roads that led to the ski resorts in the hills to the east. My first stop looked fairly close as the crow flies, but the hills that took me up and down and wound through

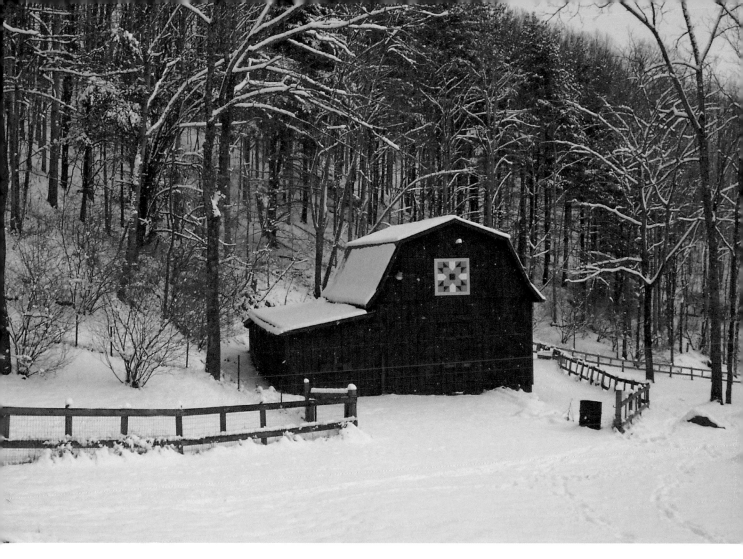

the woods were not apparent on the map. By the time I reached the Hanson farm, I thought for sure I must be in Tennessee. I later found out that I was actually pretty close.

Judie Hanson had moved to North Carolina with her husband, Tom, to get away from city life, and she designed one of Madison's most interesting paintings. Judie combined two familiar patterns in her block—the simple Nine Patch that she learned as a beginning quilter, and Snowball, which represents the cold winters of her former home in Chicago. The Hansons found the simple life they sought on their Madison County farm with the cattle, hay, and cashmere goats, but Judy laughed when she admitted that the quilt block has taken on a different meaning: "Farm work just kind of snowballs!"

I left the Hansons, traveled down to flat land, and was headed to the Revere–Rice Cove Community Center. I knew by now that the map wasn't drawn to scale, but when what looked like a mile or two turned into ten, I thought I had missed a

Ponder Cove Bed and Breakfast. *Photo by Gary Rawlins*

101

north carolina

turn for sure. This time, old-fashioned country helpfulness would have to do. A farmer on his tractor said the turn off was "just a ways" more. Six miles farther, a young man carrying a basket of what looked to be winter squash said that it was just past the church around the curve. He didn't specify which curve; it was another few miles. Once again, the road headed straight up. It was nearing dark, and after all of that effort, the gate to the center was locked. I decided to head home and try again. The next time, I took a different approach.

A couple of weeks later, Madison County Arts Council members Pat Franklin and Betty Hurst met me at a coffee shop in Marshall, a small town past Mars Hill that sits on the French Broad River. Zuma coffee shop was buzzing with business and filled with hearty hellos and hugs—a center of small-town activity, unlike similar establishments in Atlanta, where anonymity is part of the appeal.

Over lunch, Betty filled me in on the North Carolina trail's beginnings. She had seen the growing quilt trail during a 2005 trip to Tennessee. Her friend Candace Barbee, whose name I was familiar with by now, had shared the story of Donna Sue's concept and the enthusiastic reception that the quilt trail had received so far. Betty was excited by the potential for rural Madison County, and local arts council president Ann Rawson agreed, calling the project "a fabulous way to not only tell the story of quilts but also to give that special touch to extremely rural counties that people wouldn't necessarily see."

Betty, Pat, and I headed out, with Pat driving her four-door sedan and petite Betty in the backseat. Clearly, the two had spent a lot of time together, as their running jokes began right away and continued throughout the drive. This was much more fun than my last solo trip. Pat's laughing didn't stop her from navigating the twisting roads quickly and with practiced skill as Betty slid back and forth and told me a bit more.

The community had already received financial support from the North Carolina Arts Council, but the grant required that they secure funding from outside sources as well. Handmade in America, an organization that coordinates arts-based economic development in the state, contributed additional monies through the Blue Ridge National Heritage Area, so the matching funds were quickly in place. Betty is pleased to have been one of the founders of the quilt trail that inspired so many others in the state. She proudly exclaimed, "Everybody wanted to do it once they saw it here!"

The first quilt blocks in Madison County were placed in prominent locations where they could readily be seen, but Pat Franklin wanted to spread the project into more remote parts of the county. She painted eight of the ten quilt squares that were installed in 2006. Pat is the first to admit that she is not an artist, but she can paint any block with straight lines. "I paint what I can draw," she said, while rounding a sharp curve.

We stopped to see a few small painted blocks along the way, gradually venturing into mostly unpopulated territory, until we wound up at Jackie Ball's riding stables. There, a quilt square hangs on the end of the horse barn, visible when pulling into the drive. Jackie greeted us with an affable grin, posed for photos next to his barn quilt, and said that it was quite a conversation piece for his customers. The juxtaposition of the artwork with the horses' heads peering out along the side of the barn was quite the image indeed.

The chilly day was getting late, and I was a three-hour drive from home, but I was told that I had to see the horses. Wait—I had just seen horses. It was fine, I assured the women; I had seen plenty. "No," the two exclaimed, in near unison. "You have to see the horses!" Pat insisted. I was pretty sure that any protests on my part would have been ignored. There was just one small problem. Pat had not painted this particular quilt square and had visited the farm only a couple of times. She thought she had a pretty clear idea of where it was once she turned down a certain road. We passed an intersection, but there was no sign. Apparently, stealing road signs is either a prank or a way to make a few bucks; either way, we spent about half an hour—"No, it's before the church." "This is too far; I think you need to turn around." "I'm sure this is it."

About the time that the two resolute women were beginning to waver, we pulled into a narrow drive and were soon facing a small rounded barn with four shockingly neon horses unlike any quilt square I had seen or have encountered since. "Told you—you had to see it," Pat said, with satisfaction.

Andy Bennett shouted a greeting from the barn's loft but thought it best that I speak to his wife, Cathy, who was not at home. We stayed just a few minutes, and I promised to contact Cathy, as this was one story I had to know. When we spoke, Cathy described how eager to participate she and Andy had been when the barn quilt program began. Cathy does some quilting but didn't have an attachment to any pattern that would be a meaningful addition to the farm. Then she thought of the draft horses.

The Bennetts try to use horses for all aspects of their farming. They raise vegetables and sorghum, to make syrup, and Andy uses the horses for logging. "We try to do everything as sustainably as possible," Cathy explained. "The horses are a big part of the way we farm, and we feel like it's a good, sensible way to do what we are doing." Because the horses are the foundation of the farm, making them the focus of the barn quilt seemed only natural.

Artist Lois Simbach had been itching to create a barn quilt, and when she discovered that her friends were about to design one, she was delighted to have a chance to spend time on the Bennetts' farm. Lois said, "I don't do 'normal' art; it's got to be over the edge, or I'm not interested. We started off saying 'Let's do horses!' and it went from there."

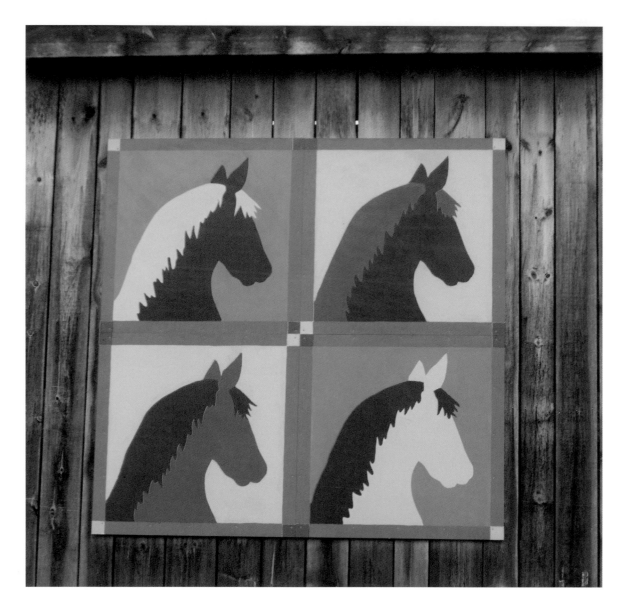

Horses at the Bennett farm

The three friends enjoyed the camaraderie of creating a joint design and discovering how their talents meshed. Cathy described the process as "a great combination between Lois's energy and our wanting it to have some sort of geometry to it—to suggest a quilt. It evolved into a style that was the combination of all of our artistic tastes."

Both Lois and Cathy characterize the barn quilt as having a bit of an "Andy Warhol style," which was exactly my impression. This would be the only time I would associate such an artist—or any artist—with a painted quilt. I hope that the road signs have been replaced so that the Bennetts' pop art treasure will be easier to find for other travelers.

104

I couldn't resist: I had traced the Madison County project to Candace Barbee and then to Donna Sue—two degrees of separation. But I wanted to record the location of the first one in the state. This time there was no contest between rival groups; it was just that no one had thought the occasion worth recording and no one seemed to recall. The issue should be easily enough solved, I thought. I would just speak to the arts council and have them look into their files. Trouble was, the arts council had been through several changes in personnel, and no one there seemed to have been involved with the project.

After many phone calls, I was invited to return to Madison and look through the file cabinet marked "barn quilts" myself. The file drawer was packed with documents, not really organized into folders, but within the first few minutes, I unearthed a handmade invitation to the installation of North Carolina's first barn quilt, painted by artist Lisa Mandle.

I tracked down Lisa, who talked about her delight in being able to use her artistic talents to create a one-of-a-kind painting for her community. Using the Electric Quilt software, she went to work, creating what she calls "a fun composition, playing off of a star pattern with a kind of pop art feel." Lisa's parents and in-laws did most of the painting, and the finished quilt was hung on the side of the Zuma Too restaurant in downtown Marshall.

The unusual design of the Zuma Too quilt made it a great source of pride for the Madison County Arts Council and the rest of the community, but when the restaurant changed hands, the value of the quilt painting was not apparent to the new owners. The artfully created square was covered with white paint and used as a sign announcing the establishment's upcoming opening! A painstaking restoration returned the painting to its former beauty, and it was remounted on the arts council building in Marshall.

During the last few years, western North Carolina has become a maze of quilt trails, and with twenty-plus states to cover, some sections have yet to make it to my itinerary. But a couple of unique projects in out-of-the-way places caught my interest. One of those was at a very unlikely location—the Upper Mountain Research Station in Ashe County. Director Les Miller explained that the agricultural research station is at the highest elevation of any in the state, so a lot of the research is focused on cold tolerance. There is a small vineyard with grapes that can be grown above three thousand feet, along with blueberries, strawberries, raspberries, and blackberries. Les said, "Our mission is to look at viable and sustainable agriculture. How can we grow it—can it be a cash crop for someone? We make the mistakes and let someone else do it the right way."

Quilts had already become important to the research station prior to the barn quilt project. The station had a multipurpose building where a "tobacco field day"

was to be held for a large number of visitors to come in to learn more about the station's work with that crop. Something was needed to muffle the inevitable echoes of so many voices, so an ingenious method of sound insulation was employed—about a dozen quilts were hung. I thought the idea mighty inventive but had to cringe when Les mentioned that some of the quilts dated back to the early 1900s. Then again, those quilts were meant to be used, and they were certainly helping the community.

When Les was approached by the Ashe County Arts Council, he was really excited: "We had quilts inside from time to time but now would have them all the time!" The location of the barn at the eastern corner of the county helped create a new direction for the driving trail, and its visibility facing Highway 88 is perfect. Corn and Beans was chosen to represent the ties to agriculture, and the square was painted by local students. Almost as soon as the first one had been installed, Les and his staff began looking for others that would be appropriate for the station.

The second one is the Farmer's Hex, to promote crop growth. According to Les, "It wards off bad spirits, you know! This has been a great group project for our staff, and it gives us another avenue for the research station to be out there for people to see. We want more farmers to come on field days and work with the cooperative extension to see what can be viable."

I was excited by the project sponsored by the Hiddenite Center, in Alexander County east of Asheville, for two reasons—the impetus behind the trail and the unusual method by which the quilt squares are created. The folk and cultural arts museum cherishes the area's quilting heritage and has continually conducted quilt documentations. Dwaine Coley, the center's director, thought that the barn quilt project would be a great way to connect the quilt back to its rural roots, taking the quilt back to the farm to create reconnection to the community.

A grant from the North Carolina Arts Council provided funds to create eight barn quilts. In the fall of 2009, the center displayed fifty quilts chosen from among the hundreds that had been documented from across the state. A "viewers' choice" vote narrowed the field to a dozen favorites, from which a committee selected eight that provided the best variety of quilters and quilting styles.

Each of the quilt squares is accompanied by a roadside sign that indicates the name of the quilt and its maker and provides some information about the barn on which it hangs. The quilts either were made in the immediate area or were part of a local collection. The Stepping Stones quilt block now hangs at the Linney farm, where the original cloth quilt was made by Elsie Clark Linney about 1915. The dark red of the quilt matches the red of the barn, as if the two were destined to be reconnected. The Flowering Vine pattern at the King barn depicts a nineteenth-

Flowering Vine, King barn. *Photo by Hiddenite Center, Inc.*

century quilt made with natural dyes and also draws visitors to a farm that began as a land grant and has been in the same family for over two hundred years.

Dwaine is thrilled with the quality of the quilts and the positive reception they have received but admits to one drawback to the unusual construction: "The quilts look real, which is a bit scary in that our public thinks that we are hanging real quilts outdoors." Because the photographic process shows even the tiniest stitches, the quilts do look remarkably like fabric, requiring a bit more time to view and appreciate than the painted versions. I had mixed feelings; I love the process involved in painting quilt blocks, but being able to see the quilters' artistry was incredibly rewarding.

Half a dozen quilt trails have appeared throughout the mountains of North Carolina during the last couple of years. I haven't been able to see them all and to learn their stories, but I am not at all sorry for the excuse to return to the Blue Ridge in the near future.

107

north carolina

ohio

I HAD BEGUN MY exploration of Ohio's quilt trails at its beginnings—in Adams and Brown Counties. On the way out of the state, a special event made a stop in Gallia County a priority. When Donna Sue went to Gallia County a couple of years earlier to talk about the quilt trail, Roy McGinnis and Gale Leslie of the Bob Evans Farm and Heritage Museum were also taken with the story of Maxine's quilting. They visited Maxine in 2007, and when they saw the extent of her work, they decided to mount a one-woman exhibition the following year. Gale curated the exhibit, which was in place from April to December 2008 and filled five rooms of the museum's farmhouse with Maxine's art.

Maxine recalled, "There were literally thousands of people who came through, and nearly everyone had a quilt story of some sort. Some were more interested in one than another and would say, 'My mother made a quilt like this one,' or 'My grandmother did.' There were all sorts of questions. It was a lifetime experience for me and one that I had never hoped to have.

"One of the most interesting things for me was that I was surprised at the extent of my work. I also crochet and embroider, and I just didn't realize that I had done that much in my lifetime."

Donna Sue said, "To see her so happy and to be celebrated—that was awesome. I did realize how talented she was, but to see it all together took my breath away. It was also the dedication of their two quilt squares, so combining Mother's

artist exhibit and the opening of the quilt trail was magnificent. Friends and colleagues came from all over Ohio and West Virginia, and that was very exciting for both me and Mother."

The two quilt squares were painted by Rio Grande University students and added to the dairy barn on the property to mark the occasion. One of the blocks combines the map of the county with an Ohio Star block and a fleur-de-lis emblem, to create a logo for the county's quilt trail. The other is Central Star, a Welsh pattern that acknowledges the settlers who came to the area from Wales.

I didn't have time to savor Maxine's exhibition for as long as I would have liked; in my single-minded focus on barn quilts, I had set aside only half an hour to view the work of a lifetime. It was late in the afternoon when I set off for my next destination. The Fellure barn is a long and narrow gray structure that sits so close to busy Route 7 that I passed right by. I neared a huge power plant and figured I had gone too far, and on my return I located the barn easily. By the time I had my car precariously tucked away, out of traffic and out of sight, John and Wanda Fellure had come out to speak to me about the red, white, and blue Texas Broken Star that faces the road. The patriotic quilt square is surrounded by smaller red and blue stars, and a plaque below the square lists the name, dedication date, and inscription: "In Memory of Wanda V. Waugh." "That was my mother," Wanda said with a catch in her voice. "This was one of the quilts that she quilted in high school, and she was always so proud of it."

I headed toward Lincoln Pike, where before too long I encountered a massive red barn whose entire end was painted with the words, "Niday Farm Centennial 1904–2004." After greeting me at the farmhouse door, Mary Niday escorted me to the side of the barn, where the quilt block is painted directly on the barn's sliding doors. I was impressed with the artistry, which included tiny calico flowers in the red, white, and blue design and smaller quilt squares surrounding the quilt block.

Mary and I looked through album upon album of photos of barns and family, and she eventually shared the humorous story behind her quilt square. Rather than creating a quilt block based on her earlier sewing, Mary did quite the opposite. Mary had made a batch of quilt blocks back in 1976 for the country's bicentennial, each a different pattern in patriotic colors. She wanted to make a sampler quilt instead of just one repeated block. Her intentions were good, but the individual blocks ended up in the attic, where they remained until the Nidays heard about the quilt barns.

Mary wanted their barn to be one of the first, and she thought she might choose from one of the patterns that had been put aside. When the blocks came down from the attic, Mary chose the Century of Progress right away to reflect the farm's recent centennial celebration, but then she felt silly. "After all," Mary said, "the square was supposed to represent a quilt, and I had only the pieces. So I got inspired to make the quilt that I had started so many years earlier."

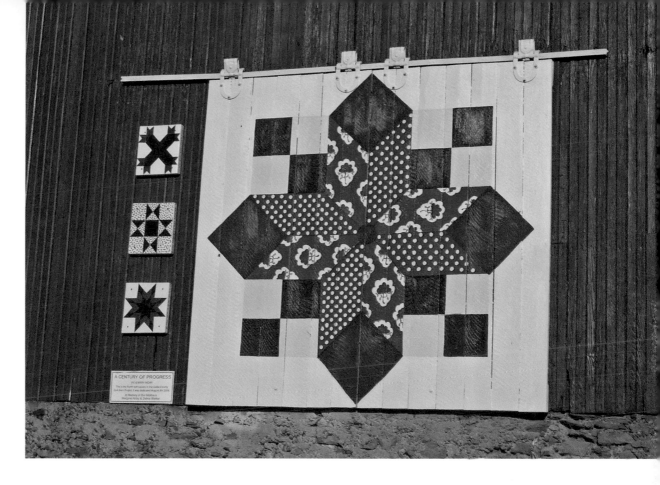

Mary quickly remembered why she had put the project aside: she simply did not enjoy the chore of joining the blocks together. A local quilter completed the sampler, just in time for Mary to give it to her daughter for her fortieth birthday.

Mary proved to be the consummate hostess; a meal of homemade food including a peach pie made from the freshest ingredients sent me off to a sound sleep. The next morning, as I prepared to depart, I noticed that my watch had stopped, leaving me a bit nervous about making it to each of the day's appointments on time. Mary removed her watch and, despite my protestations, insisted that I take it. "I have other watches, and you need this one more than I do," she said. I would encounter this generous spirit of rural life many times in my travels, and I always did so wearing Mary Niday's watch.

When I returned to Ohio, it was to tell the story of the quilt trail at the Appalachian Studies Conference in Portsmouth. I was eager to see Donna Sue. We had talked almost daily for seven months. Sometimes I listened as she talked about the grueling trips to the hospital in Cincinnati and the latest word from the doctors. Quite often, she would say, "Suzi, there is nothing to tell," and we would talk about

Century of Progress,
Niday barn

my teaching, my friends, and my personal life. We had met in person only once, but there was little that we didn't feel comfortable sharing.

Of course I knew that Donna Sue had lost her hair; in fact, I, who hate shopping like a small child hates brussels sprouts, had visited the "big city mall" to find hats for her. Seeing Donna Sue was a joy—here she was, visiting with old friends and new alike, wearing a flamboyant black hat with white feathers. I was pleased when she said that it made her feel pretty. At the same time, I could hardly look into the eyes that betrayed the pain behind her glowing smile.

The highlight of the conference was the presentation of a friendship quilt that had been a group project of women from across the country. Karen Musgrave had put together the quilt, made up of squares created by dozens of Donna Sue's friends. I pieced a replica of the Flying Geese square that had caught my eye in Kentucky and led me to Donna Sue—a talisman of sorts. The end result was magnificent: some squares were created from photos, some hid treasures or prayers in small pockets, and others were beaded. My square seemed humble amid the artistry of others, but I hoped Donna Sue would understand the meaning behind it.

The conference afforded the opportunity to visit a nearby quilt trail—the Patchwork Path through Athens County, Ohio. Like other trails, this one tells stories, but unlike many, this trail speaks more about the community than about its individual families. The project began as part of a Regional Flavor Initiative, whose aims paralleled those that Donna Sue had set forth as the goals for the barn quilt project—replacing dwindling economic resources by creating opportunities for tourism and entrepreneurship that emphasize each region's historic and cultural assets.

Convention and visitors bureau director Paige Alost had arranged for us to have breakfast with quilt artist John Lefelhocz, who had created one-of-a-kind modern patterns that would give the Patchwork Path an Athens County theme. John is reserved and unpretentious, but as he spoke about his artwork, the passion was apparent in the detail with which he described his creations. John proved to be not just an artist but well-versed in Athens' past, as he explained that he had found the inspiration for three of his designs in the works of a well-known landscape architect.

The elaborate buildings and grounds that were once home to the state asylum for the mentally ill are now part of the Ohio University campus known as the Ridges. Landscape architect Herman Haerlin, a student of Frederick Law Olmsted, who designed New York's Central Park, laid out the asylum's grounds. John adapted the curves of Haerlin's iron scrollwork into three modernistic quilt blocks: Ridges Arrows, Ridges Cross and Clover, and Ridges Spinning Top, each located on historic barns along the trail. As he spoke, John sketched some of the designs, explaining how sections of the scrollwork had become quilt patterns. I was intrigued and ready to see his work, which also included another well-known quilt square.

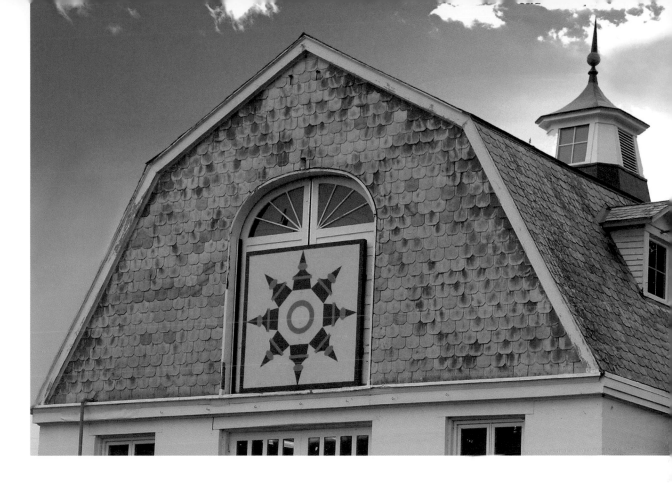

Paige and I set off to see the block at the Dairy Barn Arts Center. The barn was built in 1914 as a functioning dairy that served the nearby asylum. It was quite an impressive building, and I loved the way that John had incorporated the barn's unusual cupolas into the star pattern on the end facing the road. Our timing was great—the Quilt National show was going on, so I had the chance to view some of the art quilts on display in a juried show that is well regarded both nationally and internationally. Paige explained that the majestic barn with its slate roof was scheduled for demolition in 1977, but a committee of concerned residents convinced the state to convert the building into an arts center, and the building is now in the National Register of Historic Places.

Traditional patterns that represent some aspect of Athens County are scattered through the three loops that make up the trail. The ubiquitous Corn and Beans block is included, as well as an Indian Trail square, which acknowledges the earliest inhabitants of the area and the ceremonial mounds they left behind. The Appalachian Sunburst, Ohio Star, and Buckeye blocks tie the local area to the state and the surrounding region. "The trail tells multiple stories," Paige said, "reminding us of what things used to look like and of the need for constant renewal." We also stopped to see John Lefelhocz's three scrollwork designs, and I could imagine each as a cloth quilt that might be fit for hanging in the Dairy Barn.

Dairy Barn block, Athens Dairy barn

113

ohio

Tucked among trees along a back road, an unusual flower quilt square seemed to me reminiscent of a hibiscus. Paige identified it as the Pawpaw, and she seemed surprised that the name wasn't familiar to me. Of course, before long I was to be well-versed in pawpaws. Chris Chmiel, known in the area as "the Pawpaw King," has brought much notice to a local resource that was once taken for granted. Chris told me that the pawpaw fruit is native to the area and that both native cultures and frontiersmen had used pawpaws extensively. Chris had been looking for a niche in sustainable farming, and the pawpaw seemed like it had a lot going for it. It's very nutritious, can be grown organically, is naturally resistant to bugs and grazing animals, and, according to Chris, is used for medicines to fight cancer.

Chris began by harvesting pawpaws and then founded Integration Acres Farm to cultivate the fruit and to produce pulp, jams, and other pawpaw products. The block on the nearby barn depicts the yellow fruit with rows of seeds and the tree's purple blossom in the center. "Pawpaws are well known here in Athens," Chris explained, "and I am really proud of the fact that it has become the official native fruit of Ohio. For those who live here, pawpaws have become a cultural icon."

Another area icon appears on the Krager barn nearby. I had admired a brightly colored metal flower sculpture in Donna Sue's home, but the much larger two-dimensional version under the green barn roof was even more impressive. The Passion Flower design is the emblem of Passion Works, an extraordinary art studio in Athens. Founder Patty Mitchell calls the studio "a collaborative arts center where artists with and without developmental disabilities work together to create fine art." The production of these pieces generates employment as well as a renewable funding stream to continue arts programming.

Patty lives each day experiencing the creativity that resides within each person and the ability of the arts to touch the human spirit, a process that began years ago when Patty studied fine art photography and lived at the Athens Mental Health Center as a resident volunteer. In exchange for room and board, she developed recreational art activities for the residents. "Whatever I was learning in school I would share with clients," she recalled. "People responded really well—they were less depressed. If they weren't speaking, some people started talking. It was pretty profound."

Patty was moved by what she had experienced and wanted to carry it further —to create community studios where people who were at the fringes of the community would be at the center. In 1998, she founded Passion Works, where artists help each other to create a sheltered workshop in a supportive environment. They combine their respective strengths, allowing each to practice the tools and techniques needed to transform their thoughts and feelings into tangible artistic creations.

The studio is well known for the passion flower sculptures like the one that Donna Sue displayed in her home, which are made of recycled aluminum and

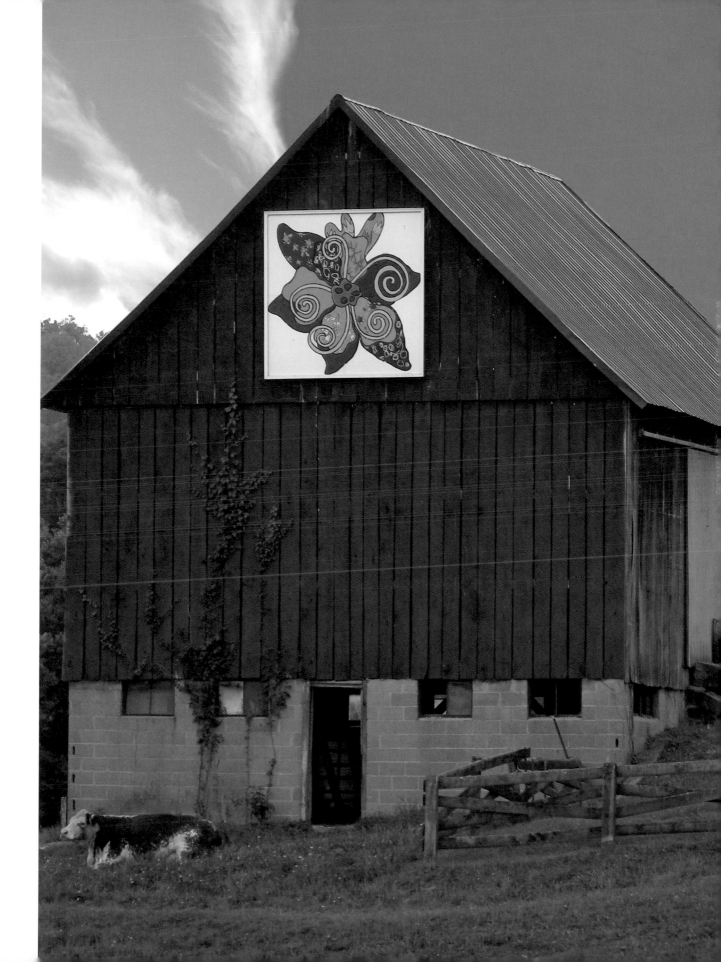

blooming with exuberant colors. The Passion Flower is the official flower of Athens, and the studio has sold over twenty thousand of the flowers thus far, demonstrating strong community support and providing a means for the artists to earn money and respect. Patty worked with Wendy Minor-Viney, one of the artists in residence, to adapt the sculpture to a two-dimensional quilt square, and Passion Works artists created the painting, which hangs on the nineteenth-century barn.

The Passion Works studio exemplifies the belief that creativity is an innate part of all people, and their success demonstrates that art enhances the quality of life and strengthens communities—both in art studios and along the quilt trail.

Paige told me about one other way that the quilt trail is part of the local landscape. The annual Quilt Barn Ride, a bicycle tour sponsored by the Athens AM Rotary Club, features a thirty-mile scenic loop and includes stops at five of the quilt barns along the way. The event attracts about one hundred riders from across the region each July and is both an enjoyable event and a fundraiser for cancer research. Paige said, "Not only do riders get to see our beautiful quilt barns, but they get to enjoy the quiet back roads of our region, winding past historic farms, waterways, and lots of wildlife! The Quilt Barn Ride is perfect for families, amateurs, and serious cyclists."

Brandi Betts was bursting with energy and ready to take me on the tour of Vinton County. The forested hills of the area are celebrated among outdoorsmen and hunters, so it was only fitting that the county's first barn quilt was part of the Twenty-First Annual Wild Turkey Festival. As Vinton County marketing director, Brandi had attended the Tri-State meetings in Berea, and she believed in the project's potential. With encouragement from Donna Sue, Brandi applied for and received a grant to paint six quilt squares.

"Still," Brandi said, "no one knew what a quilt barn was, so I had to find a way to sell the concept." The influx of visitors during the festival provided a chance to get the word out, and Brandi had a Turkey Tracks quilt square already drafted and marked in the visitors bureau office, where festivalgoers could lend a hand with the painting. Everyone came in, young and old alike—even members of the band Confederate Railroad, who were there to perform. Over one hundred people walked away and took the news to others.

Brandi worked with a 4-H group, a seniors' center, and the Sojourners Care Group—a program for at-risk youth—to paint the next three quilts; with over 250 participants involved in the initial phase of the project, enthusiasm for the project became infectious, and it has been so ever since.

The visitors bureau office in McArthur became tight quarters for a family reunion when three generations of the Radabaugh family from all over the state gathered to paint a barn quilt. Pam Radabaugh selected the Christmas Star be-

cause she loves the holiday spirit and wants to enjoy it year round. "With all of those people at work," Brandi recalled, "my office looked like Santa's workshop!" The tiny workshop was put to use many times, as Brandi Betts and her staff stepped in to paint barn quilts when no group of volunteers was at hand. One of those hangs at the historic Rannells farm.

Farmers tend to be a reserved lot, but Bob Rannells broke into a smile as soon as we shook hands, and he seemed excited at the chance to tell us about the farm that has been in his family for five generations. The age of the barn is uncertain, but it was listed on the deed when Bob's great-great-grandfather purchased the property in 1833. Bob credited the sturdiness of the barn partly to the roofing: the gray slate shingles, which can still be seen on historic public buildings and churches of the era, are impervious to weather. I had heard a great deal about the role of roofs in keeping barns standing; it seemed like the perfect solution. The barn is also unusual in that its side door opens to reveal haymows on either side, rather than a single storage area above. The bold yellow, blue, and green Farm Friendliness quilt block suits the welcoming smile of the farmer, who loves nothing more than inviting those who pull into the drive for photographs to come on up to the farm for a visit.

When Brandi stopped by the Faught farm, she knew that the red barn was the perfect site for a quilt square. Shirley Faught had begun sewing the quilt she calls "Mountains" for her brother Herman, after she heard him bemoan the fact that he had never had a quilt for his bed. Herman was in the navy and still proudly flies the flag, so Shirley felt that he would appreciate the red and blue Mountain Top pattern on a background of white. Shirley worked on the quilt sometimes just for an hour or so at a time, and it took almost three years to complete. One evening, Shirley took up her sewing when she was tired, and about an hour later, she realized that she had sewn one of the Mountain Tops upside down. "I had a new pattern," she said with a laugh, "but I like it."

The Faughts' barn quilt created another opportunity to include the public in a group painting event. During the 2008 Lake Alma Beach Festival, dozens of people had a hand in the creation of the Mountains quilt square. Even Smokey the Bear was seen with brush in paw. The unusual circumstances added extra interest to the quilt block. "Look very closely," Shirley said, standing just a few feet from the barn. "See the texture? It was a windy day, and sand from the lake blew onto the paint while it was drying!"

Once the idea caught on, quilt squares became an integral part of community celebrations. I had enjoyed the artistry of an Airplane quilt in Kentucky, but the one at the airport in Vinton County with a small airplane parked next to it seemed much more at home. The Vinton County Air Show provided entertainment for a huge crowd, some of whom pitched in to paint the Airplane quilt square with its rich blue background.

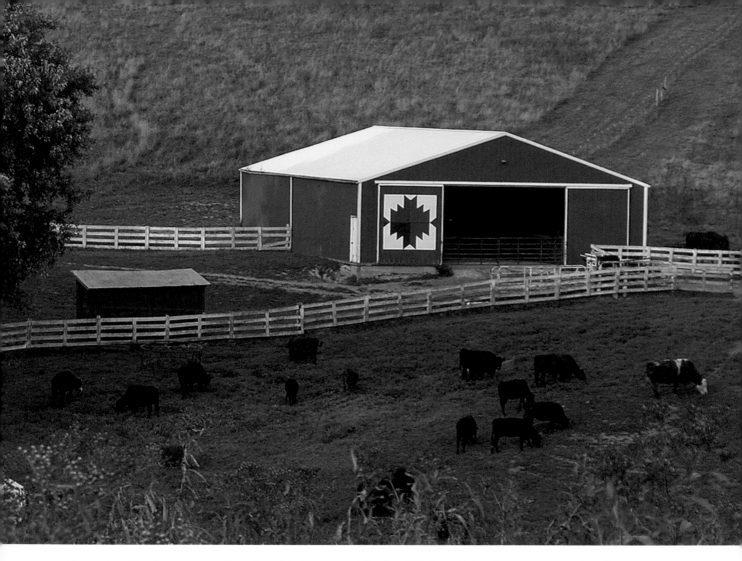

Mountains, Faught barn. *Photo by Brandi D. Betts*

Brandi and I also stopped by the Old Swan School, a one-room schoolhouse, where teacher Dorothy Scott was honored by friends, relatives, and former students who painted the Little Red Schoolhouse quilt as a tribute to her. Brandi had devoted herself to involving as much of the community as possible, in ways that were also meaningful to them.

In all, over 1,300 people, including visitors from nearby cities and even a family from Japan, participated in the painting of twenty-seven blocks. The youngest was an eleven-month-old, whose grandmother helped her hold the paintbrush. The oldest participant was one month away from her hundredth birthday when she lent a hand to create what is now known as "A Stitch in Time: The Quilt Barns of Vinton County."

Its location on a line between Ripley and Columbus gives Greenfield, Ohio, historic significance—as a stop both along railroad freight lines and along the Under-

118

ground Railroad. The Greenfield Historical Society has woven much of that history into the creation of its Paint Creek Patterns—the quilt trail named for the stream that runs through the area and connects with the Ohio River to the south.

Greenfield Historical Society board member Patsy Smith saw a 2005 article about the Monroe County quilt barns and imagined that the group might enjoy building a quilt trail in Highland County. Greenfield, once a hub of industry, had seen its factories steadily closing, and the potential to bring tourism into the area was appealing.

Wendy Royse, copresident of the historical society, saw the photographs of Scott Hagan's large Monroe County barn quilts, which are painted directly on the barns, and immediately thought, "Yes—we want to do this!" Wendy laughed as she said, "Then I stood in front of my barn and said, 'Hmm—maybe not!'" Donna Sue led a workshop in Greenfield, encouraging the group to proceed using the less intimidating and more common method of painting quilts on boards and then mounting them. A core group of women of the Greenfield Historical Society teamed up to get the trail under way.

Suzi Sharp recalled, "It was amazing the tactics we used at first to get people to have a quilt. We'd say, 'Everybody's going to have one,' hoping they wouldn't want to be left out. It was so exciting when someone said 'Yes'!" Though some of the barn owners painted their own squares, Suzi and the ladies of the historical society created most of the barn quilts, and along with copresident Harold Schmidt, they have created a trail of over fifty painted quilts that extends across Highland County and into nearby Ross County as well.

As we drove the trail, Suzi and Wendy talked a bit about the activities of abolitionists in the area. We stopped at a Fayette County farm whose long white barn is decorated with the Log Cabin quilt block painted by owners Debbie and Tom Beatty. The farm has been in the Beatty family since 1824 and was home to abolitionist Alexander Beatty, the subject of a colorful story.

Alexander's tale, as told by his family, involves a free black man named Augustus West, who asked Alex to assist him in earning some money. Alex would take Gus south and sell him and then return later to help with his escape. The two split the proceeds of the sale and after the first successful trip repeated the plan twice. With the money gained from the scheme, Gus West bought land and established the first free black settlement in the area, not too far from the Beatty farm. The Beatty family is proud that their farm will soon reach the one-hundred-year mark in its history but even more proud of the farm's place in the dedication of its previous owner to the cause of abolition.

The historical society has made every effort to draw attention to the historic barns in the area by including them on the trail. Mary Ann and John Larkin's Century Farm is home to two barns, each with its own quilt square. The Basket, which can be seen from the Larkin home, is a traditional pattern that many say is part of

a quilt whose purpose was to serve as a signal to slaves to gather their belongings to prepare for escape, while the Flying Geese quilt was used to provide directions for safe routes. While not all sources agree with these accounts, associating quilts with the heroic acts of their ancestors is another way of celebrating what is known about Fayette and the surrounding counties. Historic records show that Greenfield was home to the largest abolitionist society in the state, and it was certainly a place where many contributed to efforts to assist escaped slaves in their journey to freedom.

The combination of colorful modern quilt squares, traditional patterns, and the many opportunities to visit sites where the abolitionist movement flourished makes a visit to Greenfield and surrounding Fayette County well worth the journey. The Paint Creek Patterns are signs both of family connections and of the deeply rooted individualism of which Greenfield, Ohio, is so proud.

Kay Hamilton and I met over breakfast and were still talking long after sundown. As part of her job with the Miami County Visitors and Convention Bureau, Kay works with the barn quilt program, which is renowned for its artistry. We set off through the rural back roads to see the painted quilt patterns that Maxine Groves told me might just be the most impressive yet. Though I had seen hundreds of painted barns by this point, Maxine was right. It wasn't just that the designs were painted directly on the barn surfaces. There was an unmistakable artistry in each of them—just the right mix of colors, bits of extra embellishment. I knew that we were to meet the artist at lunchtime, and I couldn't wait.

Judy Rose smiled with delight as she spoke about the project that has so enriched her life. The adventure began in 2007 with Diana Thompson, director of the Miami County Visitors and Convention Bureau. Diana had seen how popular the state's Bicentennial barns were and thought the Miami County Bicentennial could be commemorated in a similar fashion. Judy was on the board of the visitors bureau, and her friend and fellow board member Evelyn Sheafer seemed to know everyone in the county, so Diana presented the idea to them. "I didn't know it at the time," Judy said, "but it was a gift."

Like many other barn quilt committees, the women had a lot of trouble in the beginning, because people thought they were going to hang cloth quilts on their barns, and they said that the quilts would fade or get mildewed. Judy recalled, "People thought we were out of our minds! I had the artist, and Evelyn had the barn, so finally I said, 'Let's just do it. Then we can point to it and say, "That's what we're doing."'"

The artist, Rafael Santoyo, came from Mexico to work in the El Sombrero Restaurant, owned by Ruben Pelayo. Rafael had done detailed carpentry work and painted murals in the dining rooms, so Judy knew that he had artistic talent.

His talent became even more apparent with his first barn painting. Rafael painted an Ohio Star on Evelyn's barn. The office started getting phone calls, and both Evelyn and Judy were flooded with phone calls as well.

Judy and Evelyn conferred with Diana and decided that Rafael would continue to do the painting. "That was going to be our theme," Judy said, "to have a folk artist do all of them." As a muralist, Rafael was glad for the chance to paint on the barns. He explained, "I can use my imagination and make them more interesting than on a square of wood." Rafael paints all of his designs freehand, and being able to step back from his work and see it from a distance is essential for the artist, who spends from thirty to fifty hours on each painting.

Rafael Santoyo's favorite among all of the quilts that he has painted is at Bob and Rynn Malarkey's barn. The two enjoy cycling and were riding along one day when they saw a beautiful quilt square on an old barn in the middle of a field. Bob went to the door and asked how to get one; he immediately got on the list. When it came to be the Malarkeys' turn, the Mariner's Compass was perfect. The way it sits on the barn, it points toward true north, true east, true west, and true south.

Most of the barns in Miami County are in the countryside, but the Malarkeys' barn is tucked away in Troy behind a preschool and is adjacent to an in-town park and walking trail. As Rynn pointed out, "Some people do seek it out, but other than me, most see it when they are walking the trails in the urban reserve. They see the colors in the distance, and when the path comes around the lake, they are face to face with it. My husband walks every night, and it's just so neat for him."

The 1830s barn was already a historical landmark, but as Rynn explained, "It is such a plain white barn; now it speaks a little bit more than it did before."

Kay Hamilton and I made our way across the county to visit with Sara Duff. As we pulled into her drive, I saw her visitors' comment box along with a batch of brochures for travelers to take. I thought it was a great way to spread word about the quilt trail to those who might happen by her barn. Sara recalls preparing her barn for its quilt square: "It was like getting your daughter ready for a recital!" She had called her son and told him that the barn needed painting. She wasn't sure when Rafael was coming, but she knew that the barn was number seven on the list. Her son delivered a bit of bad news, though—they needed a carpenter to repair the barn before it could be painted. The clock was ticking, and Sara became excited and nervous about having all three projects come together at just the right time.

Before long, the barn repairs were under way, and Judy Rose and Evelyn Sheafer came to visit to select a pattern. Sara knew that she wanted red, white, and blue for her barn, and she looked through her mother's quilt books, but nothing stood out. Then she remembered a trip to visit friends in Texas: "We went to a restaurant where the foyer must have been three stories tall, and on the wall was the biggest quilt I have ever seen—it was just magnificent. My husband said, 'Now

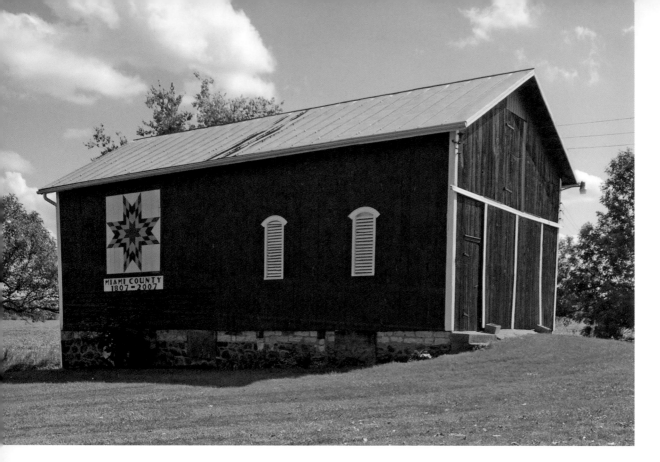

Texts Star, Duff barn. *Photo by Brian Wellman, Dayton, Ohio*

that's a quilt!'" Max had passed away, and the farm had been important to him. So the Texas Star seemed the appropriate choice for his barn.

Ironically, Sara had already made plans to go on a trip, so she wasn't there to see the barn quilt being painted. She kept thinking, "Rafael, please go slower," but he set to work while she was away. The guestbook that she keeps near the road makes sure that Sara doesn't miss a visitor, even when she is not at home.

Of course I knew that it was time for another lesson when Kay said that we were headed for the Piqua Historical Area. Before seeing the barn quilt, we chatted with manager Andy Hite, who related a bit of early Ohio history—a subject that I had never explored. I was surprised to learn that Native American contact has been documented for about thirteen thousand years. Andy also pointed out that Ohio was once the American frontier: "There wasn't much of anything farther west in 1804."

Piqua is built around the home of John Johnston, an early settler who bought this property in 1804. He was a federal Indian agent, and he also oversaw the beginning of the canal system in Ohio. The Johnston farmhouse, the barn, and other buildings were restored after the state purchased the land in the 1960s, and an interpretive center opened in 1972, with tours of the house and canal boat tours. Andy Hite said, "I like the fact that the things we talk about actually happened right here."

122

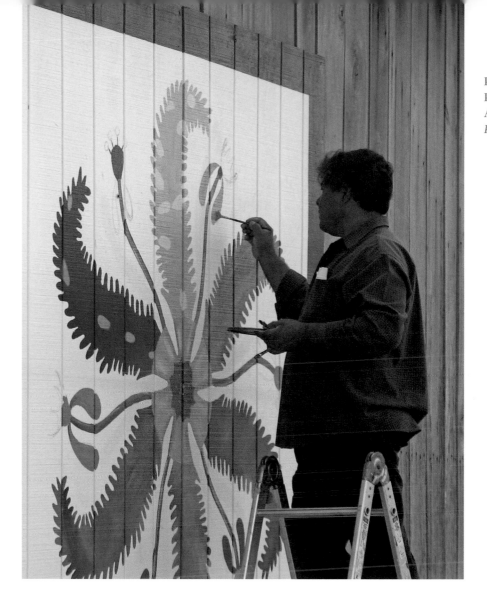

Princess Feathers,
Piqua Historical
Area, in progress.
Photo by Kay Hamilton

The bicentennial of the barn was celebrated in 2008, so adding the Princess Feathers barn quilt, patterned after one in the Johnston home, seemed an appropriate addition. I loved the pattern and thought it might be one that I would create someday in cloth.

I had seen a photograph of Randy and Linda Mott's barn, and when I first spoke to Kay, I asked that she make sure it was on our route. I was fascinated by the manner in which the quilt block was painted. The fan-shaped pattern wrapped around the corner of the barn and was painted right on top of the gutter. I had seen one other "corner barn quilt," in Adams County, but this one was magnificent.

The unusual design was born not of creativity but of necessity. The barn sits at the end of a long, curved lane, so the view of the front is obscured by trees. But that didn't stop Judy Rose. She looked for designs that could be adapted to the corner of the Motts' barn, and Randy was pleased when she suggested

123

ohio

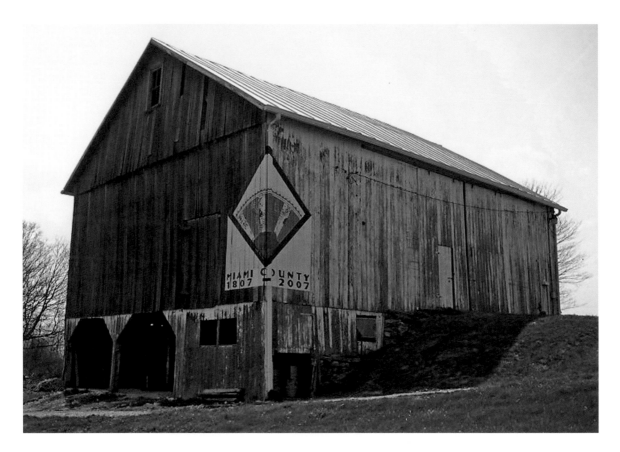

Grandmother's Fan,
Mott barn

Grandmother's Fan, as he remembered a quilt that his grandmother Mott had that was very similar.

"Rafael did a fantastic job with the painting," Randy said. "He painted it twice. At first it was solid colored, and we really loved it."

Linda laughed. "We took pictures and then here he came and set up his ladder again. We weren't sure what he was doing. That was when he painted the actual design."

Randy and Linda look forward to 2019, when the property will become a Century Farm. "We hope one of our daughters will take it on," Randy explained, "but we have guaranteed that there will never be any other houses on it." In 2007, the farm was enrolled in the Elizabeth Township Farmland Preservation Program, which means that the deed now stipulates that no other development can be done. The Motts' neighbors and two other farms in the area are enrolled, and Randy hopes to see the number of acres expand. He is a firm believer in planning for infrastructure and improvement but also values rural agriculture and green space.

With seventy painted quilts to his credit, Rafael Santoyo still looks forward to each new challenge. Sounding a bit like a quilter, he said, "I like to look at the patterns, to see what colors would look best. Then I use my imagination to add the

124

little touches to each one." When asked which of his paintings was the most challenging, he quickly answered, "The Rings," referring to the Double Wedding Ring, whose curved design makes it a test for cloth quilters as well. That the pattern would be challenging for both the artist who paints quilt squares and for the women who Rafael says "are painting with fabric" makes perfect sense.

■

After taking in the incredible artistry of Miami County, I was hesitant about visiting nearby Champaign County, where quilt blocks are made in an unusual manner. Tina Knotts of the chamber of commerce was all set to take me on a tour, though, and immediately took me to a barn that was unlike any of the hundreds that I had seen.

The barn at the end of Todd and Jill Michael's driveway caught my eye long before the quilt square came into view. The magnificent gray building had some sort of oddly shaped structure attached at the rear. The Michaels didn't acquire the property until 1996, but Todd knows a great deal about its unique features. There are no supports in the center, so everything leans against the middle. He took us inside, where we could see that the barn was actually twelve-sided, with triangular stalls. The hay could be dropped through a chute from above so that it would land in each stall. Todd also pointed out that the slats between the stalls and on the doors are rounded and polished. He explained that Urbana was the broom handle capital, with three major broom handle companies located there. So broom handles were often used in barns.

Our attention finally turned to the quilt square. When Don Bauer of the newly formed barn quilt committee approached the Michaels about painting a quilt block on their barn, he had a plan that he knew would be well received. Both Todd and Jill are Ohio State University alumni, and they sent their two children to the school as well. The red Ohio Star on the gray barn combined the school colors and the state emblem—a perfect barn quilt for two loyal Ohioans.

Don Bauer was adamant that he had hit upon the best method of creating barn quilts. At the chamber of commerce meeting, someone had the idea of barn quilts, so using information from Sac County, Iowa—a group whose helpfulness I would hear about myriad times—the group began. Don said, "Laying out the first one, the Gentleman's Fancy for my barn, was a real bear!" After painting the star at the Michaels' barn, Don became determined to find an easier way to achieve the desired look. He found a sign company that could transfer the quilt squares onto vinyl. He prefers the vinyl because it will wear better, allows for the use of more vivid colors, and gives the barn owner the freedom to create almost any quilt without being concerned with difficulty in painting.

I couldn't help cringing at the idea of a barn quilt being printed, but when Tina and I arrived at the Virts farm, I was surprised and relieved. What I thought

125

Ohio Star, Michael barn

would look machine-made looked just like a skillfully executed painted barn quilt. Charles Virts is a good-natured storyteller who soon was sharing tales of life on the farm some sixty years earlier.

As Charles opened the door of the 1901 barn, he spoke with an almost reverent tone, even though the stories he related were humorous: He used to kick a football inside the barn. It would bounce off the rafters, and Charles would try to catch it. "It was a lot of fun," he recalled, "except here is the hay chute that goes down to the lower level; I fell through twice and ended up on my back!" Charles also used to shoot his bow and arrow at the pigeons that lived in the barn, but most of the time the arrow would get stuck in the roof. There were also raccoons on the rafters, and he would shoot at them with a rifle. He said, "Of course, if you shot the raccoon the bullet would go straight through the raccoon and up through the roof. It came back to haunt me when I had to pay five thousand dollars to put a roof on the barn!"

His wife, Sheryl, told us that the two had a hard time finding a barn quilt pattern that they could both agree on. One evening, she looked at the quilt on her bed and realized that she had had a suitable design all along. Finding a name for the design proved another challenge, as there are often several different names for the same pattern. Sheryl said, "Because we live at a crossroads, and there looks to be a cross in it, the name Crossroads represents our Christian faith and the crossroads where we live."

126

Don Bauer admitted that some prefer painted quilt blocks to the vinyl ones. "People say we are not getting the client involved, but I disagree. It gives us a way to let barn owners pick anything they want as far as patterns and colors or to even photograph a pattern and put that on the quilt."

Tina Knotts agreed that there is plenty of community spirit behind the project. The annual Champaign Barn Quilt Tour draws hundreds of visitors, who drive along the route, stopping at five featured barns along the way, such as the Dowden barn, with its display of antique tractors, or the Freckle Bear Farm Fall Festival at the Lavender barn. There are plenty of barn quilts to be seen, but in addition, fabric quilts are hung from porches, fences, and clotheslines across the county for the day, both to add to the enjoyment of the event and to demonstrate the pride that many Champaign County residents have in their quilts.

■

"The idea of family histories and quilts opened up with me, and I was hooked," said Anne Cornell, director of the Pomerene Arts Center in Coshocton County, my final stop in Ohio. Ann had begun working with Christy Farnbauch of the Ohio Arts Council to develop new avenues through which to support the Arts Alliance, which includes the Pomerene Arts Center. Christy was familiar with the barn quilt project from her work in other areas, and she encouraged the Arts Alliance to take a look in that direction. The group decided not only to create quilt squares but also to look into the rich history of both the quilts and the farms.

I loved the fact that Maxine Groves had been involved in the beginnings of this trail. In April 2008, the group conducted quilt documentations, with Maxine as one of the documenters. Maxine explained that a lot of her knowledge had come from her careful study of countless books and comparing quilts at exhibits. Sometimes information is gained from the quilt owner if the story is documented —maybe the family knows that a pattern came from the late 1890s, so after a while, recognizing the work of that era would be easy.

Maxine went on to say that fabrics are often used to date quilts. The 1930s are among the most easily recognized, for the feed sacks that were so popular during the Depression. Every period of fabrics has its own look, and books are available for reference. "When you look at a quilt, then you can go through and turn to that section, and if you are proved right you feel good and if proved wrong you learn something," she explained.

Dating quilts includes layer upon layer of clues. Maxine said that the way certain red dyes faded to beige could be attached to a particular period. Also, the type of quilting might be significant, as today most quilting is done "in the ditch" between the seams, while quilting on both sides of the seams was once preferred. I felt humbled once again by the depth of Maxine's knowledge.

127

ohio

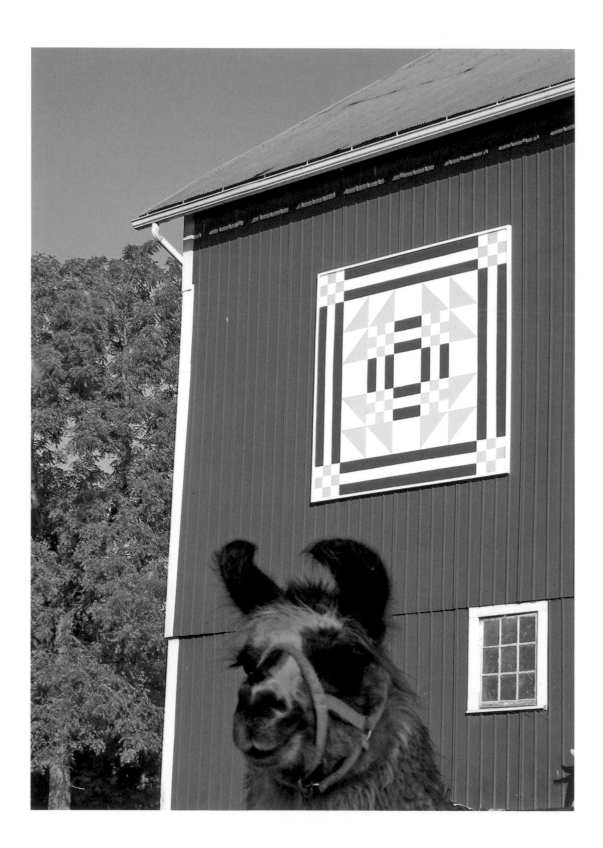

After the documentation, an exhibition of quilts at the Pomerene Arts Center featured quilts from the area of the county north of the town, and the first section of the Heritage Quilt Barn Trail was developed using some of those quilt patterns. The twenty-two-mile trail begins in New Bedford with its predominantly Amish population and winds through hilly farm country where traditional horse-powered farming is still practiced and on through town.

On my way to Anne Cornell's cottage just after dusk, I saw a glowing light flickering down the road toward me. After narrowly avoiding a collision on the dark road, I realized that the light was attached to the front of a horse-drawn buggy. When I asked Anne later, I learned that Amish tradition does not allow the use of electricity from outside sources but that battery-powered lights were permissible.

We started early the next morning and managed to see most of the barn quilts in the area. Because they are patterned after quite old quilts, only one was made from a traditional block with which I was familiar. The Fender Farm, which was settled in 1914, is home to a couple of dozen llamas, several shallow ponds, and a gray and red Gentleman's Fancy block taken from a quilt made by Dennis Fender's grandmother, Minnie Fender Schwartz. I waded through the herd to see the quilt square up close before crossing the street to speak with Dennis.

Dennis recalled going to see his grandparents often, especially when other visitors were at the farm. His grandma would get her quilts out, and Dennis was fascinated by the sight of the ladies holding the quilts and looking at them. Minnie's husband, Allen, helped draft Minnie's patterns and also drew birds, rabbits, and flowers for her to embroider. The unusual collaboration created some beautiful needlework.

Theresa Scheetz was the second quilt documenter for the Coshocton project, and she conducted interviews with quilt owners to capture firsthand the stories behind the quilts. Bernice Dreher, whose quilt square hangs on the Edgar Cox barn, recalled, "My grandmother loved going to school, and she told me that when she was fourteen, they came and got her and told her that her mother had died. She knew that she was never going to be able to go back to school." That was in 1892, and soon thereafter, Barbara Asire Bechtol expressed her grief by making the Garden of Eden quilt from scraps of her mother's clothing. Each of the simple squares in the original quilt has a black center, and though some of the surrounding scraps include pinks and blues, the overall effect is subdued. The elaborate curved quilting within the blocks seems a loving tribute to a mother who passed down her skill.

I left Coshocton—and Ohio—knowing that there was much more to discover but hoping that I had done justice to the quilt trails in Donna Sue's home state. Since then, new trails have blossomed, including the trail in Clinton County that celebrated the centennial there. But throughout my travels I had come to accept the fact that there will always be barn quilts unseen, awaiting my return.

Opposite:
Gentleman's Fancy,
Fender barn

129

ohio

iowa

I WAS EAGER TO visit Iowa, as it had played a pivotal role as the starting point of the quilt trail west of the Mississippi. In 2003, while the Adams County quilt trail was nearing completion, Donna Sue attended the National Rural Funders Collaborative conference in Nebraska, to share the barn quilt concept with other rural communities that were seeking ways to generate revenue. There, she met Patricia Gorman, at the time a field specialist with Iowa State University's Extension Service. Patricia now lives not too far from me, so over lunch in midtown Atlanta, she told me her story.

Patricia recalled walking into the Nebraska conference and seeing a woman sitting at a table with a red and blue quilt lying across a chair. "Are you cold?" she asked.

"No," said Donna Sue, "not at all." Donna Sue went on to explain the significance of the sampler quilt that she had brought with her. It was made by her mother, Maxine, and each square represented one of the twenty quilt squares in Adams County, Ohio.

Patricia's work focused on ways to relieve rural poverty, because the number of family farms was decreasing and jobs were scarce. She was also on the board of Opportunity Works, an initiative that aimed at creating economic development using the region's assets. Patricia had accompanied Stacy Van Gorp, the agency's director, to Omaha to look for ways to bring income from outside the area to the five eastern Iowa counties that she served. Travelers who might have stopped

and eaten lunch at a local diner or spent a few dollars on their way to Ames or Des Moines were now speeding past on the new Highway 20 and seeing the countryside at seventy miles per hour. Stacy noted that on the way to the conference, Patricia realized that regions across the state were similarly affected. "You could drive across Iowa to Nebraska and only turn twice," said Stacy. "That was troubling Pat."

After hearing Donna Sue speak at the conference, Patricia thought that the quilt trails might be exactly the solution that she had been looking for. She and Stacy immediately chose Grundy County—a "can do" kind of place that could be counted on to take up the idea. Donna Sue recalled, "Pat was so enthused about it—she called and said, 'Do you remember me? We don't have the bridges of Madison County but we've got the barns!' I was thrilled and honored and excited that somebody in a new part of the country wanted to participate."

The two talked once or twice a week for several months, sharing ideas and building on what Donna Sue had learned from her experience with the Adams County trail. Donna Sue felt strongly that engaging the entire community was key and that choosing barns that would take travelers along an easily navigated route would add to the project's success. Eventually the discussion moved away from quilt squares and included more of the two women's personal lives. Of course, I understood how months of talking with Donna Sue could blossom into a close friendship.

Grundy County embraced the project, and a committee was formed to organize their efforts. Janet Peterson, a University of Northern Iowa design major, interned with the group until her graduation in May 2004, when she was hired as Barn Quilt Project coordinator. Janet researched the history of the barns and the quilt patterns and put together a narrative that would eventually be provided to visitors. Donna Sue was thrilled with this development: "This was the first instance of job creation in conjunction with a quilt trail. It was exactly what we had hoped would happen."

After writing a proposal that laid out the mission and goals of the project, the Grundy committee chose quilt blocks that were connected to agriculture, farming, or rural life and placed ballot boxes in every small town in the county so that everyone could share ownership of the project. This simple but effective method of getting the entire community interested in the project was just what Donna Sue had suggested. Residents chose their favorites from among patterns such as Hens and Chicks, Log Cabin, and Windmill, and a local quilters' group paired the top twenty designs with color schemes from which barn owners would select. With the patterns chosen and $1,200 in funding from local and state farm bureaus and Opportunity Works, the project began in May 2004, with twelve barn owners signed on.

The Barn Quilts of Grundy County was a true grassroots effort. Three local banks and several individuals each sponsored a square; the Keep Iowa Beautiful program provided funds as well. The local police chief loaned his truck, and in-

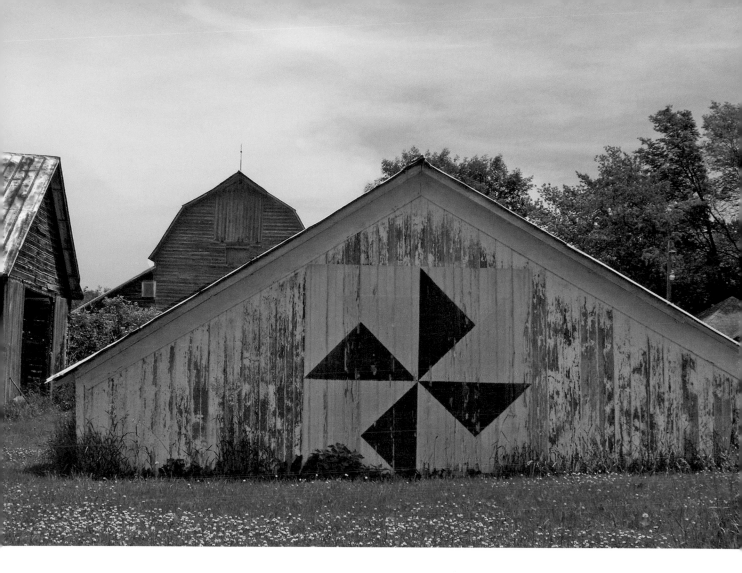

dustrial arts students pitched in to help hang the finished quilt squares. Boys from a state training school enjoyed a day in the countryside in exchange for helping to build frames to mount the squares. With donated supplies from Habitat for Humanity and paint reclaimed from the hazardous waste facility, Patricia Gorman and her daughter, artist Lizabeth Wardzinski, went to work laying out the first barn quilt painting at the Nason farm.

Don Nason's hog house had been in the process of being moved to his Century Farm when the vehicle broke down, leaving the building near the roadside, where it remained for many years. My first encounter with Iowa agriculture occurred when I asked just what kind of house hogs might have. A traditional hog house is a low structure where sows give birth and nurse their young; the peaked roof is lower than most farm buildings, as there is no upper storage area inside. The end of the building—roughly triangular in shape—complemented the windmill pattern that the artist had chosen. The weathered building with its end situated just a few yards from G Avenue was the perfect site for the first Grundy barn quilt.

Windmill, Nason hog house

133

So that the painters could work more efficiently, work on a second painting at a nearby farm was begun at the same time. The sky blue portion of the Windmill design at Nason's property was painted, and the mother/daughter team moved to the Neuroth farm, where they began work on an eight-by-eight-foot Hole in the Barn Door pattern on a wooden frame, which would be hung on the dairy barn. As each coat on one quilt block dried, the pair would return to the other—back and forth until the Nason barn quilt was completed and the Neuroths' square was ready to be hung. Eight of the first year's early patterns were painted directly on the barns, which often required working far above the ground. Perched on ladders or on scaffolding borrowed from a local plumber, Patricia and Liz, with the help of Janet Peterson, pushed forward to begin Iowa's first quilt trail. In addition, the Grundy County Farm Bureau Women sponsored and painted the County Fair pattern on the Kitzman corncrib.

The second year, groups such as quilters' guilds, 4-H clubs, and families began creating barn quilts on plywood. As had been the case in Adams County, painting directly on the barn surface had been discarded as too dangerous and inefficient. By the end of 2005, the Barn Quilts of Grundy County included twenty-five barns, which began to bring bus tours and increased retail sales to the towns along the way. In 2008, under the stewardship of coordinator Kelly Riskedahl, the project reached its initial goal of fifty barn quilts.

Patricia had given me a copy of the barn quilt map, along with a CD that accompanied the driving tour. On the way home, I listened and tried to see Iowa in my mind's eye while navigating Atlanta traffic. A narrator provides precise driving directions along the trail, so that drivers can relax and enjoy watching barn quilts instead of poring over a map. The interim between barns is filled with histories of some of the blocks along with narratives from the barn owners and commentary from a local historian—a host of tour guides to provide both driving directions and a context that makes the entire barn quilt project come alive for visitors.

Along with the CD came a real treasure: a stack of glossy Grundy County barn quilt calendars, one for each year, starting in 2005. I studied each page, pairing some with stories I had already heard and excited at the prospect of knowing more. In the weeks to come, I leafed through each calendar over and over until I had chosen a handful of favorites.

I was intrigued by the story—women putting together a quilt trail that would ultimately inspire similar projects across Iowa and in surrounding states as well. Patricia's daughters still live in Iowa, and she had plans to visit, so we coordinated the dates so that we could meet and tour the area together. The evening of my arrival, we had dinner with Lizabeth in Cedar Rapids.

"It was a crazy summer," Liz said. "One time I had to stand on a plank of wood on a grain wagon; we used whatever we could get our hands on. The scariest time was when Mom and I had to take the scaffolding down by ourselves. Every

Opposite:
Patricia Gorman and Lizabeth Wardzinski, Billerbeck barn.
Photo by Barn Quilts of Grundy County, Iowa

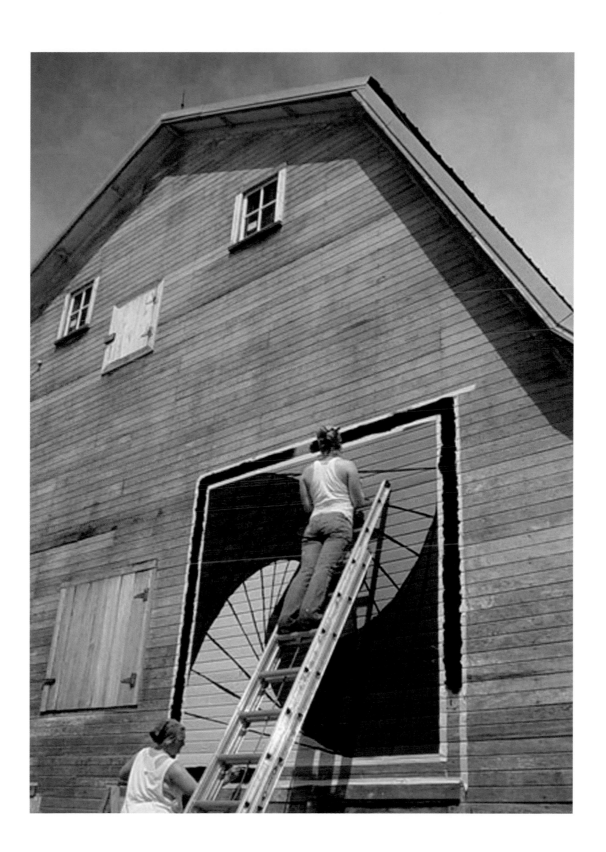

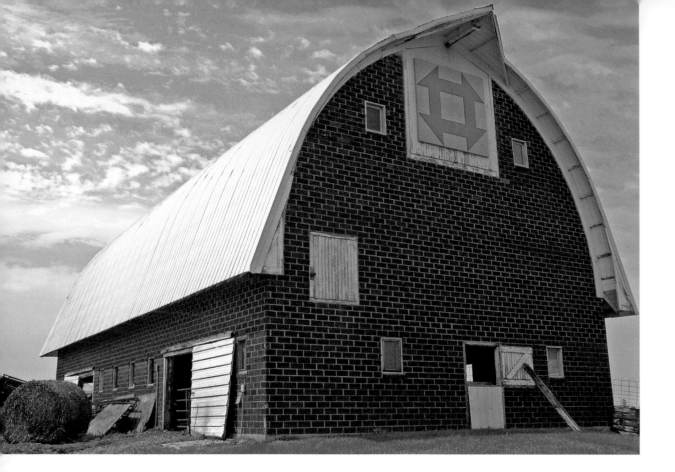

time we got off, Mom would hug me in relief, and it became a great bonding experience. I'm not a country girl, but I learned what a hog house was and the difference between a barn and a corncrib. I also learned that I could fall asleep in the middle of nowhere while waiting for paint to dry. The country is a great place for naps," she confided with a smile. Lizabeth also was pleased to be paid by some of the sponsors for her work as an artist, which enabled her to attend graduate school.

The next morning, before setting out for Grundy County, I met with Ruth Ratliff, an avid photographer who has donated her skills from the inception of the Grundy project to create the calendars that I had come to treasure. Having been frustrated many times in my attempts to photograph a barn at just the right angle at the perfect time of day, I envied her talent. When I asked why she chose to photograph barn quilts, Ruth said that the "bold angular shapes and bright colors" of both the barns and quilts are very appealing to her as a photographer. She never misses a chance to explore Iowa to find them.

Patricia and I drove toward Grundy Center, and I thought of how Donna Sue had described her first visit to Iowa: "It was so different—I wasn't used to flat land, without deciduous forests or curvy roads. For me to see this beautiful splash of color at a great distance getting closer and closer really made my heart soar with pride." Riding along with Pat, I felt that same excited anticipation. The country-

side was unlike any I had seen, and when the first barn quilt appeared, it was all the more magical.

I caught my breath as the magnificent brick barn with its Gothic arched roof and vibrant yellow and green barn quilt rose above the trees. This was one of my favorite "calendar barns." The Churn Dash pattern is mounted on the door just under the barn's roof—the haymow door, through which hay would be loaded into the upper storage area of the barn.

Joyce (Hoodjer) Badrick reminisced both about the many hours that her father had worked in the haymow of this particular barn, with her and her siblings pitching in, and also about her mother's love of quilting. Marlin and Karen Mennenga's family bought the property in 1979, and in 2008, Joyce asked whether they would be willing to host a quilt square for the Hoodjer family. The Mennengas were glad to oblige, as long as they could choose the colors. I hadn't spent quite enough time on farms yet to make the connection between the bright green and yellow of the pattern and a well-known company logo, so Marlin had to explain, "We're John Deere people!" Joyce and her siblings chose a quilt that their mother had often enjoyed piecing, so the barn quilt and its placement honor both of their parents.

Patricia and I arrived in Grundy Center, where a dozen or so barn quilt owners and committee members had gathered to meet with me. Each was asked to share how they had become involved in the barn quilt project. Laughs broke out around the table when Glen Draper revealed, "I was abducted by Pat to be part of the board!" Ann Smith, then with the extension in nearby Tama County, said, "The director came in one day, saying, 'You're never gonna guess what Pat's doing now.' He didn't understand it, but to get her to quiet down he gave her the money!"

As another round of laughter settled, Bill Arndorfer, who directs the Grundy extension, confessed that the barn quilt idea hadn't struck his fancy either, but he hadn't stood in the way. "You see how this has grown with Pat and now with Kelly—how proud people are of the quilts and how welcoming they are to those who visit. Sometimes you have to just get out of the way and let those who have the passion make it their own." It struck me how much Bill sounded like Donna Sue. As she would say, "He gets it."

I was definitely surrounded by true believers. Evie Haupt said that there had never been a reason for people to get off the interstate, and now there is one. "I constantly have people stop into my gift shop who are following the quilt trail," she explained. Arlyn Billerbeck, whose Twisted Log Cabin is among my favorite patterns, told the group of a woman who had come from Oregon to visit with her family; when she got to his farm, Arlyn asked how the visit was going, and she said it was just terrific now, as the barn quilts were what she really wanted to see!

As the stories and laughter continued, the atmosphere was more that of family reunion than committee meeting. A bit of sadness was mingled with the jokes, as

137

the group was reminded that a picture of Venita Kitzman's barn quilt—which she always claimed was the prettiest—had appeared on the bulletin at her memorial service. "I think the barn quilt is what kept her in her house," Ann Smith said, and those assembled nodded in agreement.

An unexpected benefit of the project has been the preservation of barns and other farm buildings. One example is John Conrad's barn, in the town of Conrad. He was tired of paying taxes on something he didn't use, but when he heard about the barn quilts, the barn took on a new purpose. The Conrads are supporters of education, so John wanted the Schoolhouse pattern, which is painted on the barn's doors. Patricia asked the owner, "If you decide to tear the barn down, can we have the doors and put them downtown?" The barn still stands six years later, with no mention of demolition in the near future.

One of the most far-reaching aspects of Iowa's first barn quilt project is the "how to" manual written by Patricia Gorman, combining Donna Sue's advice with a new set of lessons learned. Thirty-six Iowa counties have purchased the manual, and twenty-nine of those have gone on to launch quilt trails. Purchase of the manual includes the rights to use the brightly colored Iowa Barn Quilts logo. The hundreds of signs, brochures, maps, and barn quilt souvenirs bearing this logo add to the quilt trails' visibility and are a reminder that the Iowa quilt trail began in Grundy County.

Donna Sue was pleased with the success of the Barn Quilts of Grundy County: "It was the first time that I actually heard a good example of how to engage the community; the voting was unique and special because it created awareness about the project. I was thrilled with their ingenuity with going to the recycling center and asking them to save the paint for them. Those were two marvelous examples. They actually used a local artist—the money was going back into the community by her being paid." Donna Sue went on to say that the first Iowa quilt trail had "set the bar high" for what could be done.

Both Patricia and Donna Sue were enthusiastic about the possibility of introducing barn quilts to the area surrounding Grundy County, so Donna Sue returned to Iowa to meet with interested groups in the area. She recalled, "That trip to Iowa was a great growth period in championing the trail's development. I felt comfortable and confident about the model and its value and was able to explain what the impact was on communities."

Barn Quilts of Grundy logo

One of the counties Donna Sue visited was Buchanan, where the enthusiasm for the project was still quite evident when I arrived. At the Heartland Acres Agribition Center, we met Judy Scott, who has been at the heart of the Barn Quilts of Buchanan County since its beginning. Judy has an interest in quilts and belongs to two cloth quilt guilds, so she attended the meeting to see what it was all about.

Judy said, "At the end of Donna Sue's presentation, we looked around the room, and somebody had to do it. I thought, why not? I came away as the coordinator."

That was in April 2006, and by July fourth, the group had the first quilt square painted and ready to ride on a parade float, which sparked immediate interest. Three years later, the trail had grown to over seventy blocks.

The Buchanan County barn owners gathered in a small auditorium, ready to share their stories. Betty Wathan talked a bit about her Variable Star barn quilt, which hangs on quite a large barn. She said, "Whenever anyone asks my husband, Bill, why we needed the quilt, he always says it was to keep the barn warm." Another barn owner made me laugh until tears when he proclaimed in a practiced deadpan manner, "Whenever somebody asks me why all these quilts are out there I basically tell them it's to tell the UFOs where to land. That's my story."

Throughout Buchanan County, the painted quilts reflect the interests of the barn owners. The unusual flowers in her garden inspired Anita Hiserman's pink Lotus pattern. Anita considered having her barn painted prior to hanging the quilt square, but Judy Scott insisted that the contrast of the bright pattern against the weathered barn would be "gorgeous." The Heffernen family chose to paint the Weathervane pattern that graces the barn on their Century Farm in green in recognition of Richard Heffernan's Irish heritage. Deb Milbach had tried in vain to talk her husband into hosting a barn quilt, but he had to say yes once Judy found a Scottie Dog pattern that matches the couple's pets. And when Jeannie Mast's children asked what she wanted for Christmas a few years back, she didn't leave them guessing. Jeannie's Eastern Star quilt block, chosen because she lives east of town, is painted in her favorite colors.

Ruth Hamilton's story harkened back to my very first barn quilt expedition in North Carolina. Ruth wanted a barn quilt that reflected the family heritage associated with her farm, and she brought Judy Scott a piece of wool fabric to use as the basis for the block. It was the Hamilton Plaid, which is the tartan for her husband's family. The intricate fabric design was paired with a quilt called Scottish Cross to create a one-of-a-kind barn quilt. Although the painting crew found the project challenging, Ruth is quite pleased with the result.

When it comes to building the quilt blocks, Judy says she is part of a small but efficient team. She credits her "carpenter-in-residence" husband, Don, for making the job easy for her. Judy does all of the priming; he cuts the lumber and puts the boards together; and then the committee completes the drafting and painting. With a snowmobile trailer at the ready to transport the completed squares to the locations where they will be mounted, the Barn Quilts of Buchanan County committee has no plans to stop as long as orders keep coming.

In Buchanan County, I encountered a shift that I didn't expect. Instead of my seeking out the barn owners, they were coming to see me. During my first news interview, when asked how I had learned about barn quilts, I thought, I'm not

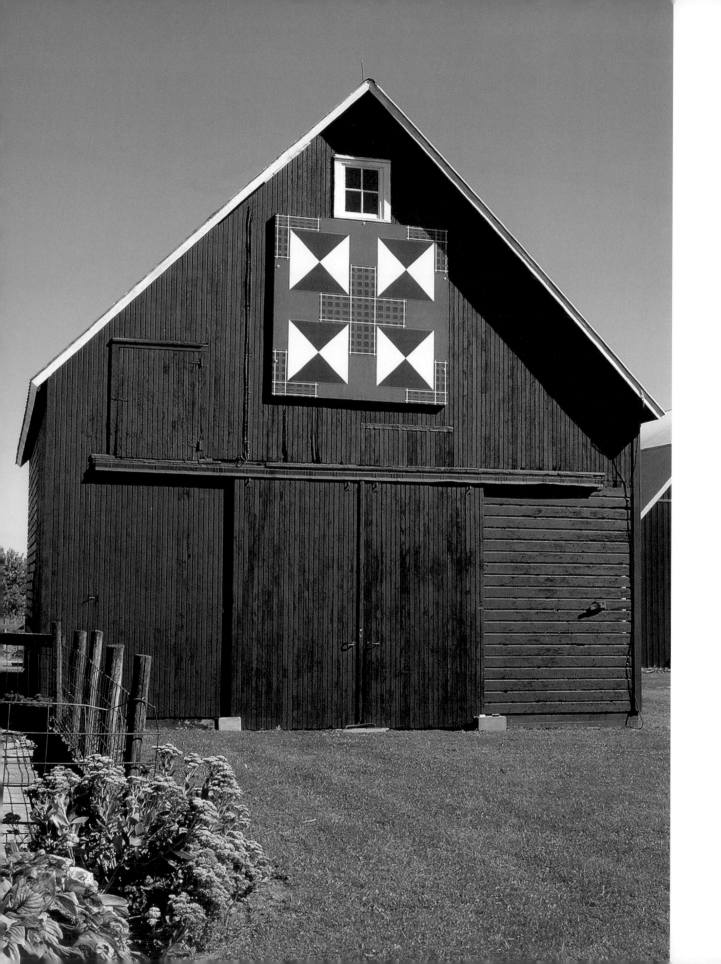

news; the barn quilts are news. But as much as I was fascinated with the story of the quilt trails, people were beginning to become interested in my story. I was glad, though, because speaking about my journey gave me new opportunities to talk about the origins of the trail and Donna Sue.

It was almost dusk—too late to see many barn quilts—but Patricia and I stopped in to meet the committee in Butler County, who also began their barn quilt program after meeting Donna Sue.

I loved the way that Lucille Leerhoff characterized the hanging of her barn quilt. "It was like a birthing," she said of the large group of friends and neighbors gathered for the celebration when her barn quilt was hung. The Ohio Star pattern had been created for Lucille by her grandchildren as a 4-H project.

Lucille also shared a humorous anecdote. After the barn quilt was installed, she wasn't sure what to expect, but a few days later her granddaughter called to her from the yard, "Do you know anyone from Texas who drives a blue van?" Lucille was taken aback at first but soon was outside making new friends. She recalled with a laugh, "I knew right then that we were going to start having a lot of company!"

In my retelling that evening, Lucille's little story struck a chord with Donna Sue; it was the first time I had heard her laugh with delight in a very long time.

Patricia had made arrangements for me to visit neighboring Fayette County the next afternoon. As I drove northeast, the surroundings looked a lot more like the South than Iowa, wooded areas defined by slopes and curves and barns set back into hillsides overlooking the pastures and fields. The barns of Fayette County proved diverse as well: long, low tile barns; wooden barns painted an unusual orange-red shade; and even a tile silo. I found myself enjoying the barns themselves as much as the quilts.

Fayette Chamber of Commerce director and Quilt Trail Committee chair Robin Bostrum came to our meeting with a box jammed full of paper quilt patterns that are souvenirs of one of the most enjoyable activities associated with the Fayette project. She spread them across the large table, a fantastic riot of crayon colors, as she told me about the coloring contest for the elementary school kids who had each created a square. "When they were done," Robin said, "we hung them up, and after four hours, one whole side of the gym was covered with quilt squares!" I looked forward to meeting second-grader Hannah Schmidt, who had won the contest, the next day.

Generating income in the local community was one of the barn quilt project's goals, and Lynn Lauer, who owns a quilt shop in Fayette, created her own opportunity. After the first round of quilt blocks was installed, she designed a set of "Block of the Month" kits so that quilters could create fabric replicas of the quilts that they had seen on the tour. Lynn has had tourists buy one of the kits and then have each month's block sent to them. I thought Lynn's idea a bit odd—

141

iowa

creating a quilt based on barn quilts based on cloth quilts? But she was on to something, as two successful books of quilt patterns based on barn quilts have since been published.

That night I was settled comfortably into Robin Bostrum's guest room but was wakened by roaring winds unlike anything I had ever heard. The rain was thick as a curtain, but I could just make out a few trees that were bent almost in half from the gale. I lay on the bed clutching my purse and the last few days' notes, lest the roof fly off and take those essentials with it. The terror turned into opportunity, though, as the next morning's continued storms—with hail added for emphasis—gave me no choice but to head east to Wisconsin, a state I had not included in my itinerary.

Bad weather had prevented my visiting with any of the barn owners in Fayette County, but that box full of squares from the children's coloring contest and young Hannah Schmidt's winning design stuck in my mind. The barn quilt committee had indicated that the barn itself had an interesting story, and I wanted to know more. A few weeks later, I had a chance to speak with Annie and David Schmidt, Hannah's parents.

Ironically, the Schmidts' barn had been rejected by the barn quilt committee because it sits farther from the highway than most along the route. Even after Hannah won the contest, Annie had to do a bit of talking to convince the committee that the Schmidts' barn, which can be seen from the highway, was a suitable location for a quilt square.

Annie wanted to have the pattern that Hannah had colored for the contest on their barn, but the barn quilt that Hannah designed was already destined for the Fayette County Fairground. Although the usual rule is that patterns are not duplicated, the Schmidts were allowed an exception, as Hannah's County Fair block could be the only choice for their property.

I loved hearing about Hannah's triumph but was also intrigued by what I had been told about the barn, which had connections to a fair from generations past. It seems that after the 1904 St. Louis World's Fair, the lumber used to build some of the pavilions was offered for sale after they were dismantled. David's great-grandfather, Otto Schmidt, saw an advertisement in the local newspaper and ordered the boards that he would need to build his barn. The materials were shipped by rail to a spot about a mile from his acreage and were then transported by a team of horses to the property where the barn was constructed.

David admitted that even the sturdiest barn requires periodic maintenance, but it's simple: "You keep a solid roof on it and keep the water out, and they last forever." I had heard this statement enough to accept it as fact. As for the brightly colored barn quilt, David said, "It's such a neat thing—it gives you an incentive to keep the barn up. After all, you wouldn't want to be the one to break the string."

barn quilts and the american quilt trail movement

With a full day scheduled for a three-hundred-mile drive west, I had time for the side trip that had been nagging at me for several days. A few days earlier, Patricia Gorman and I had met with about half a dozen women in Black Hawk County, where several organizational meetings had been held but the momentum had not gathered to begin a quilt trail. A couple of the women had completed solo projects. The most industrious was Jan Jefferson, who painted a square for the Jefferson Orchard and Greenhouse, a business she and her husband created on his family farm. She had invited me to visit and enticed me with the promise that she would direct me to a quilt square that was unlike any other. She didn't seem the kind to brag, so I had tucked her card away and hoped to make room in my itinerary for a visit.

I set out early and found Jan dressed in work clothes and a baseball cap, tending to some vegetable seedlings behind the apple trees. By this time, I was beginning to think that anything could grow in Iowa. Jan guided me to the end of the 150-year-old barn where her original fleur-de-lis design trimmed in gold blossomed from the gray. It was one of the few fair-weather days I would enjoy in Iowa, so walking around the property was a welcome break. Jan told me that after creating her own barn quilt, she had advertised in local publications that she was a "barn quilt painter for hire." It wasn't long before Lyle Holz pulled his truck into Jan's driveway with a quilt that he hoped could be reproduced in paint. "Then," Jan said, "he showed me a quilt like nothing I had ever seen." Jan tried to describe the quilt, but I couldn't picture it —butterflies made of handkerchiefs? As she had predicted, I had to see it for myself.

You can't get lost in Iowa; after all, there are no curves. But on the way to the Holz barn, I managed to do so. The road, which appeared on the map to lead straight through, dead-ended with a field ahead and forced a turn. I traveled a convoluted route, stopping several times for directions; by the time I located the beautifully maintained red barn along a seldom-traveled side road, my car was covered with dust and I was completely fed up. But the barn quilt quickly made me forget my complaints.

The barnyard was spotless, as if it had been spruced up just for my arrival. On the front of his barn, Lyle Holz had painted the names of each of the family members who had owned it: his great-grandfather who started the farm, then his grandfather, parents, and finally his sister, who passed away. Lyle said, "I did the writing on the barn for my father's side of the family. I thought I owed a tribute to my mother's side of the family, too."

Lyle had seen the barn quilts but didn't have a family quilt on which to base his square. It took some time, but eventually Lyle had the perfect quilt to use as a model. He remembered that when he was a kid, the family didn't have much, but his grandma would get a hankie for Christmas and birthdays, and she was glad to get those. When she passed away, between her and Lyle's mother, they had about

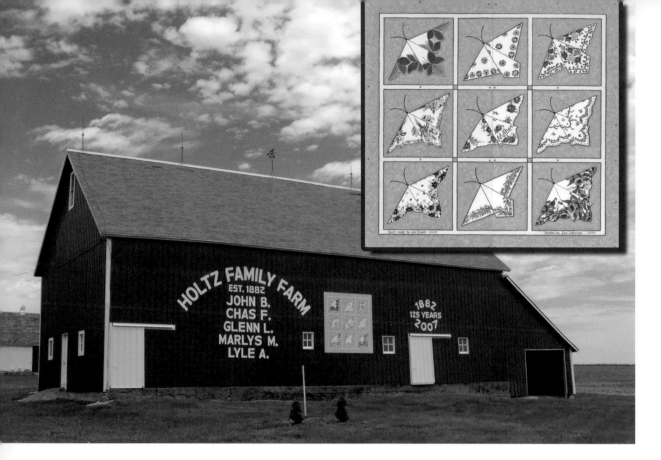

Butterfly Handker-
chiefs, Holtz barn

a hundred that had never been used. I smiled, thinking of the slippers still in their boxes that neatly lined my mother's closet.

The handkerchiefs were laid aside until family friend Lois Stueck saw them when she was visiting Lyle's wife, Alice. From a magazine, Lois had cut a quilt pattern that used handkerchiefs, and she offered to make a wall hanging using some of the handkerchiefs from Lyle's mother and grandmother. If the replica did the original any justice, it was quite a piece of handiwork.

Each handkerchief had been reproduced down to the smallest detail—the border lace on one, the tiny flowers on another. I hoped that visitors would do as I did and walk into the yard in front of the quilt to see it, so that they could appreciate the artist's skill. Then again, this particular barn quilt doesn't get much traffic, as its location isn't published and is spread only by word of mouth. I thought I might post directions to the site on my blog. Certainly Lyle's dedication and Jan's artwork deserved to be shared. Yet I wanted to relish being one of the privileged few for a while longer.

A couple of hours of two-lane highways brought me to the town of Humboldt and the county of the same name. The gathering was a bit unusual, as barn quilt committees tend to attract more women than men, whereas here, mostly men

144

had come out to meet me. Donna Day's quilting group and other women had been readily drawn to the barn quilt project, but Donna realized that for the quilt trail to be a success, everyone would have to get involved, since the barns are the men's domain.

Being an English teacher, I flinched when I heard one farmer state, "We don't neighbor like we used to." But once I realized that he was intentionally using a noun as a verb, I knew what he meant. The tradition of sharing meals and card games at small family farms that had become a vestige of rural life is gradually being replaced by a new tradition that brings the farmers—both women and men—of Humboldt together.

Horace and Doris Adams married in 1947 and moved to the farm in Humboldt that his grandfather had homesteaded some seventy-eight years earlier. Almost immediately, Horace set out to build the sturdy barn with a tile base, which was used to house cows and later pigs. Horace chose the tile foundation for his barn because he liked the look, but there are other reasons for this construction. Another farmer explained that the waste from animals housed within the barn would rot out the boards. The hollow brick also allows air to pass through to insulate the building. The tile portion of the barn usually extends eight feet from the bottom—enough to allow for thorough cleaning of the cement floor with water. "He would have been a poor farmer," Horace said, "if he had eight feet of waste in that barn!"

The Adams chose the Corn and Beans quilt block, which is one of the most common on Iowa farms. The well-ordered rows of triangles in the block are sometimes said to represent the orderly rotation of corn and soybeans from year to year that keeps farmland rich and fertile. Others say that the exact planting of the crops is replicated in the quilt. I like to think that both are correct.

The barn quilt receives a great deal of attention from drivers on the nearby highway, but sometimes that can be a mixed blessing. Horace recalled being awakened at three o'clock one morning hearing voices in the barnyard. "I turned the yard light on," he said, "figuring I would scare 'em. Turns out they were driving through and saw the barn quilt and pulled right in!"

Continuing west through the afternoon, I stopped to see a few barns in Pocahontas County, home to thirty barn quilts as well as "shelter quilts" that were added to the buildings in many of the county's parks and recreation areas. I breezed through Sioux, Hamilton, Sauk, Guthrie, and Howard Counties, stopping for the occasional photo and reaching Plymouth County after dark.

Ruth and Leonard Barker were disappointed that my drive west had taken longer than expected. Their hometown of LeMars is both the seat of Plymouth County and the ice cream capital of the world, and the day of my arrival coincided with Ice Cream Days. After a long drive, I could have used some cool refreshment, but

Corn and Beans, Adams barn

the supply was long gone. I also began to notice a trend. Conrad, Iowa, had billed itself as "The Black Dirt Capital" and celebrated, of all things, "Black Dirt Days." The tradition in LeMars was remarkably similar. I would soon find that celebrating their local assets was common across Iowa—bragging rights and community pride seemed to go hand in hand.

The three of us started out early the next day, in the midst of a steady drizzle. Riding in the back of the Barkers' sedan, I wrote furiously as Leonard talked about the fields that we were passing. The brilliant green fields were soybeans, which were planted in rotation with corn. Leonard explained the "no-till" method of farming, in which the previous year's plantings are left when the next season begins. The curved mounds of land were created to allow for planting while preventing erosion. I was riveted. I had seen plenty of barn quilts and heard a lot about history but had few lessons in agriculture. I scribbled notes as if I were going to take up farming the next day.

If no one had told me, her attention-grabbing presence would have led me to guess that Wanda Phillips had been a teacher. As soon as she found out about the paintings, Wanda declared, "I had to do one!" She knew that a hands-on project was the best way to get the students involved with each other and focused back on the school year. To that end, Wanda worked with her fourth- and fifth-grade tal-

barn quilts and the american quilt trail movement

ented and gifted class to draft the pattern, using a projector to enlarge the drawing. The square on what was once a hog barn is an original design that Wanda created, featuring four ears of corn—one for each of her children. The number also reflects Plymouth County's location near the four corners of Montana, South Dakota, and Nebraska, which was another bit of information to file away. Although the barn where hogs were once raised is now home only to swallows and raccoons, it holds great sentimental value. Wanda fondly remembers the mounting of the square, when a ninety-two-year-old woman took charge of the hanging: "A little to the right, no, a little to the left."

"It was just like hanging a picture," Wanda said.

When we arrived at the Harrington barn, I didn't need to ask many questions, as Karen Harrington had prepared a flyer that told the story of her barn quilt, an unusual design named From Here to There. The two German flags in the barn quilt's design denote the family's pride in their heritage. Her great-grandfather Peter Reese came to America from Germany in the late nineteenth century and purchased 160 acres from the railroad—the standard size for a farm at the time. The quilt square also includes two U.S. flags, which symbolize the American Dream and Peter's success in his new homeland. To Karen, the stripes in the flag represent the rays of sunlight that lit the path to success, while the stars refer to the heavens —the highest place that could be reached. Karen said, "What we have learned from our ancestors has brought blessings and strengthened our family ties." She explained that the hearts on the square are emblematic of the love that the family has for their forefathers and their rural heritage. Finally, Karen's daughters, who designed the quilt block, painted tiny Reese's Cups in each corner—a sweet tribute to the farm's founder.

The next leg of my journey took me to Sac County, about eighty miles southeast, home to one of the most talked-about quilt trails across the country. Over strawberry pie and coffee, the extended barn quilt family—Sue and Harold Peyton, their daughter, Amy, and half a dozen friends—shared their story. The Barn Quilts of Sac County project began with a family trip and a young man's desire to distinguish himself among his peers. Sue Peyton had seen an article about the Grundy County project, and on the ride home from Christmas vacation in 2004, the family saw some of the barns. At the time, her son, Kevin, was thinking toward the Herbert Hoover Uncommon Student Award—an Iowa-based award for high school juniors through the Herbert Hoover Presidential Library. Kevin seized the idea of barn quilts as something he could bring to his community. The timing was perfect, as Donna Sue's early 2005 visits to Iowa were just a couple of months away. With the information from both Grundy County and Donna Sue in hand, Kevin and his family were ready to move ahead.

147

From Here to There,
Harrington barn

The Peyton family's lifelong involvement with 4-H clubs helped their children develop the skills needed to plan a community project. Researching Grundy County's success and brainstorming with family and friends proved useful in determining how to adapt a quilt trail to Sac County. Kevin knew he would need the support of key groups within the county, and the local extension office was instrumental in reaching out to the entire area.

Community groups donated funds, and Diamond Vogel Paint helped defray costs through a Paint Iowa Beautiful grant. Art and agriculture classes from the area high schools assisted with cutting and painting the boards. Sue Peyton was pleased to note that once the schools became involved, there were more barn quilts painted than there were available locations. The first four quilt blocks were displayed on floats during the Memorial Day parade. Sue recalled, "Once people saw the first few, they were raring to go! Everyone wanted to help paint and to have one put up. By October, we had twenty-three."

Naturally, the first barn quilt in Sac County is at the Peyton farm. It was put up on Friday afternoon before Memorial Day so that it would be there for everyone to see on the holiday. The Harvest Star, in bright yellow, red, and blue, is visible from quite a distance against the white surface. Soon, the Peytons' garage became the center for barn quilt painting and provided a space to work in any weather.

barn quilts and the american quilt trail movement

Harold, Sue's husband, said that the entire family "eats, sleeps, and lives barn quilts and has since 2005."

The barn quilts also became a 4-H project for Kevin. At the end of that first year, he was the state's top Hoover Award winner and later became a national recipient of the Prudential Spirit of Community Award; he used the funds to study agricultural engineering at Iowa State University. For this young man, the benefits are more than monetary. "The experience for me has been invaluable," he said. "Seeing the way that different personalities rally around a common goal was amazing. Meeting with the older generation of farmers and hearing their stories of how it used to be—that history is just awesome. I can see how far we have come." The barn quilt project has come far as well, with fifty-five barn quilts to its credit.

The next day, Sue and I set out to visit some of the barn quilts. I remembered her saying that one of the lessons gleaned from Grundy County was to keep all of the stops along the trail on paved roads. As Sue turned to head down a gravelly side road, I thought perhaps she was taking a shortcut, but within moments, a barn with a red, blue, and yellow quilt square came into view. "You know what they say—exceptions to every rule," Sue commented with a laugh, as we walked toward the house where Jean and Al Liske waited.

The care with which the Liske farm was restored had earned its place on the quilt trail. The farm was Jean Liske's "home place," where she was born and grew up. The block and cottonwood barn with its Gothic roof was built during the Second World War, and Jean's fondest memory is of the year after the foundation was poured. The beams to begin construction were not available until the following year, and the delay provided summer entertainment for Jean and her cousins. "It was a delightful summer," she recalled. "We thought that was great—we could actually roller skate on the concrete!"

Some sixty years later, the barn was in serious need of repair. Al said, "We had to do something. It was going to fall down, or we had to tear it down. It was her idea that we restore it, and I think it was a good one." Al made all new doors and had the barn painted. The old lightning rods were put back up even though they're not connected to anything, and the block walls are also original. Jean's dad told Al that it cost them four thousand dollars to build that barn, but just the new roof was closer to five thousand dollars. "He's been gone a long time, and I know he'd be proud of it—that we didn't bulldoze it," Al said.

Jean and Al thought a barn quilt would put the crowning touch on their newly restored barn, but their unpaved road made them ineligible to be part of the quilt tour. Unbeknownst to them, their children approached the committee and pled their case. Sue Peyton said, "They could have just let the barn go. They decided to spend the money and do a lot of the work themselves. When their kids nominated them for this, we thought, 'Even though it's on a gravel road, we'll go ahead.'" After the children surprised her with the happy news, Jean chose

149

Buffalo Ridge, Huel-
man corncrib

the Country Lane pattern: "Since we live on a country lane, on a gravel road, it fits!"

Sue and I drove a while and stopped to photograph some of the quilt squares. She had said that the palette of the barn quilts was kept to primary and secondary colors, and though it might sound dull, the effect was a trail in which each seemed part of the whole. Soon a sea of whirling windmills appeared on the horizon, and Sue explained that we were approaching the slight rise in elevation known as Buffalo Ridge. I didn't discern a difference in the terrain, but a red corncrib set just off the road to the left caught my eye.

Gene and Marguerite Huelman live on the farm where Gene's family moved in 1926. The farm is already well known to those who stop by to stroll through the shade of Marguerite's exquisite gardens. With a corncrib so close to the road and a quilt block named Buffalo Ridge available, the site was a natural choice.

The Huelmans' is a typical corncrib, with a door on one end so that a wagon full of corn could be pulled inside and then loaded into the bins that take up the rest of the building on either side. The boards on the sides of the crib are spaced a bit apart to let air circulate and dry the ears of corn, used for feeding livestock. I crouched in the grass to photograph the building, but Marguerite was having none of that—she clambered up the stairs on the outside of the crib, beckoning for me to follow.

150

barn quilts and the american quilt trail movement

I am not one for heights, but her genuine delight overrode my hesitation. Besides, I had learned a bit about barn construction the past couple of days, and here was a chance to know more. Marguerite opened the door to show the view from the upper level, where the center area holds bins for storing oats and soybeans. Below, Gene demonstrated how the small sliding wooden panels in the ceiling would allow grain to fall from the bins. I marveled at the ingenuity; the same type of apparatus that would require a team of engineers and cost hundreds of dollars today was once fashioned completely by hand.

A cautious descent led us to Gene standing next to a mechanical wonder of his family's crib—an elevator, which picks the corn up and pulls it to the top, dumping it into the bins on either side. Gene said, "For 1926, this was pretty unique; the elevator is original and it still works just fine!" To emphasize his point, Gene flipped the switch, and sure enough, the cups on the eighty-three-year-old mechanism begin rising along the track. Unfortunately, Sue Peyton had chosen just that moment to step into a side bin to examine the construction more closely. A shower of dirt and corn fell around her, and Gene quickly turned the motor off as Sue yelled in surprise and jumped away from the falling debris, causing good-natured laughter all around.

Gene loves his barn quilt, but the first year, when the holidays came around, he had second thoughts. Gene had always placed a manger scene in front of the barn with a light projecting the image onto the building's surface. With the barn quilt, Gene reinvented his manger scene—a painted crib with the baby Jesus lying in the straw that he mounts underneath the barn quilt. He then adds a pair of loving arms. "Like Mary putting the quilt over the Babe," he explained, as Marguerite hurried inside to find a photo so that Sue and I could see her husband's uniquely charming creation.

The Prairie Pedlar looked just as a garden center should—surrounded by layers of shrubs and wildflowers, gazebos, and birdbaths. The business, operated by Jack and Jane Hogue since 1985, is home to the only pastel barn quilt on the Sac County trail: the lavender Double Aster. A brightly colored square wouldn't look right against the gray of the barn, especially because it serves as the backdrop for the weddings that often take place on the property. Jane joked that they probably should have had the Wedding Ring pattern on the barn. "Then again," she offered with a laugh, hoping her suggestion would be seconded, "we could paint one and put it on the other end of the barn, where a lot of the receptions are!"

The barn is distinctive, having been ordered from the Sears, Roebuck catalog in 1942 and delivered by train. This was new to me—mail-order barns? For a moment, I thought that Jack was trying to put one over on the city girl, but he explained that Sears had a special barn catalog in which they sold chicken coops and bins and all

kinds of things. The barn kit included everything except the cement floor and the labor. It had all the nails, enough paint for two coats, and all the windows.

Jack went on to say that almost all of the hip-roof barns like this were built in the war years 1940–45. The reason farmers liked these barns is that there are no beams that hold the roof up; the weight rests on the rafters, creating a larger space in the haymow. The barn was $695 in 1943, which was, according to Jack, very expensive at that time. Jack added that the new shingling that was installed while the barn quilt was being painted cost "way more than $695."

Sue and I continued on the tour, stopping to admire several barn quilts along the way and talking constantly. She took up the story of the Sac County project. The ongoing painting in the Peytons' garage, "barn quilt central," provided an opportunity for clandestine painting sessions. Once again, a group of children—this time a much younger group—convinced the committee that an exception should be allowed.

We pulled into a gravel drive, where Derek, Nicole, and Hannah Huser were waiting. Their father, Tim, explained that because they don't live on a hard-surface road, they weren't accepted at first. I suppressed a laugh—there seemed to be many exceptions to the rules. Nicole told me how much her mother wanted a barn quilt from day one but knew she couldn't have one. The children's wish to surprise their mom won them approval from the barn quilt committee, and they went to work.

The kids found excuses to sneak away and paint the quilt without their mother knowing. They created the design incorporating the Iowa State colors of red and yellow with the green of the many trees on the property. One afternoon, Derek almost ruined the surprise. He was talking to his mom on the phone, and she asked where the girls were. He said they were painting. Before she could ask what he meant, Derek recovered, saying, "They are at Grandma's house—umm—painting something." The "something" was My Mother's Star that the kids painted as a Mother's Day surprise.

According to Hannah, "She had no clue. Mom was at work that day, and when she drove in the driveway, she had tears." The children are proud of their quilt, but young Nicole admits that she is dreading the day that it has to be repainted.

Late in the day, Sue and I stopped in front of a very unusual barn quilt—a purple and gold star with a white angel mounted in front of it, so that the angel seemed to float in front of the painting. Carol Nuetzman's voice filled with emotion as she told the story of her best friend, Kathy Olerich, who passed away right before Christmas. Carol's pastor made the angel and mounted it on the barn as a reminder of Kathy.

Carol continued, "When they were beginning to make the barn quilts, I knew that if I was going to have one, it had to enhance the angel." Sue Peyton added that it took some doing, but they were able to find a way to include the angel and still show off the quilt square. The white angel now floats against the deep purple

Opposite:
Double Aster, Prairie Pedlar

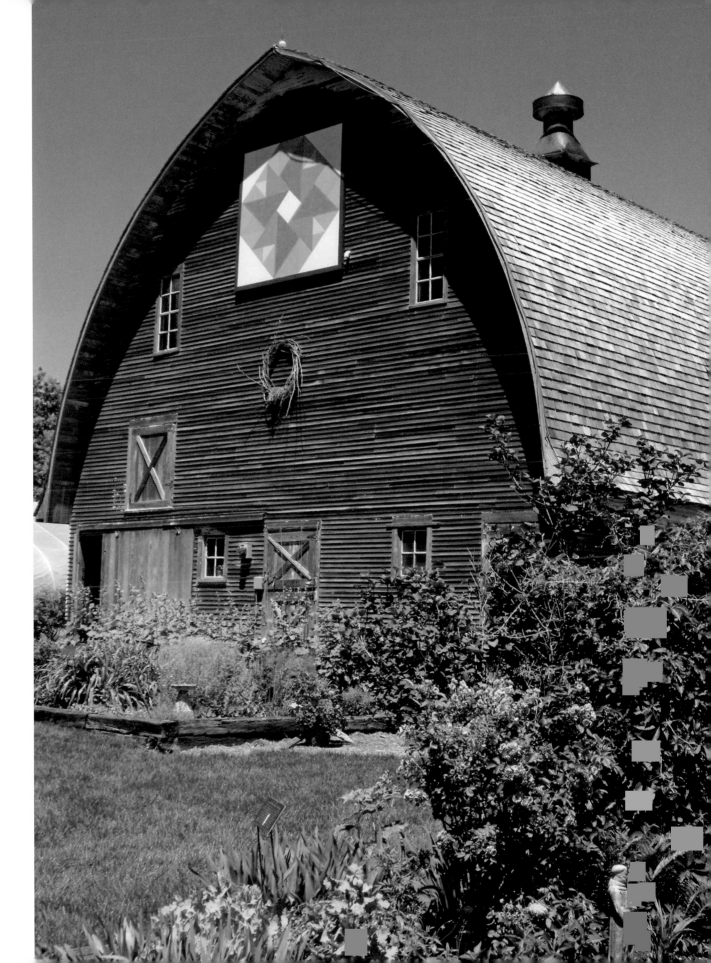

center of the Guiding Star, surrounded by rays of blue and gold. Carol draws a special comfort from the view of her barn quilt at night, when the angel is lit and glows brightly in the darkness. In the peak of the roof, the inscription "1900" serves as another dear reminder—of the year Carol's great-grandfather built the family barn.

Sac County's barn quilts have created a lot of enthusiasm in the community, especially among the many school and 4-H groups who have participated in creating them. Like her brother, Amy Peyton used the barn quilt project to combine community service with an opportunity for her future success. After working on some of the larger barn quilts, Amy coordinated efforts to create "community quilts" so that every town had a small quilt block mounted on posts—with the hope that people would drive through and stop in each part of the county.

Amy also worked with senior citizens to paint quilts for each of the five nursing homes in the county. She coordinated the efforts in Sac City and recruited people to work with the seniors in the other communities. Amy said, "My grandparents were in nursing homes, and Grandpa was in there when we did the painting in Sac. I knew how much that interaction meant to him."

At work on my Mother's Star. *Photo by Sue Peyton, Barn Quilts of Sac County, Iowa*

Her interest in the barn quilts led Amy to work with friend and barn quilt committee member Kathy Cook to document the history of each barn and farm. The result is the book *The Barn Quilts of Sac County*. Sales of the book generate enough income to support the ongoing barn quilt project. The book, along with her other service projects, has helped earn Amy multiple scholarships and awards.

Neil Mason, whose Blazing Star barn quilt was created as a family project, has come to believe that the barn quilts have renewed Sac County. Neil said, "One of the neatest things about the barn quilt organization is that it's so community-oriented. We started digging into the history of the barns and found a purpose for them again. It brought the whole county together, and it was a conversation piece. We needed it, and we still do."

Before I left Sac County, Sue Peyton took me to see the fairgrounds with its 4-H block and to another important display. In Sac City, a glass-fronted building about the size of a storage shed houses an artifact that represents the area—the World's Largest Popcorn Ball. It seems that Sac County is the popcorn capital; I

154

hadn't even known that the snack required a particular breed of corn. The certificate from Guinness World Records sits inside the glass, a testament to the unusual spirit of Iowans that inspires them to find a local treasure worthy of being called best.

■

It was time to work my way east and head home, and I had a route planned that would take me through a few quilt trails and land at one of the largest. Greene County was interesting because it was off the interstate—still accessible by the Lincoln Highway, which once connected America's east and west coasts. Though it has been replaced in some areas by newer roads, it still spans the state of Iowa and is a much-used path for tours of the rural countryside. In Greene County, the Lincoln Highway is also part of the barn quilt trail, which began on Judy Clark's Century Farm. The twelve by-twelve-foot LeMoyne Star's red, white, and blue are the signature colors of the highway and also represent the family's patriotism.

Judy and her fellow committee members heard Donna Sue speak at one of the workshops in Grundy County in 2005 and were inspired. For the most part, the Greene County project relied on the community to help build the trail, one barn at a time. The project's success relied mostly on volunteers from the various organizations who sponsored blocks and from the barn owners, who then brought together family and friends to do the painting. One summer, an Eagle Scout made the barn quilts part of his community service project; after his troop built and primed eight squares, they were easy enough for volunteers to paint. With thirty-two barn quilts in place, the county is well covered.

I had not previously seen the Spools pattern reproduced as a quilt square, and the one in Greene County caught my eye. Barn owner Kathy Walker is a seamstress, a former home economics teacher who now owns an alterations shop. But she never wanted to quilt. Quilter Joanne Schnebly, whose job it was to help select the square for Kathy Walker's barn, knew exactly the right one.

Kathy chose black spools on a cream background—or so she thought. One afternoon, her daughter-in-law Allison looked at the square and said that she saw cream-colored spools on a black background. Upon studying the pattern carefully, Kathy could see that the pattern could be looked at either way. I agreed with Allison that the spools were beige and could not for the life of me see what Kathy meant. As with one of those trick puzzles, I had to look at the design for a few minutes until suddenly I could see the spools turn. "It's like a lot of things," Kathy said. "Two people can be talking about exactly the same thing and see it two completely different ways!"

Committee organizer Judy Clark emphasized that the project has saved many of the area's barns. Quite a few of the barn owners who requested a block started touching up the barns, repairing them, and painting them to set off the barn quilt.

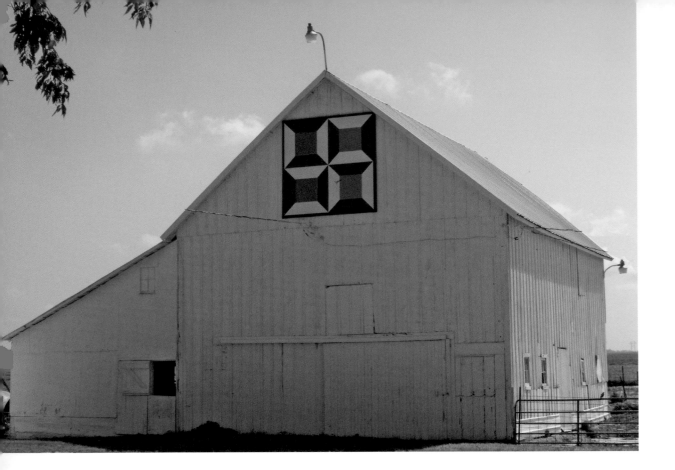

Spools, Walker barn

I heard that sentiment many times in Iowa—saving barns is important to communities where farming is still very much a way of life.

Near the end of the day, I was back in the eastern part of the state and Washington County. Patricia Gorman and I had visited briefly with the women there at the start of my tour, but I wanted to spend a bit more time. The committee members I had met were full of life, and the barn quilting spirit seemed to play an essential role in the community.

When I met the Washington County committee, each was wearing a white shirt with what appears to be a flower outlined on the front. Jane Dallmeyer explained the Pumpkin Seed design. Washington is the center of the county, and the roads go out to the four corners of the county and come back. The four loops of the Pumpkin Seed pattern symbolize the four loops of barn quilts that the group established.

This was one of the newest trails I had visited, having been established in 2007. Nancy Adrian of the county extension helped start the group, and Julie Mangold and her husband, Terry, became the cochairs of the committee. When I visited with Patricia, Julie had been eager to show off the unique quilt block on her barn.

barn quilts and the american quilt trail movement

Following Julie's VW as she flew down the country roads was a bit of a challenge, but we arrived at her barn safely. The quilt square didn't look like any that I had ever seen; the green background was covered with odd white shapes with black stripes. "It's called Cows in the Field," Julie said, but I still didn't get it. A walk around back to the field revealed the origins of the odd design—the banded cows that live on the farm. I had no idea that there were black cows with a white middle section, sometimes referred to as Oreo cows. Another farming first.

Julie directed us to the starting point for the Amish Loop, whose barn quilts are painted in the traditional colors of Amish quilts. About a mile up Highway 1, a white barn sitting very close to the road caught my eye. I soon found out that it was the first to be spotted by the committee when they began looking for barns to form the loop. The Kolosiek barn was one of three barns on the Joe and Carrie Kolosiek homestead and has been known by the family name since Joe built it to house sheep in 1928. Emily Kolosiek, daughter of Joe and Carrie, remembers that her Uncle Frank hauled sand, using a team of draft horses and a wagon, from the English River for the concrete foundation.

Father Charles Fladung, one of the barn's current owners, was honored to be asked to have the barn included in the quilt trail but insisted that the pattern honor the family who had founded the homestead. The barn has two quilt blocks—a Nine Patch on the south side and a Double Nine Patch on the north. The blocks are based on a quilt pieced by Carrie Kolosiek and quilted by her mother-in-law, Mary Pribyl. Emily Kolosiek has used the quilt regularly for eighty years, so it was only fitting that the quilt pattern be chosen to decorate her father's barn. Because some of the squares are white, the painting includes pale blue stitching to replicate the quilter's skill.

It had been a few days since bad weather had interfered with my barn quilt viewing, but in Washington, the clouds rolled in again. Before the weather got too bad, I spent some time with Rosemary Pacha, whose bubbly personality had to make quilt painting fun, and her charming friend Jane Dallmeyer. The two showed me around some of the barns in town, and Rosemary also told me about her barn quilt.

Rosemary has quite an unusual barn quilt and a deep connection to the land. Her pattern was chosen from the Silos and Smokestacks series, which uses pieced construction to depict barns and farm scenes. Rosemary's Barn and Silo block features a red barn on a background of royal blue with a silo firmly attached— a nostalgic representation of the barn whose silo was demolished by a tornado in the 1960s. Rosemary remembers that the same tornado tore the roof and upper section from the barn, where she once made hideouts out of hay bales and swung from the rope that was used to open the haymow door. The Pachas' barn quilt is quite unusual in that it is made of metal and painted with the same iridescent paint used to make highway signs visible at night. Rosemary said, "When

someone pulls into our driveway and their lights hit the barn quilt, it looks just like stained glass!"

Many patterns from long ago make up the Liberty Loop, which leads to Crawfordsville, which proudly proclaims itself home of the first meeting of the Republican Party. The dozen quilt blocks, all painted in the same deep shades of red and blue, are highly visible against the white barns along the way. A Nature Loop and Agriculture Loop include appropriately themed quilts that lead travelers into the southern reaches of the county, where the trail has reached its one hundredth quilt square.

Most recently, in keeping with Iowa tradition, Washington County was named Barn Quilt Capital of Iowa. It seemed fitting that the Iowa tradition of being known as the first, the best, or the largest had finally manifested itself in barn quilts.

My trip to Iowa marked a change in my journey. It was the last place where I would walk in Donna Sue's footsteps, where I would speak to those who had met and been influenced by her. Being her "eyes and ears," as she liked to say, had meant filling Donna Sue in on the progress that had been made in the intervening years since her visits.

From then on, many of the quilt trail committee members I would meet thought that the project originated in Iowa. Some, from Nebraska, Illinois, Colorado, and Wisconsin, had traveled to the state and gone home to build on the tradition. The large number of trails in Iowa and the media attention given to them spread the word to Oregon, New York—the list goes on. As I moved forward, I would not only bring Donna Sue revelations about what her efforts in Iowa had wrought but also share her story with those who had not yet heard of Adams County, Ohio.

Opposite:
Nine Patch, Kolosiek barn. *Photo copyright 2009 Ruth Ratliff*

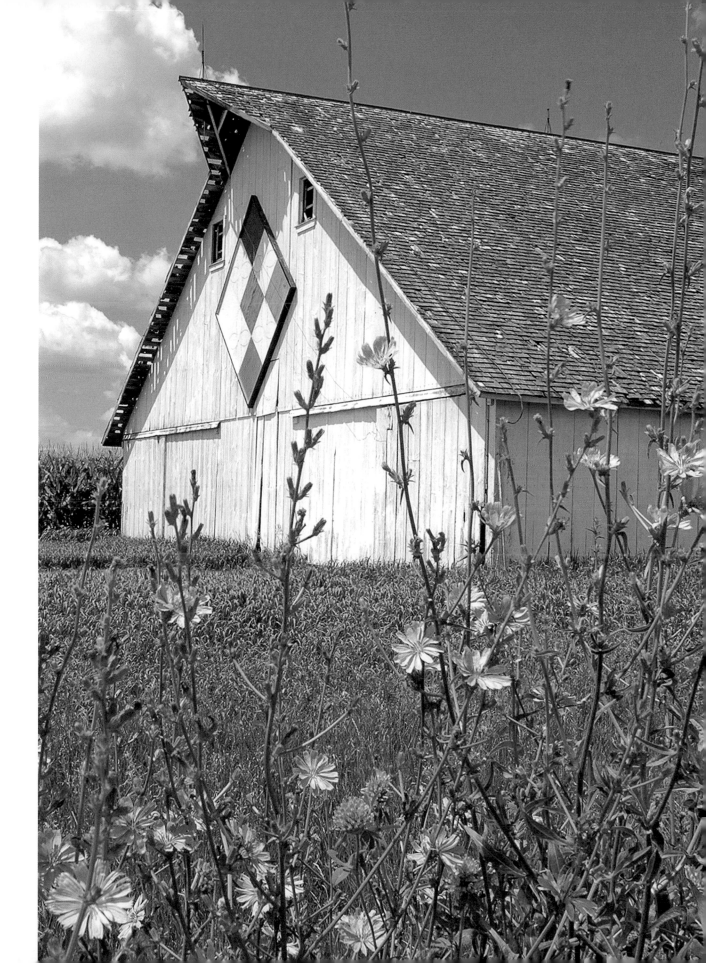

illinois

Donna Sue often remarks that a successful quilt trail needs a "spark plug" to get things going. Holly Froning of the Kankakee County, Illinois, extension office—a part-time employee who devotes countless volunteer efforts to the barn quilt project —is so energetic that she seems more like a teenager than the mother of teens. She gives credit to the committee of quilters, arts council members, and barn owners in Kankakee County and says, "The right people just seemed to join and contribute."

Two skilled quilters, Roberta Renville and Jerry Legan, created a selection of patterns for barn owners who did not have a family quilt to use as a model. Jerry is also a retired engineer, so he felt sure that he could draft the quilt blocks. Alex Panozzo had a vacant farm stand that could be used for painting. He and Roberta Renville bought the supplies to begin the project and were later reimbursed as barn owners paid the fees for their completed squares. Holly went on to say that without their generosity, the project would never have been able to get started when it did.

My first contact with the Barn Quilts of Kankakee was through Clayton and Carolyn Pratt, who discovered barn quilts while visiting bicycling friends in eastern Iowa who were participating in RAGBRAI, the annual weeklong bike ride across the state. A fellow rider spoke enthusiastically about the numerous quilt squares he had seen along the route, and the next day Clayton and Carolyn set out to see for themselves. On returning home, they shared the information with the county tourism office, which recruited the extension office and Holly.

During our first phone conversations, Clayton Pratt mentioned that a local café called Blues had the best pie I would ever taste, and he insisted that I had to experience it firsthand. I demurred, but over a few months of e-mails, the enticement continued, with a new variety of pie worked into the conversation each time we were in contact. Eventually, the Pratts' determination—not the sweets—convinced me that something worth seeing was going on in their community.

Though the Pratts had been instrumental in creating public awareness of the project, Clayton Pratt modestly claimed, "We're just the photographers." The two "photographers" have been responsible for creating promotional posters and calendars and for keeping the Kankakee barn quilts in the public eye—most notably via a series of YouTube videos. The first video in the series was an overview of the project, but the second featured a unique group of artists who took barn quilt painting to a new level.

Pat Alcorn's class of homeschooled high school students, including two of her own children, painted two quilts in the trompe l'oeil style—a phrase that means "trick the eye" and refers to artistic techniques that create the illusion of three dimensions on a flat surface. The first of the students' barn quilts was created for Irene Solecki's corncrib. Irene said that Holly suggested that Irene's daughter, Pat, could paint the quilt with the kids in her art class. When it was time to pick out a pattern, the two came across Golden Wedding Ring. Irene's husband, Ken, had recently died, just before they would have been married fifty years. Pat added that she and her mom quilt together from time to time, so they used the colors from a quilt that they had collaborated on about twenty years earlier.

I had seen the painted quilt on my computer screen, but as is so often the case, it was far more impressive in person. I spent a few minutes admiring and photographing the unique creation before heading to the Soleckis' home to speak with the artists. The teens were lined up against one side of the porch, brimming with excitement at the prospect of being interviewed.

As the seven young people talked about their experiences painting the barn quilt, it became evident that the project was a lot of fun but also a lot of work. Katelyn Glidewell said, "To me, drawing it was the most difficult part." With a wide smile, her brother Austin immediately contradicted her. "It was the shading. When we were told we were going to do shading on it, we didn't know what we were in for—you have to do the same color over and over to make it darker." Katelyn agreed that creating the illusion of depth was tedious, as it took six students about six weeks, working one small section at a time. Pat Alcorn knew better than to keep track but is sure that altogether, the painting took hundreds of man-hours.

All of the effort was worth it, as the Golden Wedding Ring painting looks so realistic that even a careful look fools the eye. Irene Solecki laughed and recalled, "A lady came by and said, 'I can't believe they would hang that quilt up there. Winter is coming, and it will be torn to pieces!'"

barn quilts and the american quilt trail movement

Kankakee home-schooled students.
Photo by Pat Alcorn

The homeschooled students were so pleased with the enthusiastic response to their work that they had to outdo themselves with another three-dimensional creation for the Rosenbooms' Pilot Grove Farm. Marilyn Rosenboom has two quilts in the Lone Star pattern and asked that the painters incorporate the red, white, and blue that appeared in one of her quilts, adding bandanna fabric for a creative touch.

Pat Alcorn was thinking about just how to approach this project when her family went to Rome, where in the Sistine Chapel they saw how Michelangelo painted draped fabric. They used photographs of his work as a model and then added polka dots to the background to make the pattern look more like cloth and to allow the shading to show up better.

After working so hard to perfect the shading, it was back to fun. Trevor Alcorn said with a grin, "We did look at handkerchiefs, but then we just made up the designs. If you look at that one"—he pointed to one of the swirls on a red section—"it looks like a dog's nose. I didn't mean to do it," he said mischievously, "but our dog, Lucy, was always around us!"

After the group finished, they celebrated by taking their own tour of the county. Katelyn recalled, "We liked seeing the many patterns that were chosen for different barns that suited people's tastes." Still, whenever she passes one of the group's creations, she can't help but acknowledge, "That's a good-looking quilt!"

One of Jerry Legan's designs, the Quiltmaker's Block, hangs on the Diefenbach barn, where Warner Diefenbach keeps a guest book in the milk house and

163

loves to share stories of decades past. Warner particularly remembers the summer of 1933. With the excitement of a young boy describing his first day at school, Warner recounted the unusual process used when his father decided to extend the length of the barn. "Dad got the contractor out here, and he said the best thing to do was to dig the foundation and do the cement work and then cut off the front of the barn and move the shell right on out." I thought I had heard him wrong—cut off the front of the barn? As we walked, Clayton Pratt assured me that indeed, that is what had been done.

Warner pointed out the spot on the inside of the barn where the front once stood. "They put a plank on here and put some oil so it would slide easily. My uncle had a John Deere tractor with steel wheels—he came from a mile and a half away to pull it. They had to have a lot of manpower because as they pulled the wall, it would tip one way and then the other. I was eleven years old," he recalled with delight. "It was very exciting."

Warner pointed out the barn's construction. The old structure has mortise and tenon joints—a traditional method of joining boards in which a protruding tab, called the tenon, is created on the end of one piece of wood by cutting inward from the edges. The mortise is a slot cut into the center of the board that is at a right angle, into which the tenon is placed. These joints are known for their sturdiness, as Warner loves to demonstrate. Reaching high above the doorway on the side of the barn, Warner produced a carpenter's level and placed it on a crossbeam. "It's held up quite well," he observed with feigned surprise as the bubble came to rest perfectly in the center of the level, indicating that the barn where he has farmed since three weeks after graduating high school hasn't budged an inch in seventy-five years.

That night, what would become an annual event was scheduled to take place inside the Rosenboom barn. On arriving at the farm, I took a few moments to get a good look at the Lone Star barn quilt that the teens had talked about. I knew for certain that it was a flat piece of plywood. I had even seen photographs of it being painted. But the painting fooled my eye; I could not see it as anything but three-dimensional.

The Rosenboom barn has been converted into a party space and also is home to a collection of barnyard artifacts. My lack of knowledge led to quite a few chuckles, as Russ Rosenboom strolled from one to the next. "Guess what this is? Nope—it's not an exercise machine; it's a pedal-operated grindstone. A whisk? No, this is a cleaner for oil lamps." I was certain that I was the butt of a joke when Russ insisted that a pair of conjoined wheels in a sort of vessel was a hog oiler, but I later confirmed it to be true.

The Rosenbooms presented me with a foot-long spiked piece of iron identified as a corn drier, which now serves as a window decoration and seasonal holiday

ornament holder in my Georgia home. By the time the educational tour ended, most of the barn quilt community had arrived for a potluck dinner; once again, I was subject to overfeeding. Afterwards, some of the barn owners took the opportunity to tell the stories of their barn quilts.

Dean Larson was practically giddy with excitement when he spoke. The Larson corncrib, out in the northeast part of the county, is home to a traditional Corn and Beans quilt square. Dean remembers moving to the farm when he was six. His father had been a sharecropper, so the family had not lived in a large home. Poor Dean got lost the first time he was left to wander the two-story farmhouse

Lone Star, Rosenboom barn

165

alone! Dean and his sisters thought that living on the farm was a curse. Dean wondered why the city kids didn't have chores, and sister Beverly agreed. "We had to literally 'tote the bale,'" she recalled. "I was terrified of the 'business end' of a cow and hated working in the gardens. It finally occurred to me—'This is what we're going to eat!' After that, I learned to appreciate the farm. I used to lie down in a wheat field and look at the clouds and just step away to a world of my own."

The renovated farmhouse and the quilt square on the corncrib pay tribute to Dean and Beverly's love of the land and to the hard work of their parents, who made it when no one thought they would. Their father drove a school bus to make ends meet and was very careful with the family's resources. Dean gave me a chuckle when he said, "Dad saved everything! In the milk house, I found a ring of keys with a note attached that said, 'These keys don't go to anything.' When I have a bad day, I go out there for a laugh."

Chris Doud had admired the block barn along the Kankakee River since she was a child, and when it came up for sale in 2006, she and her husband, Mike, were ready to buy. Chris admits that the neon-colored Fish block, chosen because of the barn's location, is "a bit loud," but the colors suit her upbeat personality. Chris explained how she personalized the classic pattern: "I had some of my dad's neckties from the seventies, and some of them are so cool—the colors and patterns are bright and wild, and I thought if I used those, my quilt would have a lot of personality." The block's spotted and striped sections of brilliant blue, green, orange, and yellow are taken from the ties and give the block the look of being pieced with fabrics from the disco days.

The Douds' barn made the news in May 2009 when a car plowed through the building. Chris remembers the crash that woke her at one a.m. when she ran outside to see taillights shining from inside her prized barn. She called Holly Froning to tell her of the crash, and Holly's first question was, "Did he hit the barn quilt?" Though a big chunk of the barn was ruined, the quilt square remained unscathed —a testament to the endurance of barn quilts in the area.

In just two years, the Barn Quilts of Kankakee have become an integral part of the landscape, and even the youngest residents have taken notice. When a local children's theater group put on a production of *Charlotte's Web,* a barn was part of the background set. The barn was in place, but the children weren't satisfied until they had a barn quilt painted on it to make it their own. With the new generations firmly convinced that barn quilts and Kankakee go hand in hand, I left with the feeling that the project would continue to grow and thrive.

A couple of hundred miles due west, where it reaches the southern border between Missouri and Illinois, the Mississippi River curves northward to catch the waters of the Illinois and doubles back to head south again. Calhoun County, Illi-

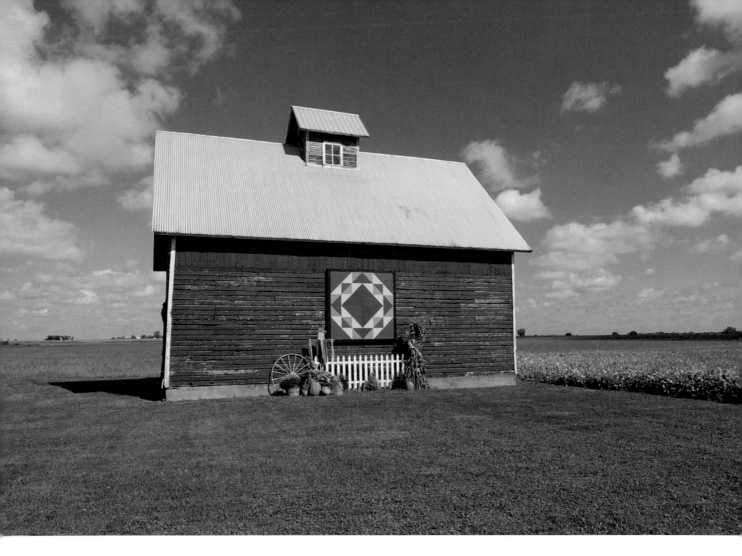

Corn and Beans,
Larson corncrib.
*Photo by Carolyn
Splear Pratt*

nois, occupies the narrow peninsular area created in between. This isolation helps keep the natural beauty of the grassy glades and river views intact but poses difficulties with regard to economic development. Like many other rural counties, Calhoun sought to promote agritourism and still preserve the natural beauty of the area. The barn quilt projects of Iowa provided the inspiration, but few in the community of five thousand wanted to participate.

Robbie Strauch recalled, "We kept telling people what we wanted to do, but we had to *show* them what we wanted to do." To that end, local artist Jill Rulan painted a quilt block based on one that her husband's mother had made. It was a 1930s quilt, and the Strauch barn dates to the 1930s, so it was a natural fit. The Flagstone pattern on the Strauch barn generated enough interest that the community adopted the idea and organized their efforts.

Jane Wilhelms, a member of the newly formed barn quilt committee, proposed an unusual fundraiser: Quilts and Churches. On an October weekend in 2007, seven little churches of different denominations were full to the brim with

illinois

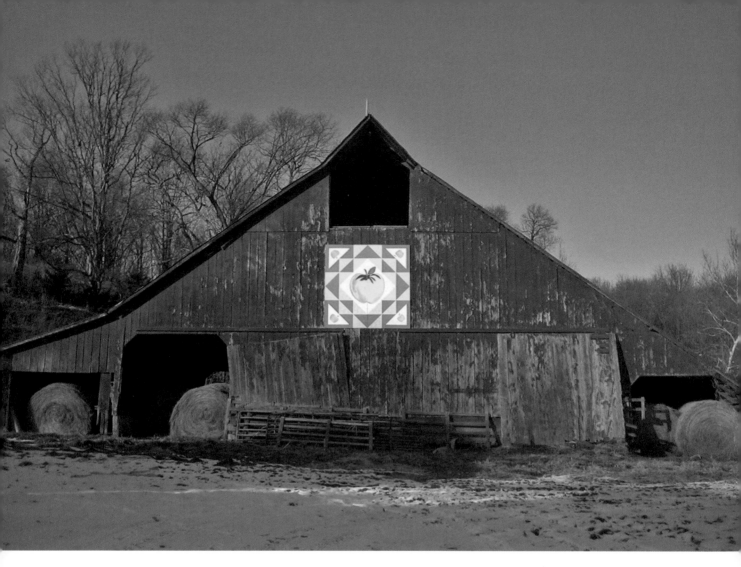

ABC Block, Brangen-
berg barn. *Photo by
Julie Brangenberg*

handmade quilts. "They were so beautiful displayed against the pews," said Jane.
Attendees were given gloves with which to handle the quilts, some of which are
more than one hundred years old. The event created an awareness of the rich his-
tory of quilting in the area and provided funding for the first four barn quilts in
Calhoun County. The tour was so successful that the 2008 event included tour
buscs and received four hundred visitors over one weekend. Twelve of the origi-
nal quilts displayed at the churches were used as models for quilt squares.

The simple pattern of the quilt block on Barbara Ledder's horse barn didn't
impress me all that much initially, but it has an interesting history. The quilt block
consists of squares in all different colors, and unlike most quilt fabrics, the ones in
Barbara's block are mostly dark and drab—browns and grays and even black. I was
surprised to learn that this was a replica of a family quilt and was eager to know
its story. Barbara's father and his grandmother ran a store in Golden Eagle that
was the center of the community. They also had a movie theater and even sold

168

farm equipment. Men could come to the store and have suits made to order, selecting the material they wanted from squares of fabric on a board.

Barbara's great-grandma was very practical; she pieced the rough squares of material from the samples and used sheep's-wool batting to make a quilt for each grandchild. Barbara's mom, Betty, has one of the "Suit Quilts," and when it came time to select a pattern to be painted, that one just had to represent the family by hanging on Barbara's horse barn.

I love adaptations of traditional quilt patterns to fit the location, and the one on the Brangenburg farm is certainly one of the most unusual. The ABC (Apples, Beans, and Corn) design is an adaptation of the traditional Corn and Beans pattern and was made to order for the spot. Joseph Brangenberg Sr. established the farm in 1870, and Joe Jr., one of ten children, bought part of the farm from his parents and established an apple orchard. His apples became acclaimed, so much so that Joe became known as the "Golden Delicious Apple King" of Calhoun. In 1933, Joe's crop brought in enough money to build a house on the property, and the hillside behind his red barns became known as "Golden Delicious Hill." Current owner Julie Brangenberg said, "We wanted to help with tourism and economic development in the county, but now I love the way my barn looks with the quilt on it."

The barn quilt project has helped to unite Calhoun County and to forge many new friendships. Artist Jill Rulon, who painted the first quilt and several of the others, said, "I have friends now from river to river. This has brought this county to a place where it has never been unless there has been a flood; the only thing we have ever done together is sandbag to keep the water back. It's amazing—I feel like we are throwing a blanket over the county; we know who we are."

I appreciated Jill's sentiment and was reminded how many times participants in barn quilt projects across the country had spoken of the sense of community and the joy of new friendships formed that accompanied their efforts. Each time I heard a similar statement and shared it with Donna Sue, her humility astounded me. "It could have been anything, Suzi," she maintained. "It just happened that barn quilts came along at exactly the right time." Perhaps she was right that the quilt trails had fulfilled an unspoken need that people had to find ways to rebuild communities. But Donna Sue's intuition had brought them just the right thing.

wisconsin

I HAD DOUBTED WHETHER I would make it to Wisconsin, as the state isn't on the way to anywhere I planned on going, but I wound up making two trips there. The first came during my escape from the hailstorm in Fayette County, Iowa. I had been in touch by phone and e-mail with quilter Lynn Lokken, who was one of the driving forces behind Wisconsin's first quilt trail, in Green County. It was a six-hour round-trip, but having flown across the country, I didn't want to waste a day. Lynn was pleased and stunned to hear that I was on my way, so she took the afternoon off and was ready to take me on the tour when I arrived. We hopped into her car and headed off, and I immediately saw that, as expected, most of the barns were dairies—with large walls suitable for barn quilts.

Dave Wald was working around the barn as we arrived, and he greeted us enthusiastically. His was one of the first barns in the county to receive a barn quilt. A flock of gray doves nests in the barn, so it was only natural that the pattern chosen be Doves at the Door. Marcia, his wife, loves to wear black, white, and red—as when we visited—so the black and white quilt block on the red barn suits her perfectly. "It's a great source of conversation," Dave said. "Strangers pull up in the driveway and want to know all about the farm—'How many cows do you have? How much do you milk?' It's nice to be able to tell people about what we do here."

Lynn and I stopped at several farms, but the Devoe barn grabbed my attention as soon as we approached. The bright white barn with its neon-colored quilt

block seemed too perfect for a working farm. But as she shook my hand, Yvonne Devoe wore the weathered look of many hours of labor. She apologized for not being able to chat, as it was milking time. I was delighted at the chance to observe the process, so Yvonne led us into the milking parlor and set to work. Her young daughter joined her, and the two worked without stopping as I watched each step of a ritual to which I had never given much thought. I was fascinated by the efficient operation, with eight cows entering, backing into place, being cleaned and attached to the milking machine from below, then continuing out when finished, and the next set following almost immediately after. I will never buy a gallon of milk again without imagining Yvonne Devoe hard at work.

When the milking was completed, Yvonne took a break and talked a bit about her barn quilt. Because she gets up at 3:45 each morning, Yvonne needs something bright and cheerful to energize her as she begins the long day on the farm. While her husband is in the fields, Yvonne sees to the twice-daily milking and maintenance of the milking parlor in spotlessly clean condition. Such an extraordinary amount of work called for an extra-colorful barn quilt, so Yvonne chose the Italian Tile pattern, whose myriad colors shine brilliantly in the sun. She loves the energy that emanates from it: "It helps me through the day." In between farm chores, as she works around the house and takes care of her family, Yvonne can't see the barn quilt through the windows. She has a small replica of her barn quilt mounted under the low roof of the milking parlor so that she can see it out her window and be inspired just a bit more.

Jeanette Crooks, whose friends came together with volunteers throughout the county to paint a barn quilt for her when she was gravely ill, is not at all surprised that the quilt squares have become so popular in the area: "They honor the barn—that is the culture here. Everyone here, even if they now are in the city, they always remember going to visit grandma on the farm."

It was time to head back to Iowa, as I had a schedule to keep. As I sped through Lafayette County on my way out of Wisconsin, I regretted that I hadn't the time to stop and make a few visits. I knew that a small group of dedicated women had created about forty barn quilts there but also knew that I needed to find a main highway before dark. A few months later, I spoke with Lafayette County resident Mary Jo Stutenberg, who eagerly shared her story.

Mary Jo had a barn quilt prior to the countywide effort, but it wasn't by her own doing. While driving to Illinois in the summer of 2007, she saw a quilt square, and after a bit of research, she felt ready to paint her own. She narrowed her choice of design to three patterns, with plans to complete the project the next summer.

"I must have talked about the barn quilts enough," Mary Jo said, "and my sons' significant others listened." In early December, her son Matt, who lives in

Italian Tile, Devoe barn

Iowa, got together with his brother Kevin, who is in the military, and started planning. They spent one blizzardy weekend painting a quilt as a surprise Christmas gift for Mary Jo and her husband. Of course, the brothers had a bit of a surprise as well—they got snowed in while painting.

The quilt block remained hidden in the barn until Christmas morning. Mary Jo recalled, "They gave me the book from Sac County and a book with photos of them painting, and it started to click—'Oh, my gosh!' It was a neat surprise, and we can look out the bedroom window and see it right on the barn."

The pattern they selected is American Pride, which had been Mary Jo's first choice. It represents Kevin's service in Iraq for about fifteen months, and it is also a tribute to the young men's grandfathers, who both served in World War II.

Some months later, Mary Jo's story resurfaced, this time in Kentucky, during a conversation with jewelry maker Randi Gish Smith. Randi had recently begun

173

wisconsin

creating clay jewelry when she saw the many barn quilts going up in surrounding Fleming County, Kentucky. She thought that she might reproduce some of the colorful quilt patterns using polymer clay and created a charm patterned after the block on the local extension office as a sample. Soon Randi was traveling to festivals throughout the state, working with individual counties to replicate their barn quilts in wearable form to help promote the trails and to allow barn quilt enthusiasts to "own" their favorites.

At every opportunity, Randi shares Donna Sue's story and her own enthusiasm for the quilt trails. Randi told me how much enjoyment the project had brought to her, and she went on to give an example. A young man was returning from Iraq and happened to stop by a festival in Kentucky, where he was excited to see Randi's work. He explained that he was headed for Wisconsin, where he and his brother were going to paint a quilt as a surprise for—I stopped Randi in midsentence. Surely it couldn't be. I had to ask—was the pattern American Pride? Sure enough, Randi's newest custom design was a replica of Mary Jo Stutenberg's barn quilt! I felt a sweet sense of accomplishment at being able to piece together the two stories from across the country.

I definitely didn't plan to visit Racine—another out-of-the-way spot. I contacted Kathi Wilson, who had brought the project to the area, so that I could find out a bit about the trail. Kathi immediately became determined that I ought to visit. I just couldn't—honestly. I had only so much time. After a few entreating e-mails, Kathi started to mention a pastry called Danish Kringle, which apparently is produced only in a very small area. Like the Pratts of Kankakee, Illinois, Kathi managed to sneak a mention of the sweet delicacy into every message we exchanged. It seemed as if a conspiracy was afoot. All right, I would glance at the map. It wouldn't be easy, but a flight into Chicago, a dash up to Racine, and then a drive down to Kankakee could be accomplished within a long weekend. Thus I returned to Wisconsin.

I met Kathi at a Frank Lloyd Wright building that serves as the offices of the chamber of commerce for the area. Seeing one of the great architect's works for the first time set the tone; here was a bright spot, and we hadn't even gone near a farm.

We quickly toured the city of Racine, along the shores of Lake Michigan. Lighthouses and drawbridges, marinas full of sailboats, and a crescent of beach are just a few blocks from the beautifully restored downtown and historic district. Westward from the city into Racine County, past the suburbs and industrial area, the landscape quickly becomes more rural. I was reminded of Atlanta when I had first arrived in the 1970s. A fifteen-minute drive from downtown in any direction led to farmland of every kind.

barn quilts and the american quilt trail movement

Kathi doesn't work for the visitors bureau or the chamber of commerce, but she always has an ongoing project in the works. "When I least expect it," she said, "an idea will present itself." An article about the Grundy County, Iowa, barn quilts suggested the perfect road trip for Kathi and her mother, who enjoyed photographing the scenic barns; they came away convinced that the barn quilts were perfect for Racine. A single ad asking for interested barn owners yielded fifteen who wanted to participate.

Though Kathi is the spirit behind the project, she has kept the reins loose—"The least control the better" is her motto. Each barn in Racine has been painted by a different group—from Girl Scouts and Boy Scouts to Cops 'n Kids to quilters' guilds and families. I was impressed when she showed me the preassembled "painting kits," a box containing a can of each color of paint, tape, and brushes that were delivered along with the boards. There wasn't much control, but organization was firmly in place.

A tour of the Racine countryside threaded past apple orchards, pumpkin farms, and markets along with a series of beautifully preserved historic barns. We approached a barn with "Rose Hill 1918" emblazoned in white on its end, with the barn quilt barely visible at the far side. Sherry Gruhn explained that the land and barn were part of what had once been the Vyvyan farm, since then divided among the nine children. I enjoyed seeing her Swinging on a Star quilt square, but the main attraction for me was a portrait-sized photograph inside her home. The yellowed photo is of the raising of the gabled-roofed barn, which shows dozens of men standing blithely along the beams of the frame and anxious white-clad women watching from the porch. I had always pictured a barn raising as a bunch of overalled farmers heaving boards into place, not a Victorian social event.

Kathi insisted that I had to visit Jean and Phil Jacobson, who live in the township named the Town of Norway, with the first Norwegian Evangelical Lutheran Church in the United States next door. A retired county commissioner and renowned Master Gardener, Jean now spends eight hours a day doing what she loves—tending to the grasses, hydrangeas, hollyhocks, and ornamental shrubs with which she has landscaped the property around the house and barn. The gardens were magnificent, more like the grounds of a luxury resort than a barnyard, replete with ornamental iron art tucked among the plantings.

It was only fitting that the Norway Garden Club painted a Flower Basket for Jean's barn. Jean is something of a storyteller, and her account of the women working together to paint was quite amusing. Because the boards were laid flat on sawhorses as they were being painted, the women did not have a bird's-eye view of their work. Out came Ed's ladders, and the ladies took their turns climbing up and challenging each other: "You go higher. No, you!" as they continually checked the results from above. I couldn't help thinking that perhaps those sawhorses were simply a bit too tall. The artwork looks perfect overlooking one of the gardens,

but Jean said that one of the best things about the project was working alongside others and sharing the joy of accomplishment.

"Really," Kathi said as she slid a buttery Danish Kringle into the backseat of my rental car, "I'm not sure it's just about the farm or about quilting. It's about community. I have met so many people through this project who are now like family to me." Her comment echoed a sentiment that by now I had heard many times.

■

There are many counties in Wisconsin with quilt trails under way, but there was one other project that really caught my attention. Many 4-H, scouts, and other youth groups across the country had participated in their areas' efforts, but a few projects were designed specifically with education in mind. Being a teacher myself, I thought the way that the folks in Kewaunee, Wisconsin, had put together their quilt trail showed how well barn quilts could be used in an educational setting.

Jennifer Gozdzialski, a volunteer at Agricultural Heritage and Resources in Kewaunee, had heard a bit about barn quilts, but on the day a second neighbor mentioned them to her, she began to give the idea serious consideration. That evening, she called 4-H leader Nancy LaCrosse, who had heard about the project for the first time the same day. The two presented the idea to extension agent Jill Jorgensen, and the women worked together to plan a service-learning project that would involve 125 high school students.

The kickoff event at Agricultural Heritage included a professor who taught students about the differences in the typical structures of barns built by settlers of various ethnic groups. A textiles teacher discussed color choice. This project wasn't just about painting pretty designs; many lessons were built in. Students were assigned a farm family and began interviewing the barn owners, asking about their histories, both of their families and of their farms, so that students could assist with selecting an appropriate pattern.

The bright blue and white Nine Patch quilt at the Ratajczak farm was one of the last few put into place, and its appearance fascinated me. Joe Ratajczak said that as far as he knew, the man who built the barn had been a sailor on the Great Lakes and used the lake as a level because the water is always level—but he acknowledged that the story might be just folklore. The Ratajczak property does sit along the shores of Lake Michigan, so the lore might not be so far-fetched.

The barn's octagonal shape is unusual, but Joe said that it was quite common in the nineteenth century when the barn was built. When he began to explain the arrangement of the stalls, like spokes of a wheel with the hay chute in the middle, I realized that the concept was exactly the same as the twelve-sided version I had seen in Champaign County, Ohio. And like that other barn, this one had a rectangular addition attached later, when it was time to expand.

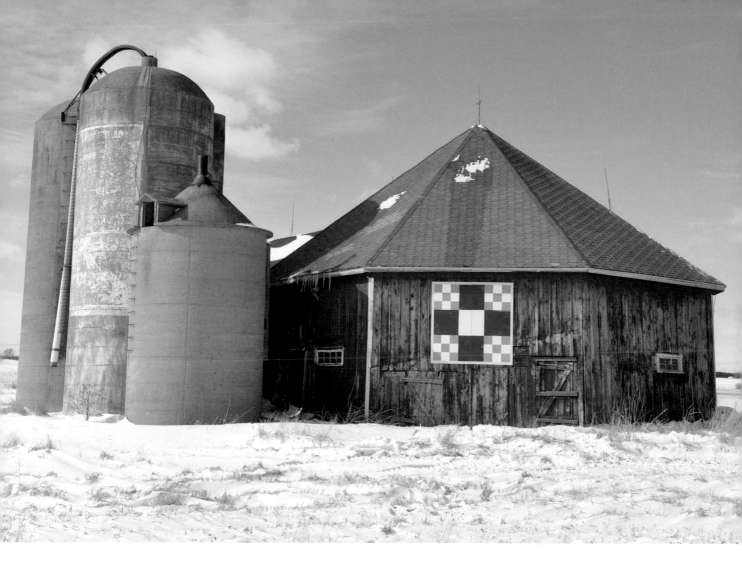

When asked why he chose the simple Nine Patch quilt pattern for his barn, Joe answered, "I wanted a simple design. After all, the barn has enough angles already!"

Jennifer Gozdzialski was pleased that the focus remained on the kids and made the project a true learning experience. They learned about the types of barns and the history behind them—things they never would have known otherwise. A few of the students also worked with a graphic designer to create the brochure, while others assisted the web designer in building the website, which includes student Bailey Post's photos. The students were capable except when it came to one area —"We had to have a math lesson," Jennifer revealed. "They couldn't remember how to convert the patterns from inches to feet!"

I thought back to one of my earliest conversations about barn quilts, with Judy Zaspel, the lone barn quilter in the northwestern area of Wisconsin. Though Judy still doesn't have any close barn quilting neighbors, it was incredible how quickly the state had gone from one barn quilt to hundreds.

Nine Patch, Ratajczak barn. *Photo by Bailey Post*

177

wisconsin

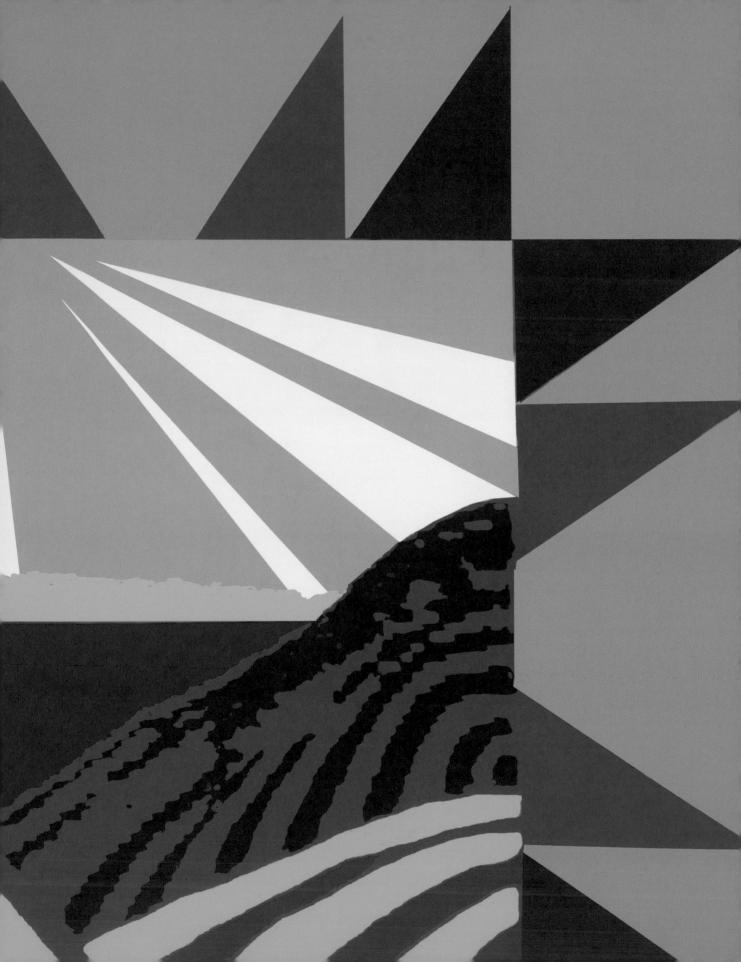

michigan

I HAD BEEN IN touch with Cindi Van Hurk several times over two years, and she had urged me more than once to visit the quilt trail she had helped create in northeastern Michigan. I knew that I would travel to some locations only by phone and e-mail, and this location was particularly remote, but I wanted very much to meet the woman who had answered my call to action a year earlier.

In the summer of 2009, Donna Sue and I were both wrapping things up —for me, my summer's constant travel, and for her, the last few weeks of chemotherapy treatment. We spoke daily, but my stories no longer elicited much response. She was too exhausted to see beyond the next moment, far less the next day or week. I began to think of all the people I had met, mostly women, in my travels over the year. I gathered together as many e-mail addresses as I could find and sent a mass message, asking that each recipient send a card— not an e-mail but something tangible—to Donna Sue. I hoped that I had correctly gauged the spirit of the women I had met along the way. The message was spread, and the response was tremendous, particularly from the women of Alcona County.

Cindi Van Hurk leapt into action, sending an e-mail asking quilters in the area to participate in a "card shower." Donna Sue's message to Cindi a couple

weeks later read, "I was having my last week of chemo and had decided I just couldn't do it anymore. Unexpectedly my mailbox filled with cards from Alcona County, Michigan, and across the country! And these weren't just cards, they had such heartfelt notes and small gifts inside, and one person even sent a donation to help with my treatment costs! Those cards from those wonderful people, some of them breast cancer survivors themselves, gave me the strength to continue with and finish my treatments. I took them to the hospital with me and reread them and shared them with the staff there. Each and every one was so wonderful and has made such a difference to me and given me such strength. Thank you from the bottom of my heart."

I could never repay Cindi for the role she had played in helping my friend at that critical time. But I could pay her a visit.

From the air, Lake Huron looked oddly similar to the Caribbean. Then the reds and oranges of fall trees burst into view, my first sight of Michigan. The prop plane landed at the tiny airport; the only person waiting for a passenger was Cindi. She drove south along the road that skirted the lakefront, and each glimpse of the water—sometimes rimmed with rock, sometimes a bit of sand—was a new surprise.

This first quilt trail in the state had an unusual beginning. In 2007, Professor Wynne Wright of Michigan State University taught a course whose students were to participate in a project that engaged a community in rural renewal. Having recently moved to Michigan from Iowa, she had seen the impact the quilt trails had in communities there and made the connection. Wynne discussed her idea with university extension agent Bonnie Wichtner-Zoia, and the two became convinced that they should work together to bring quilt trails to Alcona County, where tourism is quite important to the local economy.

Bonnie knew that the first task was to get the community involved, so she visited Cindi at Hollyhock Quilt Shoppe. Cindi had already seen the quilt barns in magazines and had been drawn to the project, so she was excited about the opportunity. Bonnie asked Cindi to help with the planning, and before she knew it, Cindi was president of the project. As is often the case, Cindi later reported that she got much more than she bargained for.

A committee was formed, but the college students had to complete their study before work could begin. During the fall semester of 2007, the committee provided the students with data about the community and participated in conference calls with them while the students completed their research. The students traveled to Alcona County near the end of the semester to present their feasibility study. They had researched programs that other states had developed and compiled information such as what materials worked best, the easiest means for installation, and other tips. The students' task was to catalyze

local community development—to help a community develop a sense of itself and its identity and invigorating interest in the residents about their culture and heritage.

As Cindi and I began our tour, she explained that we would be seeing two quilt blocks in each of the county's eleven townships. Great care had been taken to make sure that the entire county would be included and have an equal opportunity to participate. All labor had been volunteer, and the committee raised funds and provided the squares at no cost. Because the available barns are not evenly distributed through the county, the trail includes various sites of interest to highlight Alcona County's unique history. The research project was a success, as it eliminated many of the pitfalls with which other trails have struggled.

Cindi and I arrived at Cedarbrook Trout Farm, where a swatch of bright yellow and blue stood out beneath the canopy of shade. A series of spring-fed ponds surround the barn, and the ivy growing up the sides reaches toward a unique quilt block, where a little boy in overalls carries his catch. "The little fella with the overalls and the hat—that's our customer," said owner Jerry Kahn. Our arrival at Cedarbrook could not have been timed more perfectly, as a visiting couple was just beginning a tour of the facilities, and we were able to tag along. Sometimes the quilt trail provides history lessons, but in this case, biology was more the order of the day. I am now quite well versed in the life cycle of trout, from fertilization to food, after my visit to Michigan's first licensed fish farm.

The vivid golds and yellows of the trees surrounding Bill and Billie Thompson's white barn made it a compelling sight. Their circa-1940 barn is unique, as it had been disassembled at its original site and then reassembled on their property in 1999. White Barn Gardens was also the ideal location for the first block on the trail because of its visibility on a well-traveled road. The Sunflower pattern blooms brightly against the white barn overlooking the roadside stand where Billie's flowers and vegetables are sold.

The Thompsons' farm was also the site for most of the barn painting, either by the couple or by groups of volunteers. Diminutive Billie shared a humorous story of holding onto a quilt block while standing in the bucket of a truck while Bill managed the controls. Just as they were almost high enough to mount the quilt square, the bucket got stuck against the barn, and there the two of them were, with no cell phone and no way down until they determined how to get the bucket to cooperate.

After leaving the Thompsons, Cindi and I drove for a couple of hours, making detours into the tiny townships along the way. A little girl on a swing marks a newly renovated park, and a grove of trees with a school bell in the center

181

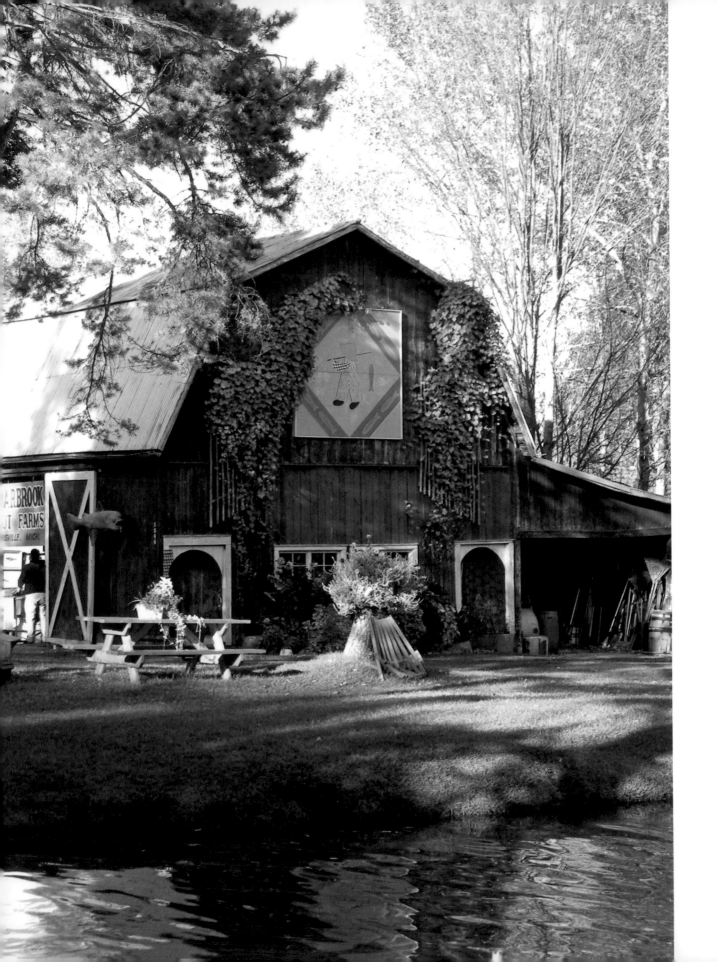

stands in front of an old white schoolhouse. In Lincoln, the restored wooden train depot is historically significant, so the town voted to hang a block there.

Late in the day, Cindi pulled into a gravel drive where a pen full of collies announced that I had stepped out of the car to photograph the North Star quilt block on the barn. Kimberly Makela emerged from the house, wearing the simple dress and head scarf typical of the Quaker community and wondering what the ruckus was all about. As soon as she understood why I was there, Kimberly had stories to tell.

First, she told us a bit about the farm, where she and her husband, William, have practiced sustainable agriculture since 1985, adding the collies, which are both farm and family dogs, recently. The farm is known for its heirloom squash, which poured forth from a bench alongside the farmhouse door, as well as for honey and homemade soaps. Down below in a pasture, I could see several dozen sheep, which Kimberly explained were Cotswold sheep, descendants from a line that could be traced to Colonial America. I knew about heirloom vegetables—varieties that had never been hybridized—but this was the first I had heard of heirloom sheep.

Kimberly became much more animated when she began to speak of the role that Quakers had played in Michigan during the time of the Underground Railroad. Because of its proximity to Canada, the state was among the last stopping points on the road to freedom. Her face glowed with pride as she informed us that the Underground Railroad was begun by Quakers, and she showed her display of quilts whose patterns are associated with helping direct escaped slaves.

One factor that contributes to the success of the Alcona project has been creative fundraising. The most profitable so far ties the painted quilts back to cloth quilts. The Hollyhock Quilt Shoppe where Cindi works sells kits for twelve-inch squares for each of the quilt block designs, with all the profits going to the project. The kits have been very popular, generating enough income in 2008 to complete eight more blocks in 2009. Before the blocks could be chosen, the committee received some exciting news—two days before Christmas, a grant letter arrived from the National Quilting Association that supplied enough money to complete twenty blocks.

Cindi feels sure that the project will continue to thrive. The property owners at the existing sites have reported increased traffic this summer, with the small businesses noting more sales, which is a goal of the project. Volunteers have done all the work, and other than the grant money, the rest of the donations have come from within the county.

Opposite:
Cedarbrook Trout Farm

Elsie Vredenburg of Osceola County, Michigan, says that her interest in the quilt trail began far away—in Kentucky. "I just happened to sit at the same table for lunch with [quilt trail organizer] Nancy Osborne when I was at the quilt show in Paducah last April. I had known about quilt barns, but didn't realize how many there were," Elsie recalled.

Elsie kept thinking after she got home how much she would like to bring barn quilts to her area. She approached her local arts group, who accepted her proposal, with Elsie heading up a committee to pursue the project.

The first block was the Osceola Star, an original design that Elsie had created for the border of a cloth quilt some fifteen years ago. The newly resurrected pattern was painted in rich shades of green and gold and mounted on Elsie's garage in Tustin, and the quilt trail was officially opened. The trail continued to Evart, where City Manager Roger Elkins had agreed to have a quilt block placed at the airport. When Elsie went to meet with Roger to decide on a pattern, he had already chosen the Compass Rose.

Roger explained that in the 1930s, '40s, and '50s, pilots didn't have instruments as they do today, so they used visual landmarks. Often there would be something painted on the roof in the town that was oriented toward the airport. Amelia Earhart helped form a group of women pilots called the Ninety-Nines, who painted compass roses on taxiways and runways of small airports so that they could be spotted easily. Roger had already thought about how the compass rose could be incorporated into a quilt. "When Elsie approached me," he said, "I was ready to see how she would use her knowledge and expertise to create this design." With another bit of history tucked away, I asked Elsie about the other barns along the trail.

There are over seventy centennial farms in the county, and Elsie hopes to include as many as possible in the trail of twenty or more quilt barns. Three of the latest additions are quilt blocks based on antique quilts that are precious to the farm owners' families. And the Osceola Township Hall is home to the Old Glory quilt block; Elsie hopes that eventually every hall in the county's sixteen townships will be similarly decorated. "I am not quilting as much as I used to," she said, "but I have been quilting since high school and have some ribbons under my belt. I've just changed my focus—from one kind of quilting to another!"

In extreme northwestern Michigan, a twenty-two-mile-long finger of land juts north from the mainland into the Grand Traverse Bay of Lake Michigan. Old Mission Peninsula—so named because it was the site of the first Christian mission settlement in the area—is renowned for its rolling hills, miles of Great Lakes shore-

line, cherry orchards, farm markets, and vineyards. Thanks to Evelyn Johnson, the area is also becoming well known for its historic barns, some of which have been decorated with barn quilts.

Evelyn researched the history of the barn that her children bought on the peninsula and became so enthralled with the subject that she became a member of the Barn Preservation Network and wrote a book that provides the history of each of the barns of Old Mission. A few years later, Evelyn became aware of the quilt barn trails in Kentucky, and on a trip to Natural Bridge State Park, she coaxed her friends into heading into the countryside to see them up close. Evelyn was immediately taken with the idea; she said, "I want them on our barns. I want them quality, and I want them off the beaten track."

Evelyn visited other quilt trails, including the original one in Adams County, Ohio, seeking information from those whose trails were already established. Evelyn credits Cindi Van Hurk of Alcona for advising her how to make the squares withstand the cold and wind. "She really gave her heart to us," Evelyn said. A small group of local volunteers painted the squares, mostly in the Johnsons' garage.

The barn quilts of Old Mission piece together elements of the families and their farms.

One of the most unusual designs is at the Gray-Springer barn. Barbara Gray Springer resides on the farm that her great-grandfather established in 1868. The cherry farm sits on the very top of the peninsula, where Barbara never grows tired of looking out her kitchen window to the 1904 barn and the beautiful bay beyond. The barn's silver roof, visible from the water, is often used as a marking point for navigation by those who boat or fish in the area.

Evelyn Johnson's enthusiasm for the barn quilts was infectious, and Barbara immediately asked her siblings whether they wanted to participate. The family worked together to determine what quilt would best represent the farm's history. Rather than selecting a traditional pattern, the group chose to create something that Barbara said "speaks to everything that makes the farm what it is." Those elements include the bays, the orchards, the sun, and also contour farming—the use of curved rows of crops that prevent soil erosion by following the natural contours of the land.

The family project was created in the Springers' garage. Once the group had come up with the elements that should go into the barn quilt, Barbara's niece Emily Gray Koehler put together the design. The tradition of artists in the family was part of the painters' inspiration. Barbara said, "We also like the fact that it gives the women of the past a niche in the preservation of our heritage, as both grandmothers quilted in this farmhouse." Emily acknowledged those quilters of the past by adding a traditional Goose Tracks pattern to the outside of the quilt

185

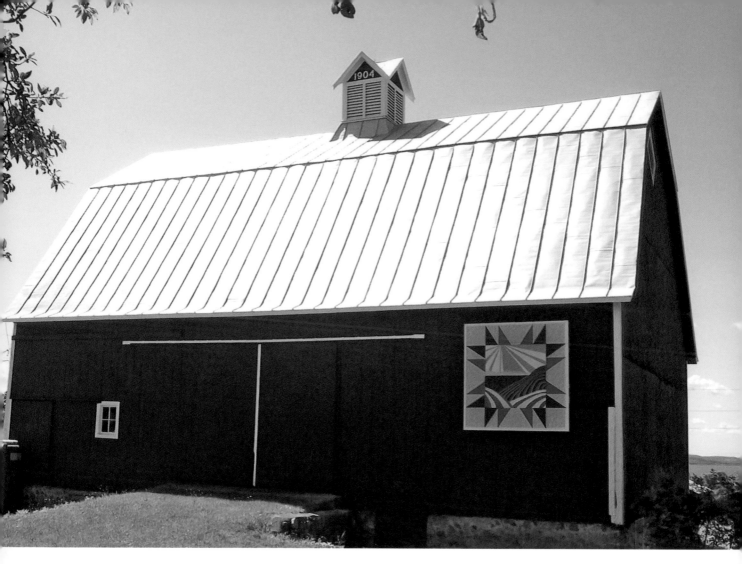

Springer-Gray barn.
Photo by Carl Johnson

square. The choice was fitting, because geese often fly over the area and are part of the magnificent view of the bay that the Gray family has enjoyed for more than 140 years.

A few of the barn quilts are reproductions of family patterns that pay tribute to the generations who founded the still-productive farms. Brendan Keenan and his wife, Teri Gray, had worked on the project on Teri's family farm. Brendan decided to create a barn quilt of his own but wanted to do something more traditional. "I think it's a worthwhile project and a nice way to pay homage to our ancestors," said Brendan, "so I wanted to reproduce an actual quilt."

The chosen quilt, crafted in the 1930s by Teri's great-grandmother, Christine Gifford, was pieced from old dresses, so the variety of materials was a challenge to reproduce. Brendan, a trained artist, was able to replicate the fabrics exactly, from the plaids to the calicos and other floral designs, mixing his own paint until

186

he used more than thirty colors, so that the image he created is true to the original. The result is quite impressive—a real work of art.

Though Old Mission already attracts tourists, the barn quilts are a way to increase awareness of the natural beauty of the unique peninsula. Some of the barns are located on main roads, but travelers who want to see them all must head away from the villages and into the lush countryside as they complete the loop. Once the tour is completed, few complain about the length of the journey.

loving tributes

MANY QUILT SQUARES are created in honor of earlier generations, to celebrate family heritage, the legacy of quilting, or those who once worked the family farm. But some of them are tributes to a single family member, a loving gesture of remembrance. I heard several of these stories, and a few stayed with me.

It was a welcome surprise in November—just a week after her surgery—when Donna Sue sent a photo of a long red barn in Yamhill, Oregon, with a note: "This is almost surreal to me . . . it takes my breath away. What a great way to use a long narrow barn. The concept keeps evolving and getting classier and classier." Donna Sue's appreciation of the art form she had created, even in the worst of times, seemed a good sign.

I agreed that the barn with a row of painted quilts along the side was impressive, and of course, I was compelled to seek out its story. I didn't have to look far. A helpful young woman at the Yamhill Chamber of Commerce knew exactly which barn I meant, and before I could broach the question, she asked if I had a pen ready to take down Margaret Shipler's phone number.

Margaret had been impressed by a 2005 article about the barn quilts of Grundy County, Iowa, but the spirited, independent woman just had to improve on the idea. "I have a seventy-two-foot-long expanse of barn," she explained. "I thought one quilt would be nice—but how about five?" The fact that no one in her area—

or in her home state of Oregon—had painted a barn quilt was no deterrent; Margaret enlisted the help of her quilting friend Shirley Martin and went to work.

Margaret's husband, Alan, had passed away the year before. He loved Margaret's quilts and the barn, which he used as a workshop, so adding the quilt blocks to the barn created the perfect tribute to him. The two women planned and painted all five quilts, choosing simple patterns from among those that Margaret had quilted and Alan had admired. The red, white, and blue colors were chosen to honor Alan's service in the Marines during the Korean War.

Margaret also added black sashing—the strips of fabric that sometimes separate rows of quilt blocks, particularly in a sampler quilt, in which an assortment of patterns is used. To make the row of blocks look more like a cloth quilt, Margaret painted tiny white stitches but left a stitch missing on one of the black sections. She explained, "The Amish believed that only God is perfect, so there is a mistake in every quilt as a reminder of that." Though she is not part of the Amish community, Margaret shares their love of simple country life.

When it came time to hang the quilt blocks, Margaret confessed, "We did a lot of sweet talking; we're no spring chickens, so we knew we were not going to get up there and hang them. My barn is on a hill, so we couldn't rent any piece of equipment that would get up next to the barn. My nephew took my husband's old '65 pickup and put the ladder in the back of it; he was just about hanging on the ladder as he nailed each piece to the barn."

The last piece to be added to the row of quilts is a painted sign—"Block Party, Yamhill, U.S." "My husband loved his parties," Margaret said, "so that was my party I gave him when he passed away. He loved people, and he would love seeing people stop and take pictures of his barn."

Donna Sue made me aware of a new quilt trail many times, but I recall only one other instance when she called my attention to an individual project. This time it was an article she had read, rather than a photograph, that had caught her imagination and inspired her to call. "Suzi, did you see the story about the ninety-two-year-old man?" she asked. Expecting a punch line, I replied that I had not and waited. "Oh, it's the most wonderful story. You just have to talk to him," she said, with a hint of affection for a stranger in her voice.

Once again I found that whoever answers the phone in a small-town municipal office will readily supply contact information, and soon I was on the phone with Bill Heintz. Bill began by telling me that he and his wife, Margaret, had married when both were sixty-five. I asked him to repeat himself, and I had heard him correctly. Sixty-five. The couple traveled extensively for fifteen years, to Alaska, Hawaii, and England, as well as on bus trips all over the country. Bill said, "When we got to be eighty years old, we decided to stay closer to home and make short trips. Margaret began quilting, and I made a big garden."

barn quilts and the american quilt trail movement

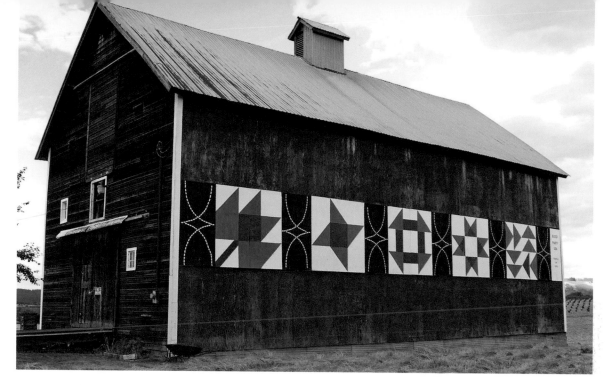

Once the two retired, their daily lives always included her quilting and his gardening. Margaret loved to quilt and worked at it daily, producing a quilt about every six months, including a special one for Bill in his favorite color of blue. Bill would work in his garden, and then about 9:30, she'd ask him to come in and sit with her. About noon, Bill would go back out again. The easy companionship that he described sounded like a sweet life. "We were very much in love," he said. "We were close to our silver anniversary."

In August 2007, both families, including Margaret's six children and thirty grandchildren, celebrated the centennial of the farmstead that Margaret had inherited from her father. Margaret had just turned ninety, but she wanted to wait a few months until Bill's birthday so that they could celebrate together.

"I had to celebrate alone," Bill said.

That October, Margaret was killed in a car accident, which sent Bill to the hospital, and he was not expected to survive. But he was determined to make it through: "I survived World War II, so I figured I could survive anything. It took a while, but I am in good health."

In December 2008, a friend suggested that Bill paint a barn quilt in his wife's memory. When he returned to the farm in April, Bill chose one of Margaret's most loved patterns—the Log Cabin—and set to work. A grandson helped him draw the design on two sheets of plywood. In between working with his flowers and vegetables, Bill painted the strips in varying shades of Margaret's favorite colors of apricot and green. The center square is the traditional red of the pattern.

"I have the quilt illuminated at night," Bill said. "Sometimes I get out of bed and sit and look at that barn quilt. It brings back a lot of memories; we were living a very happy life."

191

loving tributes

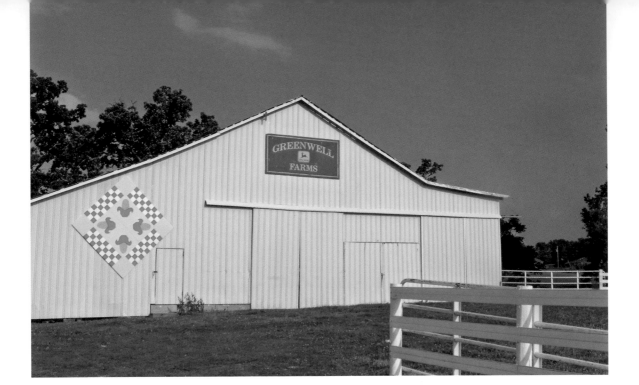

Ronnie Greenwell's
barn quilt

During my travels in Kentucky, I had been touched by the story of two quilt squares painted in honor of lost loved ones. The first time was in Grayson County. Phyllis Nash of the Grayson County Clothesline of Quilts committee had said, "Each time we paint one, we say, 'This is the prettiest one that we've ever done.' And then we'll paint another one and say, 'No, this is the best one.'" But none of the twenty-three quilt squares is more meaningful than one that hangs in the small downtown of Leitchfield.

The Tulip Block mounted on a small white building at the Breckinridge-Grayson Head Start Program overlooks a garden of red shrub roses and greenery. I visited with director Cathy Darst, who related its story. The quilt square was painted in honor of Lynda Ragland, who did a lot of volunteer work and was a valued partner in the agency. Cathy spoke of Lynda's ability to develop close bonds with the children and families. As a retired English teacher, she helped some families get through college although their circumstances made them believe they couldn't make it. "It's important to let people know what they can do," Cathy explained, "that poverty is not just in your pocket, and Lynda worked a lot in that area."

Lynda was a Master Gardener, and the agency was pleased to have those skills as well. She started working on a little area planting some flowers; she spent two springs with the gardening. According to Cathy, "She had been through a lot but found peace with working with her flowers. Over here by the little white building was where she wanted the roses."

Cathy paused, swallowed hard, and continued. "Last year Lynda was lying in bed reading a book and just died. It was devastating. We both loved quilts, so when

192

I saw the quilts going up, I thought that would be a beautiful piece to memorialize her. So we did it in memory of Lynda. I love beauty in the environment, and the quilts add to that and it keeps part of our culture. I just love it."

I saw quite a few quilt blocks on some beautiful barns that day, some of which were surrounded by grand expanses of land, but none was as lovely as the one next to the parking lot in Leitchfield.

A few days later, I had only a couple of hours to spend with Meade County, Kentucky, extension agent Jennifer Bridge, but she chose our destinations with great care. We had made a couple of stops, but as Jennifer drove to the Greenwell farm, her mood went from upbeat and excited to rather quiet. When we spoke to Barbara Greenwell, I came to understand why.

We pulled into the drive of a beautifully manicured farmyard. The long, curved driveway was lined with bright white fences that looked as if Tom Sawyer had just departed the premises. A bright yellow and green checkered quilt block with an ear of corn in the center hung to the left side.

Barbara Greenwell was expecting us, and she stood in front of the painting, carefully composing herself, as she recalled the sad event. It had taken place July second, four years earlier: "It was on one of these hot days, and Ronnie was trying to get the little white board along the edge of the roof painted all around. He went around back and by the time he got here to the front, it was awful hot. You see where the cross is? He fell off the barn there and died almost instantly." I saw the wire cross at the edge of the roof and couldn't help noticing that the board just to one side was not nearly as white as the rest.

Barbara wanted to do something in her husband's memory, so when Jennifer suggested a quilt block, it seemed like just the right memorial for Ronnie. Jennifer helped select the pattern, with corn for agriculture and the John Deere colors that honor Ronnie's preference for farm machinery and match the sign on the barn. The tiny cross on the edge of the barn might be visible only to Barbara, but the quilt square is a reminder to all who knew him how much that farm meant to Ronnie Greenwell.

Tributes to children seldom come to mind in conjunction with memorials, but the barn quilt project in rural Orleans County, New York, provided an opportunity for a mother to remember her son. When I heard that there was a quilt trail in New York, I was taken aback for a moment, but Lora Partyka explained that yes, there is an agricultural area of the state, and that the quilt square on her greenhouse had been the first in the region.

Lora asked Sandy Wilson if she would like a quilt square for her barn, and right away Sandy asked, "Do you have any quilts named Joey?" The next day, Kathy

loving tributes

DeMarco, who helped with selection of patterns, brought samples of Joseph's Coat, and Sandy agreed that it would be just the perfect addition to the barn that has been in her husband, Robert's, family since 1869.

The Wilsons' son Joey was born with Down syndrome and quite an amusing personality. His mom couldn't help smiling as she described her child: "Joey loved the farm and the animals, and he loved playing in the dirt—the messier the better. He really liked going to church and wanted to be an acolyte and light the candles."

He was called Joey until he went into the hospital when he was eleven. He had an unexplained fever that would not go away. The nurse would come in and ask, "Are you Joey?" and he would say, "No—just Joe," hoping that they wouldn't stick him with a needle. He loved tricks—he made the doctors deposit money in a bank he had that exploded when you put money in it, and he put rubber spiders in the box with the gloves. Joey was in and out of the hospital from October 1993 until the following January, when he was diagnosed with cancer.

"We brought him home and had a party and said goodbye to him," Sandy recalled tearfully. "I didn't want anybody to forget him, not that they could." Looking out at the red, yellow, and blue painted quilt, Sandy said, "I am just so glad we did it—to keep him in people's minds."

One last story caught my heart, this time in Watauga County, North Carolina, among some of the tallest mountains in the state. Boone is the county seat of Watauga County and is also the center point for the trail of a dozen barn quilts scattered through the countryside. It had been a while since mountain navigation had caused me to grind my teeth in frustration, but the challenge seemed worth it just this one more time.

Arlene Baumgardner was a painter and loved all forms of painting, so when she saw the barn quilts going up in the area, she knew she had to have one for the barn on the family farm. Arlene's son Mark says that she was very close to her granddaughters Kimberly and Karen, and she had started thinking about having barn quilts made for each of them, but that never happened. She got busy and, like most of us, didn't get time to do everything.

Mark went on, "Of course, she wasn't planning on dying when she did; she was waiting for her passport so that she could visit Canada again." Arlene had breast cancer years earlier and was completely free of it. She found out she had mesothelioma—the doctors had no idea how she contracted it—and died a couple of months later.

Mark's daughter Kimberly continued the story. "When someone close to you dies, you aren't thinking about barn quilts, but her friends came together to do this for her. So many people have come up to me and said, 'Arlene was like a mother to me.' If you had a problem, you could take it to her; she would always give good advice."

barn quilts and the american quilt trail movement

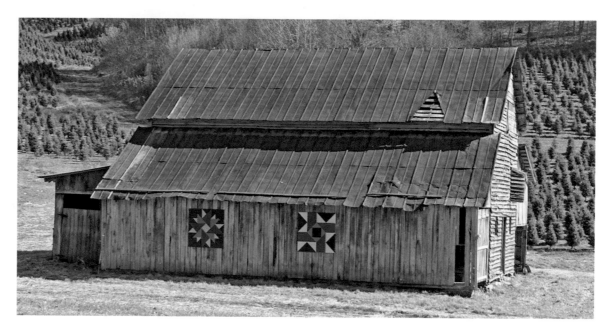

Kimberly and her sister, Karen, designed the quilt block on the right side of the barn. They chose the Waterwheel quilt partly because there was a waterwheel on the property near the barn where their grandmother played as a child. Kimberly explained the design's further significance: The spinning waterwheel represents Arlene's life, which continues even though she has passed on. The gold stands for God's control of her life and the red for Jesus' sacrifice.

The second quilt block was designed by the seniors' art class at the community center and appropriately named the Friendship Quilt in honor of Arlene. The brilliant colors required several coats, so the barn quilts were out at the center for a few weeks, and everyone from toddlers to ninety-year-olds came together to paint. Even Arlene's three young grandsons, Calvin, Daniel, and Trenton, who called their beloved grandmother "Gigi," were able to participate. "The boys were the sparkle in her eyes," Kimberly explained. "That would have meant so much to her."

The squares were put up in the spring of 2009, almost a year after Arlene had passed away, and Kimberly said, "I think they will be up until the barn falls down. They are so symbolic of how much love she had; even after she was gone, people had to come together to do that for her."

During the course of my travels, I was often struck by the strong emotions tied to a quilt square. Whether they represent personal accomplishment, community pride, or family heritage, barn quilts evoke cherished memories for their creators. These public tributes to lost loved ones exemplify just how much meaning can reside in a barn quilt. I heard hundreds of stories along the quilt trail, but the ones that come to mind most often are the stories of the memorial quilts and of the people who painted them.

195

loving tributes

the quilt trail
comes full circle

DONNA SUE SPOKE often of places she hoped that I would visit, but the Prescott farm was another matter. "The full circle story," as she called it, was one that Donna Sue urgently wanted to be sure was recorded, and she mentioned it often.

I was grateful that Melissa and Pete Prescott agreed to meet me at the nearest highway exit, as the steep backcountry roads that lead to their farm would have defied any map or electronic navigation. I arrived rather late, so our talk was postponed until the next morning, when Melissa and I sat on the porch watching the early mist rise over the hills.

After retiring, Melissa and her husband, Pete, decided to make real their long-cherished wish to leave Chesapeake, Virginia, in search of the pastoral life. Their children had left the nest and were on their way toward their own life adventures. Melissa and Pete had aspirations of growing grapes to make their own wine and raising goats to make cheese.

The Prescotts found land in Roane County, West Virginia, that piqued their interest and invited Melissa's mom out to see it. Along a steep grassy hill at the edge of the property is a small family cemetery where, among the ornate marble and granite headstones and the ancient markers whose inscriptions are barely discernible, the name "Groves" appears often. Melissa said, "Lo and behold, my great-great-grandparents, John and Mathura Groves, were buried in the cemetery." Melissa's mom knew they were from Roane County, as she had recently been

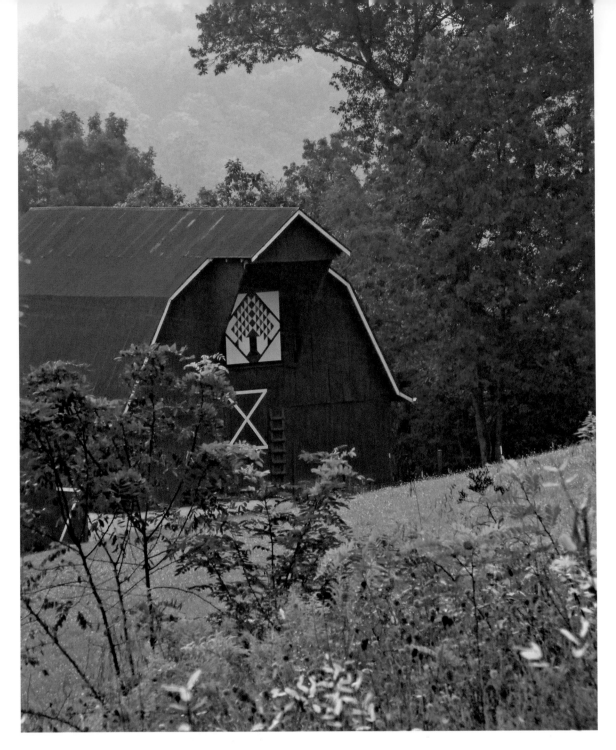

working on the family's genealogy and had heard Melissa's grandmother speak of visiting them.

Melissa and Pete decided that somebody was trying to tell them something. And the farm had everything they were looking for—a southern-facing field on the opposite side of the cemetery for growing grapes and existing barns and out-buildings for the goats. "It all worked out, and here we are," she said with a smile.

In April 2007, Melissa saw an article in *Hobby Farms* magazine, about Donna Sue Groves, who had started a project called the "quilt trail" in honor of her mother, Maxine Groves, a quilter from Roane County. Melissa thought this had to be more than another coincidence: "What are the odds—a Groves from Roane County. We're probably related. I contacted Donna Sue, and sure enough, her great-great-grandparents and mine are one and the same, and she actually has memories of visiting this farm as a young girl!"

Pete and Melissa decided that they had to create a quilt square for their barn to honor Donna Sue and Maxine, and the family connections inspired their choosing the Tree of Life pattern. Missy and I climbed through the damp goldenrod in the grass beside the house, along the fence where goats butted and pushed to get near us. Walking toward the cemetery at the top of the hill with the barn and quilt square visible down a slope framed by the hills was akin to seeing one of the world's great wonders.

A carved wooden sign, "Groves Cemetery," marks the entrance. The two of us walked among the markers with some names etched clearly in marble and others barely visible on decaying stone. Melissa provided a new piece of information—in Appalachia, Memorial Day is also referred to as Cemetery Day. That is the day that families come out and visit their small family cemeteries, so usually about twenty or thirty people walk the grounds and climb the hill to pay their respects. "There are quite a few Groveses here in the county; to meet all of these people, cousins, aunts, and uncles that were probably less than twenty to thirty miles from me growing up that I never knew existed . . ." There could be no other name for the Prescott farm but Destiny Groves.

"I so hope that Donna Sue and Maxine get to visit someday," Melissa said.

Donna Sue told me, "I love all of them, but that quilt barn is particularly precious because it is on land that my foremothers and forefathers lived on and eked out a living. I wonder what their life was like and whether they would find beauty in it."

Donna Sue had always referred to the Prescott farm as having brought the quilt trail full circle. The circle expanded even further when Roane County resident Nancy Stoepker discovered barn quilts while in Kentucky. "It's embarrassing," she told the women of the local community center; "Maxine Groves is from here and we don't have these quilts!" Within a few months, the women had a project under way, and with about thirty quilt blocks in place feel that they have set things right.

Finally, in 2009, another especially meaningful quilt was added to the trail. In Xenia, Ohio, where Donna Sue was active in community work, a quilt block was installed, and Donna Sue was invited for the dedication. Next to the quilt square, a plaque honors Donna Sue as founder of the quilt trail. "Now, the circle really is complete," Donna Sue said. "I have lived three places in my life, and all of them are joined by the quilt trail."

the quilt trail comes full circle

blanketing the
country with quilts

I SPENT EIGHTEEN MONTHS visiting the ten states where quilt trails have proliferated, some for several days and others for multiple trips over a period of months. But like the bride who was a young girl "just yesterday," the quilt trail grew and matured seemingly overnight as I worked to record its progress. In 2009, with projects in New Jersey and Oregon, the trail of quilt squares spanned the country from coast to coast. As I explored each of these newest additions, common themes and experiences emerged. Innovative methods of creating and financing quilt trails demonstrated the model's adaptability, but the movement remained true to its roots.

I had been so busy in other areas that I had not had a chance to visit the trail closest to my home. Just west of Atlanta, tucked away a couple of miles from a busy four-lane highway cluttered with convenience stores and fast food restaurants, downtown Powder Springs, Georgia, seems almost anachronistic. Along the curve at the entrance to the town square, I was greeted simultaneously by the log structure of the Seven Springs Museum and a large painted quilt on the brick building in the background where the downtown begins. The park benches and flowering plants that fill the sidewalks in front of the brick stores in the tiny downtown area invited a walk, where I found eight other quilts painted on the sides of the historic buildings.

I stopped to see the two quilts on the outside of the Country Store before venturing in. The Lone Star on one side of the building blended into the rustic

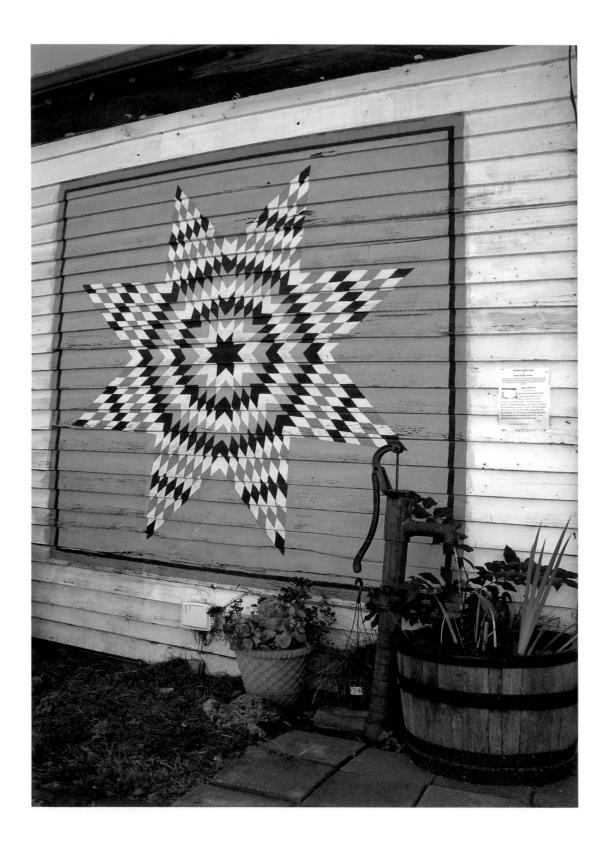

wood as if it had been there since the building was first painted. Inside, Gloria Hilderbrand told me a bit about the project and her involvement.

In 2005, florist Joe Sutton had seen quilt squares in his native Tennessee and thought the idea perfect for Powder Springs. When he returned, he went to see Gloria Hilderbrand and Diane Reese at the Country Store. "As soon as Joe came in the door, we knew we were in trouble," Gloria told me with a grin. Sure enough, Joe had found a pair of women who would take up the charge. Using vintage quilts from their own collections, Gloria and Diane painted twelve- to fourteen-foot replicas on either side of their building, parts of which date back to 1830. The Lone Star that I had admired is based on a quilt in the Hilderbrand home; the Double Irish Chain on the opposite side is copied from a quilt given to Diane by a friend.

Just next door, a tiny building is home to the Book Worm, whose owner, Susan Smelser, fell in love with the idea and commissioned two quilt paintings for the sides of her shop. One of them happens to be my perennial favorite, Grandmother's Flower Garden, which took on added charm when painted on the bricks. And of course, Joe Sutton didn't completely abandon the project; his floral shop has a large quilt on one side and one near the back entrance as well.

Altogether, there are ten painted quilts in Powder Springs, and though the town may not expand its trail, Gloria and Diane have worked to create awareness throughout the region. Business owners in the towns of Hiram, Buchanan, and Bremen had painted several quilt blocks, and the Southern Quilt Trail has expanded to include organizations in six counties.

The Powder Springs project reflects the appeal of the quilt trails even to those who live far from farm country. Several other small towns have adopted the idea of creating an in-town quilt square collection rather than a driving trail. Some are far from the nearest barn, while others serve as connecting points between barn quilts along the way. The quilt trail model brought out both creativity and ingenuity, and like the Kentucky floodwalls chosen by Nancy Osborne as surfaces for quilt squares, storefronts were a viable alternative that created many opportunities for the trail to expand.

Like Powder Springs, Randolph County, Arkansas, embraced the idea of an in-town quilt trail. A 2006 sesquicentennial celebration sparked renewed interest in the area's rich heritage, and downtown Pocahontas was declared a historic district. Five Rivers Preservation Area, Inc., was formed, with overseeing the quilt trail as part of its mission. Downtown Pocahontas is now home to thirty-seven nearly full-sized reproductions of quilts, photographically captured and attached to buildings in the business area.

Organizer Linda Bowlin knew that because there are no barns in the area, the quilts could not be hung at a distance as they are in states such as Iowa. A walking

203

trail would create a more intimate effect, but wooden quilts couldn't be hung on historic buildings. Local artists and a skilled photographer lent their creative talents to document the quilts by reproducing them on marine vinyl. As was the case in Powder Springs, the quilts were to be ones that came from the local area.

The town holds a regional quilt show during Founders' Day, and as part of that, people came forward with quilts that they wanted to sponsor or brought in quilts for which the committee found a sponsor. The president of the Five Rivers Preservation Area, Bill Carroll, prefers the photographed quilts for multiple reasons, from the decrease in the cost of creating the quilts and the time involved to the appearance of the finished product, in which the texture and the stitching on the quilts is evident.

Three of the quilts on display in Pocahontas were created by Jacquolyn Weick, whose Peddler's Trail is one of the most unusual along the trail. Jacquolyn and two friends each stitched a quilt using the same pattern. They went to a shop in Little Rock and each bought twenty-five fat quarters, that is, eighteen-by-eighteen-inch fabric squares. She said, "We walked out and not one of us had a duplicate!" The ladies put all of the fabric together and pretended that they were women on the prairie who had to wait until the peddler came to buy more fabric. It took them a year to do those quilts. Jacquolyn said, "It's really a treasure because of how it was made and the fun that we had doing it. We took pictures of them, and you couldn't tell whose was whose!"

Virginia Stevens, another well-known quilter in the area, contributed Clara's Flowers, named after her grandmother, to the trail in Pocahontas. When she first heard about the quilt trail, Virginia had doubts—"They're going to be plastic?" But when she saw them, she found them to be "just beautiful."

High in the North Carolina mountains that border Virginia, the very realistic-looking quilt squares of Wilkes County were created in a similar fashion to those in Arkansas, but the choice was not due to a shortage of barns. "The Wilkes County Quilters' Guild is not the youngest group of people," explained Jen Scorof, the group's secretary. "The ladies wanted to commemorate their tenth anniversary by creating barn quilts but needed to find a way to do so without hanging heavy plywood pieces." The ladies may not be young, but they used state-of-the-art methods to replicate actual quilts made by guild members. The photographic images are printed on lightweight PVC panels, whose thickness adds an extra dimension that makes these barn quilts look remarkably like cloth.

Innovations in design continued as the trail moved to other parts of the country. In Pennsylvania, the possibility of establishing the state's first quilt trail in her hometown of Bullskin Township set Colleen Konieczny into motion. She decided

The Peddler's Trail
Quilter & Owner: Jacquolyn Weick
Sponsor: Weick Custom Cases, Inc.

to build her barn quilts a bit differently—using metal instead of wood, as she was concerned about maintenance of both the wood and paint.

Colleen's cousin Heath Hoffer is a metal artist, so the two worked together to come up with a nontraditional method that actually "pieces" quilt blocks with bolts rather than with thread. The metal quilt pieces are cut individually and attached to the background with rubber spacers in between, setting them off from the background to make actual three-dimensional designs. The metal is sprayed with powder coating—much like automobiles. "They are so radiant," Colleen said; "I think they look really neat!"

Life with six children on the Konieczny family's two-hundred-year-old farm is busy, and with the barn quilt project in full swing, Colleen may not be able to fit a

blanketing the country with quilts

205

sightseeing trip into her schedule anytime soon. Still, she looks forward to seeing the quilt trails in other states. "I can't wait to take the tour," she said. As for me, I can't wait to see one of Colleen's creations up close.

■

Volunteers associated with the New Jersey Museum of Agriculture began work on their barn quilt project in 2009. One of the most intriguing barn quilts along the trail is not an innovation in quilt block design but calls attention to the latest in farming technology. The Sussex County farm that Jane Brodhecker and her husband bought in 1969 was perfect for the family but has recently been brought into the twenty-first century. In 1955 when Jane was in college, she thought that solar power would serve our energy needs of the future but had no idea that it would take quite so long. The farm's energy usage is high, so she thought utilizing solar energy was a good way both to economize and to "go green."

Her love for new ideas put Jane at the top of the list for a barn quilt. A new barn had just been created to house both farm equipment and the solar panels that the Brodheckers now use for all of their energy. While it doesn't have the rustic charm of others on the property, the structure with its paneled roof is representative of the environmentally friendly technology that the farm has adopted, so selecting it as the center of attention made sense. The pattern chosen was Shining Star—most appropriate for the building that serves as a shining example of how far New Jersey farming has come.

■

At the same time that some looked to the future, central Missouri celebrated the folk traditions that are at the heart of the barn quilt movement. A photograph of Margot McMillen's grand white barn in Hatton, Missouri, grabbed my attention. As soon as I spoke with Margot I had the map out, as it sounded like my kind of place. Everyone is invited to Terra Bella Farm the last Sunday of each month, when visitors of all ages walk the grounds of the organic farm, fish, create crafts with local artisans, and enjoy listening to Margot's husband, Howard Marshall, playing the fiddle. In 2009, the group added barn quilt painting to the monthly agenda, with a new block outside ready to be painted by anyone who attends the community gathering.

The barn at Terra Bella is home to a simple Nine Patch block that has sentimental value for the quilters in the area. Margot explained that the barn quilt was painted in honor of Mabel Murphy. There are a lot of quilters in Callaway County, and many of them can be traced back to one woman in the 1970s teaching people in her home—one bunch on Thursday mornings, one bunch on Fridays. The quilters in the area nominated her for a National Heritage Fellowship, and she was the first quilter honored. The simple Nine Patch represents the basic blocks Mabel began

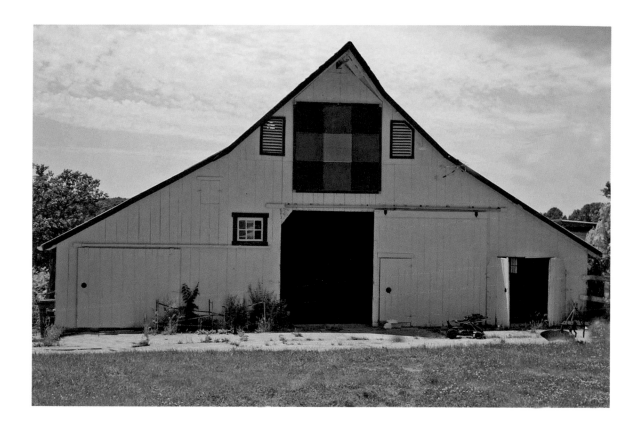

quilting at the age of eight and the time that she spent passing along the basics of the art to so many others.

The latest addition to the burgeoning group is Terry and Roger Gilmore's farm in Auxvasse. Terry added a black and white checked border to a red and gold star that she had seen on a quilt in a magazine, and her son-in-law, Brad, painted hundreds of red checks inside the gold star; the squares are so tiny that he had to paint them freehand. The painting became part of a family reunion. Terry called her children and friends because she wanted them all to touch the quilt square, so they converged at Terra Bella and painted the quilt block. "Our farm is a family farm," Terry said, "and seven years ago we moved into the home where my husband was raised, so to me it put our footprint on the farm and made the farm more ours."

School projects have been instrumental in creating connections between the local farmland and the younger generations. One of the most successful school-based efforts was created in Murdock, Nebraska, when the students of the Elmwood-Murdock Future Business Leaders of America in Murdock created a service project that they called IMPACT—"Involving members, promoting activities, creating

Nine Patch, McMillen barn. *Photo by Tammy S. Williams*

207

blanketing the country with quilts

tourism" to benefit their entire community. Member involvement was a given, and developing field trips for kids in the area fulfilled the "providing activities" component. But advisor Kurk Shrader and his students weren't quite sure what they would do about "creating tourism."

County resident Maechelle Clements had made two trips to Iowa to tour the quilt trails and wanted to bring them to Cass County. After a bit of frustration when no agency was interested, she called Kurk, who had been her children's teacher. Maechelle presented the idea to the FBLA, and the kids voted to take on the project.

In keeping with the objective of promoting tourism, students selected farms that were on hard-surfaced roads and barns that had some historic significance to create an accessible driving tour for visitors to the area. Ten of the initial fourteen barn owners who received a letter asking them to participate agreed, and two others joined to complete the planned twelve barns.

Steve and Betsy Klemme eagerly accepted the invitation to have a quilt placed on their corncrib, which was built in 1925. The intricate Starry Night pattern, painted as an entire quilt rather than a single block, was chosen by Steve. To Betsy, the pattern is a reminder of being in the rural area and being able to gaze into the night sky and see all of the stars. "I think the design we picked helps us to remember all of the blessings that we have," she said.

The positive reception of the barn quilt project inspired the school's entrepreneurship class to capitalize on the idea as a way to raise scholarship money. The students sell two-by-two-foot quilt blocks for garages and other buildings, and businesses on Main Street are purchasing the smaller quilt squares in sets of four so that they can change them out seasonally. The kids learned art and business skills, so there were all kinds of benefits, including pride in accomplishment. The barn quilt project won top awards in the state for the school's FBLA chapter and second place in the nation.

Partnerships within communities have been vital to the growth of the quilt trail, and nowhere is that more evident than in Tillamook, Oregon. The Latimer Quilt and Textile Center in Tillamook was the starting point for the first quilt trail on the West Coast. Although painted quilt blocks are not textiles, they certainly fit the Latimer Center's mission, "to preserve, promote, display and facilitate the creation of and provide education about the textile arts."

Two of the most prominently placed quilt blocks—the Oregon Star on the chamber of commerce building and the Western Star at the county fairgrounds—are based on quilt patterns that are original to the state. Other patterns selected, such as Oregon Trail, Western Star, and Lewis and Clark, either were designed by women of Oregon or have names that correspond to the area.

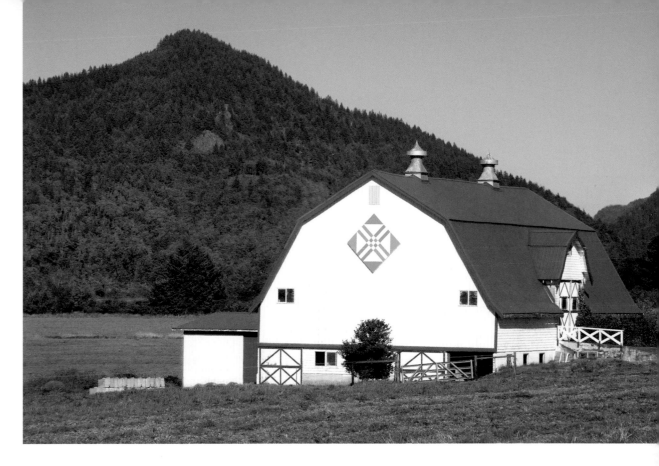

Far West, Obrist barn. *Photo by Marti J. Rhea, Photoart by Marti, LLC*

Committee member Teri Fladstol said that the quilt trail was designed to bring those who pass through on their way to the coast to enjoy a visual "treasure hunt" along the quilt trail and, in the midst of that, to experience the unique local flavors of the county. The beauty of the Coastal Mountain Range, which creates a north–south border a few miles east of Tillamook, is enough to make travelers forget about their intended destination farther west. It serves as the perfect backdrop for the Obrist farm, one of three owned by Richard Obrist. Richard's family farm, which was settled by his grandparents in the 1920s, is in Tillamook, but he has sentimental ties to the smaller farm a few miles from where he grew up.

Richard said, "I used to work on that farm for the gentleman who milked there, so I was pleased when some years later, I was able to acquire that house." Richard lived there, and when it came up for purchase, he bought the rest of the property. The farm is now home to Richard's son Todd and his wife, Olivia. The white barn, recently adorned with its Far West quilt block, is used for raising calves until they are weaned and ready to move to the original family farm where Todd and his brothers, Ryan and Chris, work alongside their father. Richard is very proud that Fairview Acres Farm in Tillamook will be passed along to the fourth generation, with grandchildren already in line to make the fifth.

The Tillamook project honors heritage and history but still includes a bit of modern flair. The "quilt bus" is wrapped with the type of material that usually

209

blanketing the country with quilts

features advertisements for fast food restaurants and television programs. In this Oregon valley, riders can be transported instead surrounded by scenes from the state's first quilt trail.

The expansion of the quilt trail into the areas surrounding Adams County, Ohio, and across Iowa was due to Donna Sue's sharing advice as to how to begin the project and possible pitfalls to avoid. Time after time, I was told that an established quilt trail committee had offered similar help to those just starting out, and that tradition has helped many a fledgling trail succeed. Many states began new projects in the past year, and one demonstrates the spirit of sharing between communities that has been a major component in the quilt trail's growth.

Don Hart, the "Quilt Guy" of Madison County, Kentucky, actively mentored one of the newest barn quilt projects, in Seneca, South Carolina. Resident Martha File saw a brochure that a friend brought home from Kentucky and wondered, "How is this happening all around us and not happening here?" Martha immediately took steps to rectify the situation. She formed a steering committee and worked with the Blue Ridge Arts Center to organize the effort. Rather than forge ahead with an eye toward quick results, the group worked methodically to ensure that well-trained individuals would be responsible for each aspect of the process.

Don and Sarah Hart, with whom I had painted my first quilt square in Kentucky a year earlier, visited Seneca in October 2009 and conducted a workshop, taking the group through the entire process of creating a large painted quilt square. Martha credits Don and Sarah for allowing participants to gain the hands-on experience that gave them the confidence they needed to move forward.

When Martha invited me to visit during the quilt show that would officially open the quilt trail, I simply had to go. There had been many times along the way when I had forced myself to turn my back on a proud quilter who wanted me to take "just a minute" to look through her treasures. My mad rush of traveling across entire states had come to an end, so I had time to treat myself.

I arrived at the community center in Seneca and was delighted by the sight of an imaginative creation—a quilt car. Jenny Grobusky had pieced a quilt top that covered a PT Cruiser, complete with windows, a driver, and passengers. The car itself was worth the trip. After a leisurely walk through the quilt display, where I renewed my appreciation for the art of quilt stitchery, Martha File and I set off on the tour.

The quilt that served as the model for the state's first official quilt block is housed at the Oconee Heritage Center, so we made a quick visit. The committee chose a quilt that, according to Martha, exemplifies twentieth-century quilting in the area. The narrow points of the design and the tiny stitches are some of the

finest quilting I have seen, including the many treasures that had been on display that morning.

Lena Mae Land's grandparents, Warren and Elizabeth Orr, lived in Mountain Rest, and Grandmother Orr felt that quilting was an important skill for a young girl. In 1929, Lena Mae spent her thirteenth summer measuring, cutting, and stitching hundreds of tiny pieces on her grandparents' front porch. The next summer, she finished the intricate Rocky Mountain Road quilt. Lena's niece Mary Land Hardy said, "When Aunt Lena would whine and complain about how sore her fingers were, Grandmother Orr would say, 'Just a little bit more, honey, just a little bit more.'"

Those perfectly matched points are evident in the painted version that hangs over the entrance to the heritage center. I hoped that visitors would stop and step inside to see Lena's skill in sewing as well. The design is now the logo for what has become the Upstate Heritage Quilt Trail, as it has already expanded into the surrounding countryside.

South Carolina's first quilt square is a wonderful example of a community's showcasing local tradition by re-creating an existing quilt made nearby. Many of the quilt trails hold a special appeal for me because of a piece of history discovered or a friendship made, but I am most often drawn to projects that replicate actual fabric art. Gee's Bend, Alabama, is among those, but the quilts represented there are uniquely significant.

Gee's Bend lives in the imagination of those for whom art is part of the landscape. Unlike other quilt trails, which seek to acknowledge the artistry of family quilters and local quilting heritage, the quilt murals in Gee's Bend are replicas of quilts that have become revered by art lovers throughout the world and compared to the work of modern artists such as Matisse and Klee.

A sharp bend in the Alabama River has kept the tiny African American community of Gee's Bend difficult to access for decades. The poverty and isolation of the area bred closely knit relationships and some unique cultural elements, including a singular style of quilting. Though the purpose of these quilts is still to put together scraps of everyday fabric to create warm bedclothes, the women of Gee's Bend stitch their quilts in bold abstract designs bearing little resemblance to the more familiar quilts that are pieced from block patterns.

Beginning in 2002, Atlanta resident Matt Arnett and his family began documenting the quilts, both in books and on film, and have mounted exhibitions of the Gee's Bend quilts in prominent museums around the country. Matt commented, "To see room after room of these amazing works of art and then to find out about this community—it's a real place that you can drive down and see. People want to

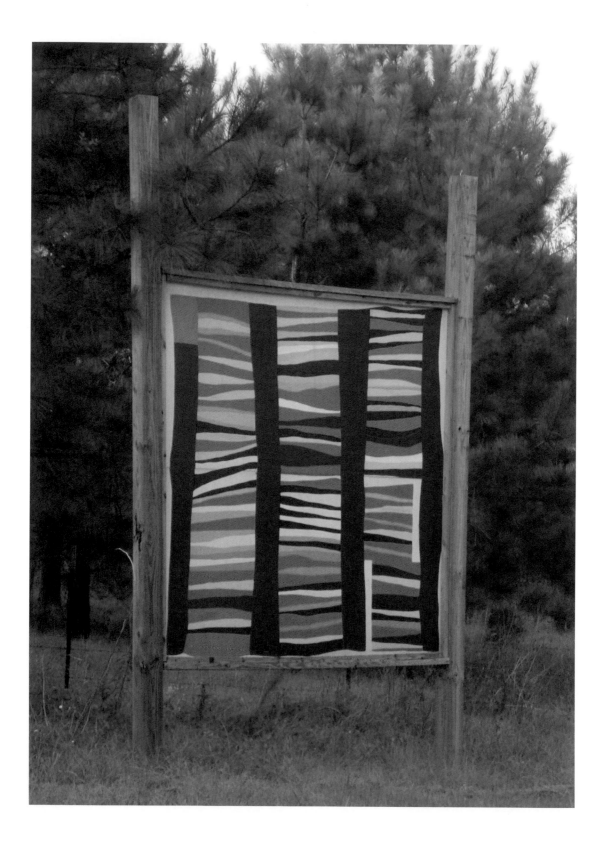

know where these works of art come from. The quilts are individual works of art, but we made it about a community rather than the artists. Each artist had her own identity, but the community component of the works' creation was highlighted, and it piqued people's curiosity about Gee's Bend."

The quilts became so acclaimed that ten of them were reproduced on postage stamps as part of the American Treasures Series, increasing their popularity even further. Gee's Bend is a remote location, yet people find their way from across the country. The quilters aren't always there, so the ten quilts that are on the postage stamps were used as the basis for murals so that, as Linda Vice, director of the Southwest Alabama Office of Tourism and Film, explained, "people can have a Gee's Bend experience no matter when they come." Artist Tyree McCloud was commissioned to paint the murals, which are mounted on freestanding posts along a trail that begins at the Freedom Quilting Bee, where women of the area made quilts that were sold to support the civil rights movement. The trail guides visitors past the home of the Quilting Bee's founder, quilter Estelle Witherspoon, and into the community.

The quilt trail in Gee's Bend may hold a different meaning for the quilters or community members who have already seen their art in magnificent venues, but the potential benefits to the local economy are the same. Matt Arnett said, "I hope it attracts tourists, because they might be drawn to the Quilt Collective and maybe meet the women and even buy an original quilt. Maybe people will stay a little longer and spend an extra few minutes in the community and in time somebody will open a small restaurant or a store." In addition to the potential economic opportunity, the Gee's Bend murals may also find new admirers of the community's celebrated quilt artistry among those who enjoy traveling the quilt trail.

The celebrated tradition of the art form has led Caledonia, Minnesota, to be dubbed "The Heart of Quilt Country." I couldn't help thinking of Iowa—a hundred miles to the south—and the similarity in the mindset of being the biggest and the best. The addition of barn quilts to the scenic rolling hills and broad vistas that overlook the Mississippi River valley made the designation even more appropriate. The community of three thousand in southeastern Minnesota now has thirty-seven barn quilts "quilting the countryside."

The barn quilt project began with a 2008 trip to Iowa. After working with her parents, Dorothy and Harold Hendel, to create a quilt square inspired by their travels, Anne Selness became convinced that the concept would be good for Caledonia, and in cooperation with the chamber of commerce, she spearheaded the effort.

Caledonia's barn quilts were created through a streamlined collaboration between the committee, area students, and barn owners. Classes were held to explain the method and assist barn owners with pattern and color selection. At the

213

blanketing the country with quilts

fairgrounds, industrial arts students primed the boards—one of the more tedious aspects of barn quilting. With chamber members on hand to help with drafting and a bank of paint from previous projects available, individuals or families created their squares at the fairgrounds and took them home to be displayed, satisfied at having done most of the work themselves.

The Mighty Oak pattern on Norbert and Grace Staggemeyer's barn caught my eye, and speaking with Grace added to my store of new information, which had been neglected of late. Grace told me that the family is in the barrel stave business. Of course, she then had to explain that staves are the boards that are used to make barrels such as those used to store wine or whiskey. The family sends staves to Australia, Hungary, Spain, and Napa Valley for wine barrels. "Even Jack Daniel's whiskey—that's our business," Grace proudly reported.

Grace was very particular about her quilt pattern. She wanted leaves, but they had to be oak—not just any leaves would do. She had seen a quilt that had oak leaves in it, but it wasn't quite right, so she kept drawing them until she created the design that suited her. "It probably doesn't mean anything to others," she said, "but it means a lot to me."

My other favorite barn quilt in Caledonia hangs on a nineteenth-century granary. The Bingham family's Maple Leaf quilt square stands out against the rustic building and is emblematic of the deep connection that the family has with the surrounding landscape. Karen Bingham eloquently said, "We treasure the beautiful hardwood forests that blanket our valleys and bluff lands. It is the maple tree that lets us know winter is almost over when the 'sap is running.' Its leaves give us abundant shade in summer and brilliant colors in autumn, and its wintery silhouette reminds us to be still and wait—because it knows the Minnesota seasons will come anew and repeat their glorious act."

Karen acknowledged that the barn quilt helps to spruce up things a bit, but she also emphasized that her barn quilt is art, and as such it is "a way to express beyond words—to lift our spirits and share it with others."

I was ready for my final journey, where I would find many of the elements that I had observed along the way. I saw the ways in which the spirits of an entire community could be lifted by working hand in hand. The involvement of local schools, the new relationships forged, and the reverence for quilting as an art were all in place. An impressive funding campaign enabled not only barn owners but also businesses in small villages to participate. The Barn Quilts of Neversink, New York, brings together the best practices of earlier projects while creating a trail rooted in local tradition.

A visit to the Catskills has always been on my to-do list. The mountains were the backdrop for the fanciful stories of Washington Irving and are always men-

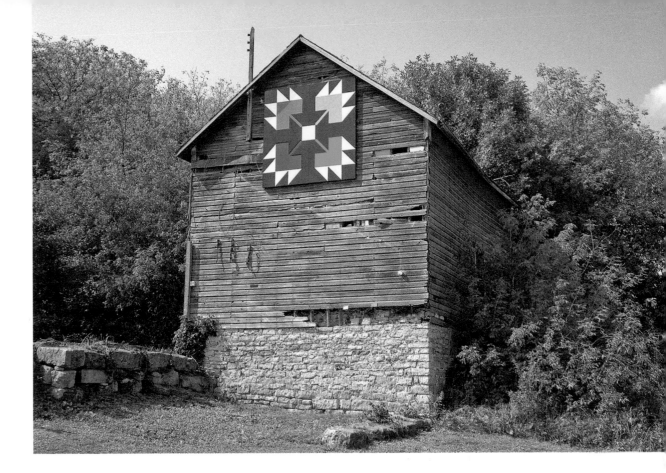

tioned in glowingly romantic terms. Nothing would do but to visit in fall, and I
scheduled my trip hoping to catch the "peak season" for autumn color.

The town of Neversink lies along a winding two-lane highway about eighty
miles northwest of New York City. My hosts, Dave and Phyllis Moore, explained
that the area once thrived, but since the 1960s the region's economy has been in a
decline. The Neversink Renaissance committee is working to bring life back to the
town of about four thousand residents at the southern edge of the Catskills, and
the Barn Quilts of Neversink is part of this effort.

I wanted to know the origins of the town's unusual name, but no one seemed
certain. Many say that the word came from an Indian name, but discovering the
truth is nearly impossible; county boundaries have shifted more than once, and
historical records are scarce. I was fascinated when I was told that the original vil-
lage was one of a small cluster taken when the city of New York flooded the area to
create two reservoirs. Some communities were lost, but the village of Neversink
was moved to its present location.

Dave picked me up in the morning, and we set out to visit with some of the
area's farmers. I became fascinated with the rows of rock walls visible throughout
the young forests that line the narrow roads, most about a lane and a half wide.
Both the sinking walls and the yellow of the fall trees called Robert Frost's poetry

215

blanketing the country with quilts

to my mind. Dave explained that each of the walls once formed the boundary of a farmstead, left decades ago for nature to reclaim. Along the ridges at Jack Clark's farm, the pastures are divided by these walls, once waist-high and able to keep livestock in place, but now sunk to knee level and serving as a reminder of what was.

Jack Clark is the quintessential farmer from the good old days, which made him a fitting subject for one of my last interviews. Listening to him, I was immediately transported back in time. Jack said, "It's stony ground—you could plow one day and spend the rest of the week picking the stones out of that one field. The old-timers said that the stones grew!" He went on to explain that the farmers would use a spring-toothed harrow to work the ground and the stones would come to the top. They would go one way, and the younger generation would pick the stones, and then go the other way and do it again. He chuckled as if revealing a long-kept secret: "When I was a boy helping my father, I threatened a lot of times to take the harrow out in the woods and hide it!" The stones were dragged by oxen to build the walls, which divided farms and then divided each farm into pastures. At one time, walls crisscrossed the fields in every direction.

In the 1950s when Jack moved away to Niagara Falls to work, some of those arduously built walls had to come down. Jack's airplane shortened the trip home to just two hours, and the upper portion of the farm was large enough for a landing area. Two walls divided the land into three pastures; Jack had the walls bulldozed so that he could land on a Friday, taxi right to the farmhouse, and take off on Monday morning. From the hill high above the reservoir, it was easy to imagine the plane sailing straight across the land into the air and to imagine the magnificent view Jack must have enjoyed. These days his view is of the barn, built in 1918, that sits downhill from the farmhouse and is home to the Barnyard Blanket pattern, an original design by an art student from Tri-Valley High School.

The barn quilt project is an important part of the Neversink Renaissance, a project that started in 2001 with improvements to community buildings and landscaping throughout the town. I was amazed to see blooming plants hanging from lampposts lining the main street. Dave said that there were over two hundred in all. The funds come from the Sullivan Renaissance, a program of the Gerry Foundation, whose mission is to improve the quality of life in Sullivan County. Each year, seed money is provided for community organizations to launch improvement projects. Projects are judged annually, and winners receive funding to continue and expand their work.

Dave and Phyllis Moore had been chairing the Renaissance Project and had thought that 2007 would be a slow year—mostly maintaining existing projects and adding some finishing touches on others. Retired art teacher Barbara Purcell had other plans. She read about the barn quilts in Iowa and thought they would make a perfect addition to the project. The committee agreed and almost immediately ordered the manual prepared by the Grundy County, Iowa, group. Organizers set

a goal of eight to ten barn quilts for the first year. The reception far exceeded expectation. That first year, thirty-one quilt blocks were hung, and in 2008, twenty-five were added, to bring the total to fifty-six.

Indian Blanket, Clark barn

Garages across the country are dedicated to barn quilt painting, but Barbara Purcell's dining room was the only quilt block studio that I found within a home. With plastic sheeting protecting the carpet and furniture, she has laid out boards on her dining room table and painted more than a dozen of the quilt squares. Daughter Lisa lends a hand, as she is especially skilled at painting the delicate curves. Two such patterns, the Turbine and Heavens Ablaze, decorate the hydro-electric power plant, certainly one of the most unusual sites I had encountered. Barbara has also been involved in the creation of most of the other barn quilts—working to select just the right patterns, then designing, drafting, and coaching the dedicated group that participates in the twice-weekly painting sessions at the first-aid building in town. The barn quilt committee compiled a set of instructions

217

blanketing the country with quilts

that they call "Barn Quilting 101," which enables folks to make barn quilts on their own.

With the new Bethel Woods concert venue at the site where the Woodstock festival took place only half an hour away, travelers from the cities are once again venturing into the area. The hope is that the town with the mysterious name will become another attraction. "This is kind of a new signature for this area," explained Dave Moore. "People want to come here to see the barn quilts." Town Manager Greg Goldstein recognizes that the benefits of the barn quilts are far more than the tourism they might bring. "Other towns envy us," he said. "It's like when you have a winning team—it's brought us a lot of pride."

Many a farmer along the way had taken me inside his barn, pointing out the skill with which his ancestors had built the sturdy structure. From roofs to haymows to ingenious arrangements of stalls and bins, I have been privy to many a lesson in the particulars of barn construction, delivered with enormous pride in having been a good steward of the building. Because the doors and interior sizes of most barns are not compatible with today's massive farm machinery, they are often replaced by modern metal buildings. Barns might store smaller implements or a collection of antique tractors, but by and large they have outlived their use and become expensively maintained relics.

Barns continue to disappear from the landscape at an alarming rate, but through the barn quilt movement, many have been repaired and saved, as the addition of the artwork creates an heirloom out of what might have become an eyesore. I had seen many such barns that had undergone extensive renovations; one of the more charming belongs to Bill and Nancy Lauck of Morgan County, Colorado.

I had seen a photo of Nancy's barn, and when I spoke to her, I was struck by Nancy's enthusiasm for barns as much as I was by her barn quilt collection. I had never seen the Rocky Mountains, and because Morgan County is less than a hundred miles from Denver, the idea of a quick visit was appealing. I did, after all, want to see some of the farthest reaches of the quilt trail, and at the time, that meant Colorado to the west. I also wanted to meet the woman who had almost singlehandedly created a trail of close to a hundred quilt squares.

I arrived in Denver a bit puzzled. The terrain was flat. I could see the mountains to the west, but I found myself driving through barren plains, wondering, "Where did everything go?" There was little within sight except for sagebrush, a few sod farms, and an occasional bright splash of yellow sunflowers, which provided some relief from the drabness. As I approached Fort Morgan, though, trees began to appear on the horizon, and soon the wasteland gave way to farmland.

The barn came into view as I made my way down the driveway, and I recalled my conversations with Nancy some months before. Nancy had attended a 2007

Nancy Lauck's quilt sampler. *Photo by Nancy Lauck*

arts council meeting, held after member Pat Knight had discovered the barn quilts of Iowa. Nancy was asked to launch the trail and began with her own barn. Like many farmwives, Nancy had to wait a bit for her husband to embrace the idea. At first Bill said, "I am not spending money on this barn!" Then they put it on the front page of the paper in color, and the roof didn't look so great. Bill said, "We're not putting any more up 'til we get it shingled!" As visitors began to stop by more often, Bill noticed that the old barn door was in poor condition. "Well, now I have a new barn door," Nancy said with a smile.

Nancy is most proud of the fact that the barn quilts are drawing attention to the barns themselves. "Gradually people are realizing that their barns are important," she commented. "When my father-in-law came to this country from Russia, they had nothing. They built a barn and worked hard. That means something to me—when someone lets a barn go, that's part of our ancestors that we are tearing down." Bill went on to explain that the settlers had to plant trees and irrigate the area to make it habitable. Nancy was right—Colorado farmers are a tough bunch.

I had never seen a barn constructed like this one, and Nancy told me that the unusual double rooflines of the 1909 structure made mounting a quilt square impossible. Nancy came up with an ingenious solution: instead of one large square, she would create a sampler quilt of sixteen squares all along the top so that they

219

can be seen. Nancy posed with me before the barn; as Bill took pictures, she explained the significance of each block.

The row begins with a Postage Stamp Basket painted by her daughter and three daughters-in-law. Nancy's grandchildren and daughters each created a square, selecting from traditional patterns such as Hole in the Barn Door, Pinwheel, Whirlwind, and Shoo Fly in eye-catching shades that included purple, orange, turquoise, lime green, and hot pink. The Bowtie that completes the row has four ties in vivid colors for her sons and sons-in-law. Of course, Corn and Beans had to be included to represent the farm itself, and the classic Delectable Mountains reflects the view of the majestic Rockies in the distance.

The county spans almost 1,300 square miles, so some of the locations are a bit far-flung. Nancy said that the next day we were going to go "out to the toolies" to see some of her work. I wasn't sure whether that was someone's name or maybe a distant town in the county, but the next day our barn quilt tour took us down one long, flat road after another, gradually moving onto gravel and dust, and I understood. I asked every farmer that we encountered, and no one could tell me why—but clearly "the toolies" meant "the middle of nowhere."

Though many quilt trails impose restrictions as to where quilt blocks will be mounted, Nancy believes that those who want a small quilt square on a home, a shed, or a garage should have one. "It's wonderful to see them everywhere," she said. Indeed, quilt squares appear in some unusual locations. I spotted a Fan block situated near the top of a very tall grain elevator and quickly declared it the world's highest barn quilt, which made Nancy smile.

Nancy Lauck exemplifies the strong-willed women who are found along the quilt trail—the type who never take no for an answer and eventually persevere. The greatest example, at least the one that Donna Sue spoke about most often, comprised the women of Terry County, Texas. The fact that they had no barns but had still managed to bring the quilt trail to their community exemplifies the spirit of the project.

Mary Collier revels in the fact that the area she serves produces more cotton than anyplace else in the world. "We do cotton!" she exclaimed. "When you think of quilts, you think of cotton; you think of the women who take cotton fabric and make it into an art form. It's in the batting, the backing, even in the thread."

As has been the case for many other communities, a December 2006 article about Donna Sue and the quilt trails caught Mary's attention, and she was taken with the idea. A few weeks later, she approached Brownfield City Council member Dale Travis, and told him, "We don't have barns, but we can paint them on anything."

Mary's friend Susan Lefevre had lived in Brownfield for thirty years and had always felt that the community needed something to call its own, so she was eager

Country Farm, Terry
County, Texas. *Photo
courtesy of Terry
County Quilt Trail
Committee*

to partner with Mary in this endeavor. The two traveled all the way to Ashland, Kentucky, to meet with Donna Sue and others who were already participating. Susan recalled, "When we found out that we were going to have the first quilt trail in Texas, I was so thrilled! People gathered together to create something we could call our own, and that was what I had wanted—for Brownfield to have our own 'brand' that told people, 'That's what's there.'"

As Mary says, "Texans are doers." Donations from the community poured in, and along with the "awesome quilt ladies" in the community, a dedicated group of volunteers worked in the shop behind Mary's house. Mary recalls sitting in her pajamas and seeing the light go on; someone would be out there painting at ten at night. The ladies were of all ages, with the oldest eighty-four. Ten blocks were painted and mounted on wooden posts throughout the area in fewer than four months and quickly gained attention as one of the furthermost reaches of the quilt trail at the time.

blanketing the country with quilts

221

Mary thought the quilt trail would just be a fun thing, but she found some of the family stories amazing: "I had no idea—I have had roughnecks from the oil fields come in and tell me a story with tears in their eyes and a quilt in their lap that they have saved. 'I remember my mother, my grandmother, my aunt, my sister.' They revere the maternal line."

Because of the severe weather—sustained winds of up to sixty miles per hour and temperatures of well over one hundred degrees—the original squares kept their fresh appearance for only a few years. The women, realizing that the quilt blocks needed to be done more professionally if they were to last, turned to an unlikely group of Texans for replacement quilt squares: inmates at the West Texas Intermediate Sanctioned Facility Prison. Inmates are required to perform community service during their time at the facility, so they were ready to take on the project. The replacement blocks and those being added to the trail are fashioned of metal but are still painted by hand; they are expected to last a long while so that they can continue to be the trademarks of Terry County.

Donna Sue appreciates the ingenuity that allowed a community with no barns to become part of the quilt trail: "They created a way to celebrate their community —based on their needs and assets—to bring people to see their unique quilt squares." Each of the "scraps" along the quilt trail has done likewise. With no larger statewide effort to draw upon, the communities found ways to capitalize on their strengths and to create something uniquely valuable.

Even more valuable at times are the personal bonds formed while collaborating on a barn quilt project. The Garrett County, Maryland, quilt trail is dear to Donna Sue not because of its prolific growth but because of her friendship with trail organizer Karen Reckner. As has often been the case, working to launch the new project led to a personal bond between the two women. It was Karen who traveled to Adams County to care for Donna Sue after surgery. The Maryland quilt trail has since grown slowly to about a dozen quilts, but it couldn't be more precious to Donna Sue.

Over the past few years, dozens of communities have continued to join the quilt trail movement, and every couple of weeks, another e-mail or blog posting brings news of yet another development. California, Indiana, Kansas, and Montana joined the quilt trail, and countless new projects have begun in the states where barn quilts are already prevalent. The map changes constantly, as additional states come on board, and through the chambers of commerce and other groups, a constant stream of new trails fill the gaps in between.

As Donna Sue once told me, "It's bigger than we will ever know."

the american
quilt trail

STANDING ON THE Adams County hillside in October 2001, the crowd of neighbors, loved ones, and hundreds of others wore faces aglow with excitement, as they had become part of something very special. As the first quilt square was completed, Donna Sue smiled widely and, dabbing away tears, remarked to a friend, "This is going to be big." But even Donna Sue could not have predicted that in ten years there would be more than three thousand painted quilt squares spread across thirty states, along with a sampler of twenty quilt blocks in Ontario, Canada.

As each new state and each additional community joined the movement, the quilt trails grew in ways that had been expected and in some that never could have been foreseen. One of the most important aspects of the initial vision was bringing economic development into rural communities, and that goal has been realized. From the simple self-guided family tour that might result in the purchase of a meal, a tank of gas, or a product from a local business to the annual events that draw hundreds of visitors, the economic benefits for each of the communities involved include both increased tourist traffic and greater interest brought to their area.

Tom Cross of the Adams County, Ohio, Visitors Bureau commented, "With all of the attractions that we have in the county, the cornerstone of our tourism is the quilt trails. How do you measure the value of that? We could never express what Donna Sue's idea has meant to this county."

The economic benefit of the quilt trails extends far beyond tourist dollars. Hundreds of thousands of dollars in grant monies—from state and local arts councils, corporations, philanthropic foundations, and other organizations—have been placed directly into the hands of those who will benefit from their use. In-kind donations from electric co-ops, paint companies, artists, and design firms have proven invaluable and have created lasting partnerships within many communities.

When the Adams County Sampler began, generating income for local artists who would paint the squares was an essential part of the plan, and for a few communities, that tradition has continued. But once the quilt blocks came off of the barns and onto boards that could be painted and then mounted, it became apparent that the project did not require skilled artistry. It seems that the phenomenal spread of the movement is largely attributable to the fact that, as Donna Sue says, "Anyone can play."

Part of the project's appeal is the sheer enjoyment of seeing local art publicly and proudly displayed. Candace Barbee, who helped launch the quilt trail in Tennessee, observed, "Normally when we see public art, it has been created by some artist that lives hundreds of miles away. This is folk art that you can drive by and see on your own, right where it originated." To be that artist is something that few ever dream of, but over the last ten years, thousands of people have discovered that the ability to create beauty is universal. Artists are not rarified beings whose works reside only in buildings in which they are spoken about in hushed tones. A quilt trail celebrates a community of artists.

The spirit of community generated by working together to create a quilt trail is transformative. "One of the really neat things about this project is that we have gotten to know people all over that we had no connection with and that we would have had no reason to know," said Sue Peyton of Sac County, Iowa. Across the country, that sentiment is repeated often—true communities built on shared experience, close friendships built while working side by side. In hundreds of conversations with quilt trail participants, that single thought echoed—creating a quilt trail inspires people to look closely at their existing communities and leads them to make friends out of strangers.

That network of friends extends nationwide, as organizers of new trails seek the advice and lessons learned from those who have gone before. Committee members mention "Sue over there in Sac," "Don the Quilt Guy," or "that nice Roy in Tennessee," referring to those who have guided them along the way and have helped them feel connected to quilt trail projects across the country.

To many, painted quilt blocks signify a personal connection to a beloved quilter or to a family tradition that may have fallen out of practice. To paint a quilt square is to say, "This is who I am. The women of my family were not simply loving caregivers who used their practical skills to create warm coverings with which to nurture us. They were artists who surrounded us with beauty, and that artistry lives within me. This is where I belong and who I belong to."

That feeling of belonging resonates with those who visit the trails. To have roots—to be connected to a place and to culture and ancestors—was once the rule but now has become the exception. Perhaps seeing that others have found a means of expression and a way to tell their stories creates in travelers the same need for connection, a reminder that they, too, are part of a culture whose art is beautiful and whose stories are waiting to be told. We are a diverse people, but our commonalities are greater than our differences.

One of the unexpected and possibly most significant aspects of the quilt trails has been youth involvement. We cannot know how many young people—from 4-H groups to scouting troops, schools, and individual families—have experienced the joy of creating art and seeing it displayed publicly. The fact that seventy youth groups in Iowa alone have been involved in painting barn quilts suggests that thousands of children, from toddlers to teenagers, have increased their appreciation of their heritage and surroundings by adding paint to a quilt square.

The quilt trail began as a way to honor Maxine and Donna Sue Groves's Appalachian heritage, but the impulse to celebrate local history and culture is universal. Barn owner Karen Bingham of Caledonia, Minnesota, suggested, "The meaning may not reside so much in the paintings themselves; they are guideposts to pieces of heritage and history that do hold meaning—to an individual, a family, or a community."

The project did meet with a couple of disappointments along the way. One of the lessons learned early on was that the quilt squares needed to be made to withstand the weather, and even the sturdiest of construction would eventually require maintenance. "That was one of the biggest mistakes we made," Donna Sue said. "We were just so excited about what we were doing—who thought about what the trail would look like in ten years?" Some of the original twenty quilt squares have been lost, and many of the others need repainting or repair. Donna Sue hopes that the Adams County community will rise to the occasion and restore the original quilt squares that have suffered from weather and wear. She strongly urges all who seek her guidance to address the issue of maintenance and build it into the plan for their quilt trails.

Another disappointment may have turned out to be a blessing of sorts. The collaborative concept between the quilt trails of Ohio, Tennessee, and Kentucky did not lead to an interconnected effort that would create Donna Sue's imaginary

clothesline. Other than in Tennessee, quilt trails do not cross county or state borders, even when another quilt square might be located just a few miles away. Local pride of ownership seems to outweigh any urge to expand through collaboration. Donna Sue had said at the project's inception that the concept was her gift, to be given freely and adapted by each community as its own. As one trail organizer put it, "If it's going to be significant to my community, the spirit of the project has to come from inside that community."

As of February 2011, at least 120 communities in thirty states have a quilt trail in place or under way. The map spans an area from New York to Texas to California. Is there, then, an American Quilt Trail—that "clothesline of quilts" that was once imagined?

Donna Sue told me, "Perhaps what we have now is not so much a clothesline but a quilt, with patches of all different shapes, sizes, and patterns. When they are all pieced together, the result is so beautiful. Watching it come together has been just magical and has given me more joy than anyone can imagine."

index

Page numbers in boldface type refer to illustrations.

229